CW01095160

Haughty Spirit

Haughty Spirit

"Pride goeth before destruction, and a haughty spirit before a fall." – Proverbs

by Sharon Green

a division of Greenery Press

Published in the United States by Greenery Press, 3739 Balboa Ave. #195, San Francisco, CA 94121, USA, http://www.bigrock.com/~greenery.

ISBN 1-890159-15-8

Other Greenery Press books by Sharon Green:
The Terrilian series – starting in Spring 2000 with "The Warrior Within"

1

Meriath studied herself in the large mirror her bedchamber had always had, a smile of satisfaction on her face. She looked the very image of the Goddess of Beauty that she was, especially in her newest gown. The draperies were a soft green chiffon that matched her eyes, the trim and accents a golden silk that went perfectly with her long golden hair. Her flawless complexion and full, rounded figure made her absolutely exquisite, just as she was supposed to be, just as everyone expected her to be.

"This time we won't add jewels," the First Hands said decisively, the tone of their voice smugly pleased. "You're perfect as you are, child, so adding anything would merely ruin the perfection. Everyone at the gathering will adore you at first sight."

"Not quite everyone," Meriath murmured, amused by the thought. Ever since the new Goddess of Beauty had started to attend gatherings a short time ago, the other goddesses there had been furiously jealous. The gods had all clustered around Meriath and vied for her attention, and she'd had a marvelous time with the ones she'd found acceptable.

"Now, now, don't you worry about what the other goddesses think of you," the First Hands soothed in a coaxing tone while one of them patted her shoulder. "They're all quite a bit older than you, so it will take some time before they come around. After all, they were the ones the gods desired before you came along."

"And now they have to wait to choose a gathering companion until I've made my choice," Meriath agreed with a nod of understanding, and then another thought occurred to her. "Will the time ever come when I'm displaced by a newly born goddess? I don't think I'd like that."

"Oh, what nonsense," the First Hands laughed with what seemed like true amusement. "Another goddess displacing you, the Goddess of Beauty? That can't possibly happen."

Meriath accepted the opinion just as she usually did, then sat down so that her hair could be brushed one last time before she left for the gathering. The First Hands had another pair of Hands actually do the brushing, but the First hovered

nearby to supervise just as they always did. It had never been clear just how many different pairs of Hands worked at the bidding of the First Hands, but their exact number didn't really matter. As long as some pair of Hands was there when Meriath needed them, she was perfectly satisfied.

And the First Hands always made sure Meriath had what she needed. The Hands had been there when Meriath had first become aware of the world around her, right after she'd been born. She'd been fully formed and grown, of course, but she hadn't known what she needed to know about the world. The First Hands had touched her gently and spoken in the same way, and once Meriath had accepted their presence they had spent the next thousand years caring for her and teaching her.

Now that Meriath moved among the gods and goddesses who were her peers, the First Hands guided and encouraged her. Because of the First Hands, Meriath had come to know just how special and privileged she really was. It felt right to be that important, and Meriath enjoyed the state more and more as time went on. The others were gods and goddesses of ordinary things, but Meriath was the Goddess of Beauty.

Once her thigh-length hair was properly brushed, Meriath made her preparations to leave for the gathering. She created a chariot of pale gold to ride in, then created four horses out of red rose petals to pull it. The horses were magnificent, of course, the most beautiful and fiery steeds Meriath was able to imagine, each of them rose red and petal soft. The fragrance of roses also floated on the air around them, completing the picture perfectly.

"We think we like these red-rose horses better than the golden oxen you used last time," the First Hands decided aloud as they helped Meriath up into the chariot. "Please let us know if the gods also seem to like them better."

"You expect the gods to notice what's pulling my chariot when I'm there for them to notice?" Meriath countered with amusement as she took the braided silk reins in her hands. "If they ever do, I'll leave here to become a hermit."

"Of course you're right," the First Hands returned with what sounded like embarrassment, now clinging to one another with obvious shame. "Please excuse so foolish and thoughtless a comment, child. Our age must be starting to tell on us."

Meriath knew that Hands never aged, not when they were creations rather than living things, but she felt too eager to get to the gathering to mention the point. Later, once she returned to the dwelling, she would open the subject again. It was amusing to point out a mistake that one of her servants had made, and then watch the guilty one – or pair – squirm in discomfort. After pointing out the error she would, of course, have to think of a fitting punishment, but right now all she wanted to think about was the gathering.

The rose-petal horses, ranged four abreast in front of her chariot, began to move forward as soon as she willed them to. They pulled the chariot higher up into the air with every step, moving through walls and ceiling alike until they were above all obstruction and able to head for the gathering place. Meriath could have taken herself to the gathering place with nothing more than a single thought, but making her entrance this way was much more fun.

The dwellings of the other gods and goddesses were no different from Meriath's own, so she paid them no attention as she flew over them. The gathering place was her sole concern right now, and in just a few moments it appeared right where it was supposed to be. The large, colonnaded building stood in stately majesty surrounded by rolling green lawn, much of the center of the building separated into chambers that were open to the air.

Other chambers were closed off and private, but those were the ones, Meriath had been told, that were devoted to politics rather than pleasure. It seemed that the older gods and goddesses enjoyed indulging in the game of politics, but Meriath wasn't expected to join them. She was much too young to be interested in anything but pleasure, and so she hadn't even been told what the politics entailed. Time enough to find out if and when such a thing began to entice her.

As her chariot began to descend in order to take her into the gathering place, Meriath was touched again by the faint curiosity she'd felt since the first time she'd come to a gathering. One of the gods and one of the goddesses were her father and mother, but she'd never been told which ones her parents were. It didn't really matter, of course, not in any practical way, but the knowledge would have been amusing. Her mother had to be one of the goddesses who were so jealous, and her father could well be one of the gods Meriath had accepted. Now, *there* was an amusing thought…

The rose-petal horses brought Meriath's chariot to a perfect landing in the gathering place, and instantly there were dozens of gods surrounding the chariot. Meriath let herself be helped down by one of them, and as soon as she stood on the marble of the floor, the chariot and horses disappeared. The disappearance let Meriath's group of admirers move in even closer, an action which made her smile.

"How radiant a smile you have, my lovely," a really beautiful god said as he took Meriath's hand to kiss. "I'm Angedar, God of Seduction."

From the way he looked, Meriath could well believe that Angedar was the god of seduction. He was tall and seemed to be perfectly made, his long, dark hair a delightful frame for the handsomeness of his face. Set in that face were eyes so dark that they almost made Meriath melt from the heat of them. Meriath knew the names of all the gods, but paid no attention to the names unless she accepted that one, a fact

Angedar undoubtedly knew. But he also obviously knew she would accept him, and he wasn't wrong.

"Angedar, how terrible that we didn't meet sooner," Meriath told him in the breathy way that the gods seemed to enjoy so much, ignoring all the others. "I don't remember seeing you at any of the previous gatherings I've attended."

"That's because I wasn't here, my vision," Angedar replied with a rueful smile, still holding her hand. "I was away teaching some of my worshipers the proper way to conduct a seduction, but if I'd known what I was missing I would have returned much sooner."

"Naturally," Meriath agreed with her own smile, knowing that the god spoke nothing but the truth. What god would waste his time elsewhere, when he could be gaining *her* attention? "Is there anything interesting to eat among the delicacies provided for refreshment?"

"Let's go together and investigate the matter," Angedar suggested, offering both his arm and his complete attention. "I'm sure we'll find *something* to capture our interest."

Meriath placed her hand on top of his with another smile, deliberately ignoring the glaring and mutters coming from some of the other gods who still stood about. It was clear that those others had meant to come forward and introduce themselves, but Angedar had outmaneuvered them and gotten to Meriath first. Now they would have to wait until the next gathering to gain her full if temporary attention. How amusing they were in their fits of frustration...

The tables holding refreshment for the gathering seemed to stretch for miles around the enclosed sections of the chamber. When Meriath and Angedar reached the first table, they chose golden cups of golden wine and then looked about to see if any of the edibles tempted them. Angedar chose a small square of something covered in what looked like a cheese sauce, and fed the square to Meriath.

Meriath discovered that the something was roasted meat that had been so well seasoned that it was incredibly delicious, so she took another square of it and fed it to Angedar. The God of Seduction took the square and chewed it with obvious pleasure, but didn't leave the matter at that. He also took Meriath's hand and slowly licked the remnants of cheese sauce from it, his gaze holding hers all the while. Meriath shivered with delight at the feel of his tongue on her skin, suddenly even more eager for the revelries to begin.

"Greetings, Angedar." A very deep voice spoke abruptly from behind them, causing the two of them to turn. "Have you finally grown tired of frolicking with your worshipers?"

"For the moment," Angedar agreed with a nod and a very faint smile. "We haven't run into each other in quite some time, Zolanus. Have you finally grown tired of playing politics?"

"For the moment," the god called Zolanus also agreed with what seemed to be amusement. Meriath knew the intruder was the God of Justice, but found it impossible to see what he looked like. Zolanus appeared as nothing more than a dark outline with not a single feature or detail visible, a vanity Meriath took as a personal insult. How dare he deny her the chance to satisfy her curiosity…?

"You don't often join the broader aspects of a gathering," Angedar put to Zolanus with a very sleek smile. "What brings you out of the inner halls on this occasion?"

"I heard that we had a newcomer to our ranks, so I came to meet her," Zolanus replied, now turning to Meriath. "Welcome to our sacred halls, little one. You do your calling proud."

"Of course I do," Meriath returned coldly, refusing to let Zolanus take her hand. "What good would a goddess of beauty be if she weren't the most beautiful being around? Have you any other silly comments to make?"

"My intention was to offer a compliment," Zolanus returned somewhat distantly while Angedar smirked. "If you took the attempt as an insult instead, I now offer my apologies."

"Neither your compliments nor apologies hold any interest for me," Meriath told the intruder bluntly, and then she all but yawned in his face. "Was there anything else?"

"You seem distracted at the moment, so I'll take my leave," Zolanus returned stiffly with a small bow. "We can speak again at the next gathering."

"Hardly," Meriath disagreed at once with what she knew was an incredibly attractive frown. "Considering how little I enjoyed *this* conversation, why would I want to have another one with you? Just go away and don't come back."

This time the black figure stiffened visibly before performing another bow and turning to walk away. Meriath was delighted to see Zolanus finally gone, but Angedar cleared his throat in what actually seemed like discomfort.

"Perhaps you shouldn't have been quite that… abrupt with him," Angedar suggested in something of an offhand way as he turned back to Meriath. "Politically speaking, Zolanus is one of the most powerful of our peer group, and I've heard it said that it isn't wise to get on the wrong side of him."

"But why would I care about that?" Meriath asked, for some reason finding herself curious. "If I have no interest in politics, why would it matter *what* side of him I happened to be on?"

"I suppose it wouldn't matter at that," Angedar agreed with a renewed smile, raising one hand to stroke Meriath's cheek. "And no one with your… attributes has to worry in any event. Shall we return to what we were doing before we were so rudely interrupted?"

"Most definitely," Meriath told him, remembering how she'd felt when Angedar had licked her fingers. That memory was much better than some foolish curiosity she had no idea why she'd had. "And then we can go on from that point."

"Indeed," Angedar murmured, then turned back to the table of refreshments with her. The next thing he chose to give her a taste of was a different meat in a cream sauce, and when Meriath returned the favor, Angedar repeated his performance of licking her fingers clean. None of the other gods Meriath had tried had done anything like the same, and she discovered that the novelty really pleased her.

And that wasn't the only novelty Angedar came up with. Once they had played the licking game for a short time, the god of seduction created servants modeled after his human worshippers, and had those servants collect various dishes from the refreshment tables.

"While those others are busy with the food, we need one to carry a pitcher of wine," Angedar decided aloud, then produced a human female. She was small, plain, and tired-looking, and Angedar barely glanced at her before smiling happily at Meriath. "Now close your eyes, my lovely, and then I'll lead you to the couch I mean to create."

"But that's silly," Meriath protested with a laugh. "If I close my eyes, I won't be able to see the couch."

"Exactly," Angedar agreed with amusement. "I want your first sight of the couch to be a surprise, and for that you need to be right next to it. Trust me, my sweet, and you won't be sorry."

The last thing Meriath would be foolish enough to do was to trust one of the gods, but this was just a little game. There was no real danger in giving Angedar his way, so Meriath closed her eyes and let the god of seduction lead her slowly across the marble floor. Others had already created couches of their own, and some feasted on the refreshments while others began to indulge in more interesting pleasure. Meriath could hear the sounds of both endeavors as she walked along with her eyes closed, and after a few moments Angedar stopped her by the hand he held.

"I'm going to lift you up, and then you can open your eyes," Angedar said just before he suited action to words. He lifted Meriath in his arms and set her down on her feet again at once, but in a place that felt higher than the marble floor had. Meriath opened her eyes quickly, and then she laughed aloud.

"Why, Angedar, you've created a couch out of diamonds for me," Meriath exclaimed, but only to better the mood of her chosen companion. "And they're soft and warm rather than hard and cold, beauty without the discomfort."

Of course, she refrained from mentioning that the same had been done once before, by another of the gods. Riaster was the God of Minerals, so he'd made the couch of real diamonds with an invisible cover to make it more comfortable. The cover hadn't done as much as it should have against the lumpiness beneath it, and Meriath had left Riaster early to find a companion with more intelligence.

"The diamonds were made soft and warm and beautiful so that they might, in some small way, emulate your matchless self," Angedar replied with a smile as he raised himself to stand beside her on the couch. "Nothing can actually match you, of course, but some few things are capable of framing your incredible loveliness to best advantage. I simply chose one of those."

Angedar's words pleased Meriath, and the way he took both of her hands to kiss pleased her even more. He kissed each of her fingers in turn, then coaxed her into lying down with him on the soft diamond couch. Meriath was more than willing to cooperate, and once both of them were lying on their sides facing one another, Angedar brushed her lips with his.

"I consider it a privilege to be allowed to pay tribute to the Goddess of Beauty," Angedar murmured, his gaze on her face as his hands stroked down her arms. "It seems to be a bit warm in here, so permit me to increase your comfort."

"Perhaps in a little while," Meriath said with a smile, deliberately keeping him from lowering the top of her draperies. "At the moment I'd like a bit more wine."

"Of course, how thoughtless of me," Angedar muttered after the smallest hesitation, obviously unhappy with her decision but determined not to show his displeasure. "We'll both have more wine and possibly even a bite or two, and then we'll see about greater comfort."

Meriath watched him sit up and gesture over the human with the wine pitcher, the gesture one that would have gone well with a snarl. Meriath laughed to herself on the inside just as she usually did, enjoying the way denial always pushed a god off balance and out of control. Before the gathering was over, Meriath meant to have quite a lot of service from Angedar. But that service would be given in her good time, not his. The Goddess of Beauty was meant to lead all the gods around by their … desire, and Angedar would be no exception to that.

The wine was poured quickly, and then the other servants Angedar had created were gestured closer so that he and Meriath might see if anything tempted them. Meriath slowly tasted most of what was offered, while Angedar created a group of dancers that were obviously supposed to stir her blood. The male dancers stroked the females with their palms as they danced, and then the males began to kiss and lick

the females. The females moaned and tried to return the gestures, but the males refused to allow it. The male dancers kept the females at arm's length except when they were touching or tasting, and after a few moments of watching, Meriath decided to go along with the ploy – to a certain extent.

"I really do appreciate the creative," Meriath murmured to Angedar as she put her wine cup aside. "Lie back and let me show you just how much I appreciate it."

Angedar smiled at her in an encouraging way before quickly lying back, most likely thinking that his inner burst of exultation had gone unnoticed. Meriath let him continue to believe that as she reached to his shoulder and removed the golden clip holding his draperies closed. She tossed the clip aside as she moved the draperies down from his chest, taking a moment to admire his form.

The God of Seduction was beautifully made, his chest broad and smooth and tapering down to a slim waist. The muscles in his chest were also well defined, and Meriath ran the tips of her fingers over the lovely bulges before she leaned down to outline those bulges with kisses. Angedar tasted faintly of good wine and exotic herbs, the warmth of him under Meriath's hands as she began to lick him where she'd previously kissed. Tasting him like that did warm her own blood to a good degree, but it affected Angedar even more.

"Ohhh, my lovely, that's marvelous," Angedar moaned, his hands coming to her arms as his palms stroked her slowly. "Now lie back so that I may do the same to you."

"All in good time, my sweet," Meriath murmured, refusing to let him press her down to the couch. "First let's have a bit more wine as we watch the dancers you so kindly provided."

As Meriath turned to retrieve her wine cup, she heard Angedar make a sound that was very like choking. If he had choked back an inappropriate comment, that was very wise of him. If Meriath decided to find another god to entertain her, she would have very little difficulty in doing so. He, on the other hand, would probably have trouble finding a goddess willing to accept being second choice, a truth he undoubtedly understood quite well.

They both sipped wine for a moment or two, and then Angedar got the message Meriath had wanted him to. His dancers suddenly changed their behavior of the males keeping the females away. Now the males not only encouraged the females, but the males also began to defer to the females. Each male constantly went to his knees before a female, abjectly begging for her attention. After another moment or two the females allowed the males to pay them homage, and in no time at all the three couples had given up dancing for exchanging pleasures of the body.

"My, they do seem to be enjoying themselves, don't they?" Meriath remarked with a glance for a clearly suffering Angedar. "Would you like to try the same with me?"

"Yes, my lovely, I certainly would," Angedar agreed immediately, his tongue nearly hanging out. "May I begin at once?"

"When I've finished the wine in my cup," Meriath told him, ignoring the way Angedar's face crumpled nearly to the point of tears. "You don't mind waiting just a little longer, do you?"

"No, of course not, I don't mind at all," Angedar replied at once, his expression fighting to match his offhand words. "Whatever most pleases you, my sweet."

Meriath acknowledged his agreement with a nod and a pleasant smile, then sipped at her wine again. She had less than half a cup left, but it would be the longest half-cup Angedar ever saw swallowed. Meriath more than suspected how Angedar would have acted if his powers had been greater than hers, but gods and goddesses had almost exactly the same powers. Angedar might force humans to his will with no more than a small effort, but dealing with her was in no way the same. If Angedar didn't behave, he would be left with no choice but solitary relief.

"What do you know, I'm almost finished with my wine," Meriath said after quite a long string of minutes, immediately capturing Angedar's misery-filled attention. "Why don't you remove your draperies entirely, Angedar, and then they'll be out of our way."

Angedar immediately reached to his waist and began to disrobe entirely, understanding coming to him only after a long moment. Meriath still lay completely covered, but in a matter of heartbeats he would be entirely bare. Nudity meant less than nothing to gods and goddesses, but only in and of itself. Like many other things, the condition depended on circumstance for it to gain meaning. And the meaning of his being naked while she remained clothed was perfectly clear.

Meriath had only a moment to wonder if Angedar would comply, most especially since there were a lot more gods and goddesses ranged on couches around them. Then the God of Seduction finished ridding himself of draperies with short, angry movements of his hands, baring his raging desire to her sight. Meriath smiled, satisfied with the clear homage being paid to her godhood, then she finished the last of the wine in her cup before putting the cup aside.

"Now I'd like to see what you meant to do earlier," Meriath told Angedar as she lay back on the couch. "You may open the top of my draperies, but only the top."

Angedar shivered as he momentarily closed his eyes, and then he quickly reached to her shoulder to undo the golden pin there. He could have removed all her draperies instantly, of course, but she'd let him know that she had no intention of allowing that. And he had most obviously decided to accept her dictum in the way the

other gods had, with silence rather than with open anger. Meriath knew he would also keep silent afterward about his embarrassment, just as the others had. Their foolish male pride kept them from warning those who hadn't yet fallen to her, and that was just the way Meriath wanted it.

Once Angedar had Meriath's draperies open to her waist, he lost no time in caressing then kissing her breasts. Her breasts were just as perfect as the rest of her, of course, and much of Angedar's distress disappeared when he had part of his goal in view. His big hands slid over her flesh as his lips paid homage to her left nipple, the kiss ending in the tickle of his tongue. After a short while he moved his attention to her right nipple, but the left wasn't entirely forgotten. His thumb caressed the hard nub his efforts had produced, sending a secondary set of delightful chills all through Meriath.

By the time Meriath felt Angedar's hand sliding up her leg underneath her draperies, her breathing had become somewhat ragged. Angedar was much more of an artist with his tongue and lips than any of the others had been, his efforts causing Meriath to lose quite a bit of control of herself. Her eyes had long since closed to increase the pleasure she was being given, but eyes are easily opened to accompany a lazy smile.

"Do the same to me there," Meriath whispered, her hand on his to show where she meant. "Don't remove the draperies, just slowly move them aside."

Angedar moaned at hearing her commands, but the God of Seduction was in no condition to do anything other than obey. He left her breasts to resume his kissing and licking at her calves, his hands on her thighs just above her knees. Meriath closed her eyes again with a smile, opening them briefly when Angedar turned her to her belly before continuing with his ministrations. His lips and tongue slid up and across the backs of her knees and thighs, and Meriath moaned very low at the exquisite pleasure. Angedar had clearly surrendered completely, and now served her fully in the way she most wanted to be served at the moment.

Angedar kissed and licked all across her round and beautiful bottom, his palms and fingers busy with her tingling thighs. After an eternity of delight Meriath felt herself being lifted a bit from the couch, and then Angedar's tongue licked at her womanhood. Meriath instantly went into orgasm, her body shuddering and trying to thrash about. Angedar's grip held her still for his tongue and lips, though, adding to the incredible explosion and nearly taking Meriath's senses.

When full awareness returned to Meriath, she'd been turned to her back again. Angedar now kissed the mound of her womanhood, his tongue tickling her nub almost in passing. That first orgasm had left her weak and almost completely satisfied, but now she'd been returned to the state of needing satisfaction again. If Angedar had made the least effort to satisfy his own needs, Meriath would have made him wait almost as long as he had already waited. But Angedar did nothing but minister to her body, and that deserved a reward.

"Come to me, my handsome, virile god," Meriath whispered, her hand on his distracted head. "Come to me fully, but take your time."

Something very like a sob escaped Angedar's lips, and then he put himself between her thighs so quickly that Meriath wasn't certain he hadn't used his power. His need raged out from his body like the branch of a tree, and his large hands gripped her thighs so that that need might approach her own. But rather than plunge deep he merely began to enter her, then leaned down to kiss and lick her breasts again.

"Yes, that's marvelous," Meriath whispered, encouraging his obedience with her hands to the broadness of his shoulders. "Take your time, and then stroke slowly."

Angedar slid inside her with exquisite slowness as he licked and kissed her breasts, and once he was fully within he began to stroke her almost as slowly. His desire was a rod of metal caressing her inner womanhood, paying the ultimate homage to her beauty. Angedar stroked and Meriath moaned with the incredibly delicious feel of him, and eternities passed behind the sensations of pleasure.

When orgasm came to Meriath again, Angedar's release came close behind her own. His stroking had slowly increased in pace and strength while she had reveled in the delights given her body, and his climax had come at a time when she hadn't been able to refuse it to him. He must have guessed that she would have kept him for continued service if she could have, and had made certain that his slavery would be at an end. By the time the incredible pleasure had faded to a point where Meriath was willing to stir a bit, Angedar had disappeared.

"But not to discuss our encounter, I'll wager," Meriath murmured as she sat up on the couch she'd made certain to maintain. "They all know well enough that they'd never live the incident down."

And they never would. Meriath made a cup of wine for herself and pillows to lean against, at the same time glancing around. Couches stood everywhere and some, like hers, were occupied by only a single individual. Among the gods, there were those who liked to watch almost as much as others liked to participate. She, however, wasn't terribly interested in secondhand pleasure, so once she'd finished her wine she willed herself home.

Meriath appeared in the entrance hall of her dwelling just as she usually did, her thoughts now centered on a decision to be made. She couldn't decide whether to bathe first and then discipline the First Hands for the slip they'd made earlier, or to administer discipline first and then bathe. Both doings would be enjoyable, but which of them did she want to do first?

The question held her attention as she began to move across the entrance hall, no more than a distant awareness touching her of the fact that none of her servants had yet appeared. They always appeared immediately when she returned home, but this time...

Meriath was able to do no more than begin to frown when everything about her melted suddenly into unconsciousness.

2

Unconsciousness was not a usual experience, nor was an abrupt awakening. Meriath felt vastly confused when she became aware of her surroundings again, and not merely because of the new happening she'd experienced. The last thing she remembered was the entrance hall of her dwelling, but the place she now lay was somewhere else entirely. Thick darkness surrounded her almost completely, except for the bare floor upon which she lay. That floor glowed a deep and angry red, its intensity coloring her flesh with a lighter version of its sullenness.

Leaning up on one elbow had shown Meriath the matter of her tinting, but the movement also brought another matter to her attention. Her head felt oddly... tight, as though something now rested on her brow. Using her free hand to find and remove the something, Meriath experienced a shock of discovery. There was some sort of band across her brow, but the ends of the band disappeared into her temples and refused to come loose. The flat band stayed stubbornly where it sat, no matter how hard she tried to tug it off.

"Removing the restraint is now beyond you, child," an amused voice commented from beside her. "Our lord has become your master, and now his will prevails."

"What are you prattling about?" Meriath demanded in exasperation and annoyance. A pair of Hands floated in the air beside her, also tinted an angry red. "No one can become the master of a goddess, and certainly not of the Goddess of Beauty."

"And yet the deed has been done," the Hands pointed out with continuing amusement, unbelievably even sounding smug. "Our assistants and we have been instructed to teach you a modicum of good manners, and then you will be taken before your new master. Get to your knees and prepare yourself to learn."

"How dare you speak to me like that?" Meriath demanded in outrage, furiously angry at the behavior of the Hands. "I am a goddess, and now you may return to the nothingness you spring from."

Meriath's gesture was meant to completely destroy the outrageous Hands, but shock suddenly gripped the young goddess when the Hands continued to hover right where they'd been since she'd awakened. Her attempt at destruction had accomplished nothing, a failure she'd never before experienced.

"How foolish you are to attempt disobedience, child," the Hands scolded, another thing Meriath had never experienced. No pair of Hands – or even a god or goddess – had ever dared to scold her… "Now you must be shown what disobedience will bring you."

One of the hands gestured, and suddenly Meriath felt what seemed like a line of burning flame across her bottom. Meriath yelped and jerked around, only to see one of another pair of Hands gripping a long, thin stick of some kind. The Hand had apparently struck her with the stick, and the result of being struck had brought – what?

"The sensation you feel is called pain," the first pair of Hands informed her, again sounding smug. "The pain came from the switch you were struck with for disobeying, an action which will be repeated until you do obey. Do you wish to be struck again?"

"No," Meriath responded at once, one hand going to her now-tender bottom. "But I also don't want to obey you. I'm a goddess, and you're nothing but a pair of Hands."

"You really must make an effort to understand your new situation," the Hands told her with a sigh indicating what seemed to be an attempt to show patience. "For the moment you must forget about being a goddess, since all your prerogatives as a goddess have been suspended. Either you will obey the commands you're given, or you will be punished until you do obey. Now, get to your knees."

For the second time the thing called switch struck Meriath, causing her to yelp again at the added pain given her bottom. Meriath found it impossible to understand what was going on around her, but part of her confusion brought her abruptly to her knees. She had never experienced pain before, but it hadn't taken her long to know that she wanted no more of it.

"Excellent," the Hands said, now hovering directly in front of her. "The lord will be pleased that you're finally beginning to learn. Now sit back on your heels, and fold your hands at your waist."

Meriath found leaning back fractionally more comfortable than simply kneeling straight, but the rest of what she'd been told made no sense.

"How do you 'fold hands'?" she demanded of the Hands, who should have known better than to use such a foolish term. "My hands are solid, and it isn't possible to fold something solid – Ow!"

"You were punished for the tone of voice you used to us," the Hands informed Meriath in a sterner way as Meriath tried to rub at her abused bottom. "No, don't bother trying to rub your bottom again, from now on you won't be allowed to ease yourself after being punished. If you have a question about something, you must first ask permission to speak. Then you must wait until you're given that permission before you put your question. Try it now."

Meriath knelt straight on her knees again, her poor bottom throbbing to the newest stroke of the switch, her eyes beginning to fill with tears. Crying was another thing she'd never done before, but the confusion inside her grew worse and worse. Something had kept her from rubbing at her bottom, just as though an invisible wall had gotten in the way. She hated having to obey a stupid pair of hands, but she was being given no choice at all.

"I... would like permission to speak," Meriath finally forced herself to say, feeling more miserable than she had in her entire existence.

"Very well, child, ask what you need to," the Hands allowed in something close to a drawl. "But make the question brief, and afterward remain silent unless you're ordered to respond or you have a question."

"I – don't know how to fold my hands," Meriath put, feeling the heat of humiliation in her cheeks. She, the Goddess of Beauty, being forced to obey a pair of Hands...!

"You place both of your hands at your waist, and then put your left hand over the right, like this," the Hands replied, demonstrating the last of the directions. "And you're supposed to be resting back on your heels, remember."

Meriath had forgotten, so she rested back on her heels again as she performed the foolishness with her hands. That entire situation was stupid and intolerable, and the only real question she had was how long it would continue. She thought about asking the Hands, then rejected the idea. The Hands seemed determined to tell her nothing she really needed to know, and being refused would simply add to her humiliation.

"All right, we now have a fairly successful beginning," the Hands allowed with a frown clear in their voice. "This is the basic position you will take when in the presence of your master, with one or two corrections. Your head must be bowed rather than held high, and your shoulders must be a bit more rounded. Try those things now."

Meriath would have enjoyed telling the Hands how stupid they were being, but she had no desire to be struck with that switch again. So instead of speaking she merely lowered her head, and made an attempt to relax her shoulders.

"Technically correct, but there's still something not quite right," the Hands decided aloud, sounding faintly annoyed. "Well, possibly the next step will provide whatever is lacking. We'll try it and see."

The muttered speech of the Hands added to Meriath's confusion, but only for a moment. The next instant Meriath was too busy gasping at what she felt for confusion to be considered. Meriath's breasts tingled with the need to be touched, her womanhood itched and throbbed both inside and out, and it suddenly felt as though something slid up and down deep inside her bottom.

"No, don't change your position!" the Hands ordered sharply as Meriath moaned and writhed. "And don't try to touch yourself, as you won't be able to. Return to the proper posture."

"I can't!" Meriath objected in a wail, frantic over not being allowed to touch herself at all. "I need one of the gods, and I need him now!"

Rather than answering her in words, the Hands performed an odd gesture and then quickly approached her. They grasped her hair and pulled her forward just as other hands took Meriath's wrists, calves, and ankles. The Hands on her wrists pulled her arms forward until Meriath's own hands rested flat on the glowing floor to either side of her head, and the rest of the hands simply held her still.

"There is no excuse for disobedience, and all disobedience is punished," the Hands holding tight to her hair stated, their tone very stern. "You seem to learn very slowly, child, but this ought to help with your efforts."

The next moment Meriath had no need to ask what "this" meant. The switch began to strike her seat again, but not a single time. The switch fell again and again, each stroke bringing searing pain, causing Meriath to scream and struggle. But the struggle did nothing to free her, nor did it stop the punishment for too long a time. By the time the beating was over, Meriath wept sobbingly and ached with blazing pain.

"Ten strokes are a good deal more painful than a single stroke, are they not, child?" the Hands holding to her hair asked when the punishment had stopped. "You refused to obey an order, and you spoke without permission. Do you mean to do those things again?"

Meriath shuddered because of the sobbing, but still managed to shake her head. Gods and Goddesses weren't supposed to have nightmares, but somehow she had fallen into one.

"We're pleased to hear that," the Hands told her with a definite purr as they released her hair. "You may now kneel back on your heels with your hands, head, and shoulders in the proper position."

When the rest of the Hands released Meriath as well, she moved herself back to the required position. Her bottom ached horribly, but the pain seemed to have done

little in easing the balance of what she'd been made to feel. She still very much needed the attentions of one of the gods, the involuntary squirming of her body proclaiming that fact to the universe.

"Yes, the required position now seems a bit more acceptable," the Hands commented after a moment. "Possibly the punishment given you helped to achieve that... In any event, the desire you feel will continue to be with you until your master sees fit to ease you. If he sees fit to ease you. You must be on your best behavior, otherwise he could well decide to have you punished rather than eased. Do you understand, child?"

Meriath nodded miserably, understanding perfectly that she was to be tortured at the whim of her captor, whoever he happened to be. She'd had no idea that such a thing could be done to her, else she would have been a good deal more alert to the possibility. This whole terrible situation was the fault of her First Hands, for failing to tell her that such a thing could happen. As soon as she got home, Meriath would lose no time in thanking the First Hands in the most appropriate – and painful – way she could find.

"You will remain kneeling in place until a bath has been drawn for you," the Hands now informed her. "Your master will want you to be clean and shining and properly perfumed for him, and so you shall be."

Meriath nearly protested her inability to sit in a bath, but remembered to stay silent at the last instant. The Hands had told her what would be done, probably expecting her to protest so that they might punish her again. The bath would still be given her, and the added punishment would certainly make it that much worse. Staying silent was the best response Meriath could make to the Hands, denying them their enjoyment in a way they would be unable to protest.

"What a good child you are," the Hands cooed, actually sounding pleased. "It seems we've found the best way to teach you, and as long as you remember that that way will be used as necessary, there should be no difficulty between us. Remain in place until we return."

The Hands disappeared after offering their comments, a lucky thing for Meriath. If the Hands had still been there, the humiliation Meriath felt might well have caused her to incur another punishment. Rather than being angry the Hands had been pleased, a condition that grated on Meriath almost as strongly as what had been done to her.

The passage of time meant nothing in that unrelieved dark above a redly glowing floor, but enough of it limped past to cause Meriath's knees to begin to ache. The ache wasn't as bad as the one in her bottom – or the demands of her body – but it was noticeable enough that the reappearance of the Hands came as a relief.

"We're ready for you now," the Hands informed her, an odd tone to the words. It was almost as though the Hands were pleased about something more than the bath being ready… "You may rise to your feet, but keep your hands folded and your head bowed. You'll be shown the proper direction in which to walk."

Meriath felt a small bit of curiosity about the reasons behind what she was being made to do, but the urge to know faded behind the wall of self-pity that had grown inside her. There couldn't possibly be a good enough reason for someone to treat her like this, not even if it was a god who was jealous of not having been accepted by her. The one responsible was a beast, lower even than a human, and once she was free Meriath meant to let everyone know just how low the beast was. But for the moment she had no choice about obeying, so she got unsteadily to her feet.

Once Meriath was erect, a Hand came to each of her arms to direct her. She was urged to walk in the direction that had been to her right, even though there seemed to be nothing in that direction that was different from any other. The Hands on her arms continued to lead her, and in a short while she reached an area that was different.

The darkness had lightened just a bit here, enough to show what seemed to be a silent waterfall. The ground still glowed that angry red, turning the bottom part of the waterfall into a glittering curtain of reflected ire. The Hands on her arms led her closer to the waterfall, where it was possible to hear a sound like gently falling rain.

"This is where you will bathe, with the help of our assistant Hands," Meriath was told when they stopped at the edge of a pool that also glowed red. "You will allow the Hands to guide you through the process."

Meriath had never considered bathing a process, but she hadn't been asked a question and so had no need to make a reply. She simply let the Hands urge her into the pool, but surprisingly the pool was too shallow for decent bathing. The surprise, however, seemed to be all Meriath's. The Hands on her arms continued to urge her forward, until she stood under the falls itself.

The stream of water brought a second surprise, in that Meriath found it to be delightfully warm rather than cold. The stream was heavy enough to wet her quickly and thoroughly, but not so heavy that it made breathing beneath it difficult. The Hands on Meriath's arms allowed her to stand under the delightful flow for a number of minutes, and then they urged her back out.

Once Meriath stood outside the stream of water, other Hands came to spread soap all over her. First her long hair was soaped thoroughly, and then half a dozen Hands soaped her body. This was obviously the "process" the leading Hands had meant, and it quickly became a most uncomfortable process. The Hands lathering the soap on her body increased the terrible need she'd been made to feel, sliding over her

breasts and thighs and womanhood and then rubbing those places gently. The touch on her aching bottom was only a small distraction, enough to make her squirm even more rather than taking attention from what was being done elsewhere.

Meriath was so distressed she actually tried to move away from the Hands tending her, but the Hands on her arms refused to allow it. She was made to stand where she'd been placed despite the small mewling noises she found impossible to hold back, and the terrible "process" took forever. Every crevice of her body from the neck down was thoroughly seen to, and tears flowed freely from her eyes by the time she was directed back under the stream of warm water.

The falling water, assisted by various Hands, took time rinsing every bit of the soap from Meriath's body and hair, but once it was done the Hands on her arms guided her out of the pool back onto dry land. As soon as she stepped out it was possible to see that a wide mat had been placed on the ground, and the waiting Hands gestured to it.

"Once you've been dried, you will lie face down on that mat," the Hands directed as other Hands put soft cloth around her body and hair. "Lotions will be applied to soften your skin, and then you may well be ready to be taken to your master."

Meriath's need leaped at the thought of that, the thought of finally being eased, a small glimmer of hope in an otherwise hopeless situation. The promise sustained her through the drying process, which was uncomfortable, but once she had stretched out on the mat, the situation became a good deal worse. All those Hands came to smooth lotion into her skin, and the fact that the lotion eased the ache in her bottom to a large extent only made matters worse.

Meriath found it difficult when lotion was smoothed into the back of her, but when Hands guided her onto her back and then began to apply the lotion to her front, she could do nothing but whimper and squirm. Her breasts and nipples were massaged gently while the same was done to her thighs, calves, and feet. That kind of massaging was bad enough, but when the fingers of Hands came to her pit of desire and inner bottom at the same time, Meriath screamed and had to be restrained. She needed easing, not more tormenting, but the Hands didn't care. The Hands had been given their orders, and they would follow those orders no matter what they did to their helpless victim.

It took some time before the hysterics began to release their grip on Meriath, and once her sobbing had quieted, the leading Hands made their displeasure known.

"Your behavior was quite unacceptable, child," the Hands told her sternly while she lay curled on her left side on the mat. "Were it earlier you would already be in the midst of punishment, but the lord has indicated that he wishes to see you. First you will be taken to him, and then you will be punished."

Even in the midst of her misery, Meriath was able to find an inner smile. Once she was brought to her captor, he would be too eager to ease her to allow the Hands to punish her. And once he'd eased her she would be set free, to return to the life that was rightfully hers. But first she'd see those hateful Hands destroyed, slowly and painfully.

"Stand up now so that you may be properly draped," the Hands directed. "Your master will wish to unveil you himself."

That comment about unveiling made very little sense to Meriath, but she still rose to her feet to allow a gown of draping to be put on her. Silken cloth was brought, but it wasn't the gown Meriath had expected. Instead she was scantily draped in something that had no sleeves, was barely long enough to cover her womanhood, and closed with two long ties at her waist to the left that produced a deep vee at her breasts. It was impossible to tell what color the thing was, but it really made very little difference. Soon, very soon, Meriath would be free.

The Hands had Meriath kneel on the mat so that her hair might be brushed, and once her thigh-length mane was smooth and free of tangles Meriath was ordered to her feet again.

"We will be the only ones taking you to your master, so a more practical way of leading you is necessary," the Hands informed her. "Cross your wrists and present them to us."

Questions or demurrals would only have lengthened the time before she was eased, so Meriath crossed her wrists and held them out without hesitation. The Hands brought a long length of silk that might well have matched the short covering Meriath wore, and wound the length of silk around Meriath's wrists. Before she knew it Meriath was bound, and that seemed to please the Hands.

"Yes, this will be satisfactory," the Hands decided as they briefly examined their handiwork. "Come along now, child, and remember the lessons you were taught. You'll find additional punishment not in the least pleasant."

The Hands tugged on the length of silk they held, drawing Meriath along in their wake. They left the area of the falls quickly, and soon they made their way through the unrelieved darkness to a destination Meriath had trouble imagining. To live in the midst of so much darkness was depressing for the Goddess of Beauty. How were those around Meriath to see and appreciate her beauty if the darkness disallowed seeing of all kind?

The walk was not a short one, but at long last Meriath was led through a pair of looming shadows that seemed darker than the darkness about them. The shadows also seemed to resemble a pair of doors, and a few feet farther on there were similar doors more easily seen. Heavy bronze was the material the doors seemed to be made of, and beyond the second pair was a large area that was definitely brighter than what

had been outside. The large area was far from being properly lit, but it was significantly brighter than complete darkness.

Meriath was led across what might well have been a room, if the shapes that suggested chairs and couches and tables were true indications. The area, if room it was, proved to be empty of all life, but the next area, beyond a closed set of doors, was not the same. One of the Hands opened the door to the right, then led Meriath into the room beyond. Meriath discovered that her captor awaited them there, and a certain satisfaction touched her when she saw the dark outline that was Zolanus, God of Justice. He had been the most likely one to do this to her, but happily her trials would soon be over.

"Lord Zolanus, we bring you your property as you commanded," the Hands announced, now sounding suitably meek and subservient. "The golden-haired child has been prepared to serve her master."

"Somehow I doubt that she's been prepared as thoroughly as I would like, but the fault is hardly yours, Hands," Zolanus replied in his hatefully deep voice. There was also a hint of amusement in his tone, and that brought Meriath a good deal of annoyance. "You two may now leave us."

"As you command, Lord Zolanus, but first you must be told a thing," the Hands responded deferentially. "The child made a terrible fuss after her bath and thereby earned a punishment, but there was no time to administer it at once. The punishment must still be given."

"Overlooking an earned punishment is never wise," Zolanus replied, shocking Meriath deeply. "Bring her here, and we'll see to it together."

"No, you can't!" Meriath blurted as the Hands pulled her toward Zolanus by the silk tied about her wrists. "You can't possibly be willing to wait any longer than necessary to ease me!"

"You were correct in calling her a child, Hands," Zolanus commented as the length of silk was given over into his hands. "She's been made into a spoiled, self-centered child, one who needs to be taught the error of her ways. Come to me, child."

Zolanus sat up on the couch he'd been reclining on, and pulled Meriath over to him. Once she was close enough, he took her by the waist and pulled her into his lap.

"Listen to me, child, and try to understand what I tell you," Zolanus lectured as though she really was a child. His left arm circled her back, and he looked down at her where she sat on his lap. He still appeared to be nothing more than the outline of a shadow, but the feel of him – and his size – was considerably more than Meriath had been expecting. Zolanus was warm and hard, but the hardness Meriath felt the most interest in couldn't be detected.

"I'm going to try to explain something to you, Meriath," Zolanus continued, his tone now close to being grave. "You were obviously raised to believe that beauty is

the most important thing in the universe, but that doesn't happen to be true. There are things that are far more important."

"Nonsense," Meriath disagreed, finding it impossible to accept such a lie. "Doesn't everyone look first for beauty when they meet someone new? If that beauty isn't there, don't they make rude comments and show ridiculing expressions? Didn't you kidnap me because I refused you my own beauty?"

"I took you as my possession because of the rudeness you showed when we met," Zolanus corrected, his tone now filled with faint annoyance. "Desire for your beauty had nothing to do with my actions."

"Then why was I... prepared for you?" Meriath challenged, more than aware of her discomfort. "It's because you couldn't wait your turn like the other gods, not when you knew you'd have no turn. You were denied my beauty, and couldn't bear the denial."

"So you were prepared for me," Zolanus said with a glance for the Hands, almost as though he pretended to know nothing about it. "And that's why you felt you would be eased at once, because your beauty couldn't be resisted."

"Of course," Meriath agreed with a nod. "No one can resist my beauty, so why should you be any different?"

"You have no idea how offensive that smugness is, do you?" Zolanus said, but the words didn't seem to be a question he expected an answer to. "You believe everything you've said, and see no reason to change your mind. In that case, let me propose a situation that *will* change your mind. You enjoy using your beauty to control those who desire you, but what if you had no choice about responding to that desire? What if you *had* to serve anyone who desired you?"

"Serve?" Meriath echoed with a laugh. "Beauty doesn't serve, it *is* served. Haven't you learned that by now?"

"Learning," Zolanus murmured, looking down at her with a strange air about him. "There are countless things to learn, but first one must unlearn what isn't so. To continue with you now would be pointless, so we'll postpone the time until there's been a bit of learning. Listen to me carefully."

Meriath wanted to make some scathing remark about Zolanus being the last one she would listen to in any way at all, but something strange was happening. It wasn't possible to see the god's eyes, but Meriath still couldn't seem to break his gaze. And the sound of his voice held her more tightly than the very large arm around her...

"You will not remember your time as a goddess," Zolanus said, the words slow and in some way deeply touching. "The life you find yourself in will be the only one you know, but in each separate life you will remember one important fact: if you fail to serve each man who desires you, you will find no easing from serving any other. Your own desire will grow stronger with each minute you try to keep from serving, and

all relief will be denied you until you bring pleasure to the one you must serve. Do you understand me?"

"I... understand," Meriath found herself saying from a long distance off. "But... I don't understand."

"You will, child," Zolanus told her with clear amusement despite the vast distance that had grown up between them. "Eventually you should understand everything perfectly – if you're worth knowing. If not... But no need to worry now, not when there really isn't time..."

Questions rang in Meriath's head with an intensity that confused her, but none of it seemed to make a difference. The distance between her and Zolanus continued to grow until he dwindled to a dot in the darkness, a darkness that now grew again to completion...

3

I awoke from a sound sleep slowly, feeling well rested and reasonably satisfied, but with the memory of an intense physical need. A memory like that was annoying, but nothing I couldn't take care of with very little trouble. I was, after all, a queen, and no one had ever dared to refuse me anything. Not that it was really a matter of daring. People seemed to enjoy catering to my beauty, and that was just the way I liked it.

I stretched hard to chase away the last remnants of sleep, then sat up to give official notice to my maids that I was awake. One of them would run and tell my officials, and then my schedule for the day would be prepared. That schedule depended on when I arose, of course, since getting my sleep was more important than any silly appointments were likely to be. And those appointments were, naturally, subject to change at any time. If I lost interest in seeing petitioners, the ones waiting just had to wait until next time.

My morning bath had been kept ready for me, so I let my maids bathe me and then I told them what I'd decided to wear. I'd considered the matter during my bath, and then had suddenly remembered that General Arthis Clovan would be the first person I had an audience with. General Clovan was building up my army, quietly getting the realm ready to do what was necessary if some of our neighboring realms refused to be reasonable about the treaties I wanted with them. Today was the day the good general would report on his progress, and Clovan was a very handsome man.

So the outfit I decided on was a yellow and white morning gown in the new style, down to my shoe-tops in length but without a dozen underskirts. It also had long, loose sleeves and a very low-cut neckline, which ought to put dear Clovan in the proper mood. After my maids finished dressing me I examined the result in my mirror, then sat down to let my hair be brushed. The gown created exactly the look I wanted, and I could hardly wait for the amusement of Clovan's reaction.

Once my hair was properly brushed, I sent one of my maids to tell my seneschal that I would receive General Clovan in private in the small audience room. Since I usually received the general's reports in private, there should be no speculation

about what was going on. It was in my own best interests to show nothing of attraction to any man with even the least amount of power. My advisors were more than ready to insist that I marry, preferably someone who might one day be king instead of queen's consort. My advisors would be much happier dealing with a man, but they weren't going to have the chance.

I'd barely settled onto the small throne when the doors were opened by one of the hall guards and General Clovan was announced. My handsome general strode in and came directly toward me, stopping perhaps eight feet away to bow. He wore armor over a thigh-length tunic, and carried his helmet in the crook of his left arm. His being bareheaded made his long blond hair easily visible, hair that was held gathered at the nape of his neck with a strip of leather. His eyes were a lovely blue, but most often tended to be somewhat cold. By then the doors were closed again, so I smiled at my visitor.

"Good morning, General," I purred, leaning forward the least little bit. "We're pleased to see you again."

"Thank you, Your Majesty," Clovan answered as he straightened, showing a very attractive smile. "The news I bring continues to be good. Your army grows larger and stronger by the day, and will be ready for any use you care to put it to by the start of summer."

"A time that isn't all that far away," I observed with raised brows, pleasantly surprised and somewhat impressed. "You've done excellently well in the time since you took charge, General, and We mean to see you rewarded for your efforts."

"Thank you, Your Majesty," Clovan said with another bow. "Your rewards so far have been more than generous, and I look forward to earning as many as I can."

"Perhaps you'd be interested in an interim sort of reward," I murmured, standing up and moving down the two steps to leave the throne behind. "A reward that needn't be mentioned elsewhere, but one that may be bestowed more than once. Do you have any interest in something like that, General?"

By that time I stood in front of him, smiling up at his expression of faint surprise. Clovan obviously hadn't been expecting my offer, but it didn't frighten him. In point of fact those very blue eyes seemed to be inspecting me as though for the first time, and suddenly there was something other than coldness in his gaze.

"Your generosity to me grows greater every time you exercise it, my queen," he murmured, raising a finger of his right hand to stroke my cheek. "The interim reward you offer is gladly accepted, although it pains me to say that I may not accept it this very moment. I have various matters to see to this morning if your army is to be ready on time, but business should all be taken care of by lunch. If you will do me the

honor of coming to my apartment and joining me for the meal, we'll have the oppor-
tunity to … discuss my reward at great and leisurely length."

The touch of Clovan's finger to my cheek had come as a great shock, almost
as though the desire in his eyes had rushed down to flow out through his finger and
into my body to set my insides aflame. The faint need I'd felt earlier had now become
a good deal stronger and more insistent, and I nearly missed the fact that I'd been
refused. It was very clear that Clovan did want me, but not until his business had been
taken care of. As though any business could be more important than pleasing *me*…

"What a pity, General," I made myself respond in a murmur even though I
really felt like screaming at the fool as I stepped back from his touch. "If I recall
correctly, I'm not free for lunch or afterward. Perhaps some other time, then."

Intense annoyance and frustration flashed in the man's eyes as I turned away
and walked back to my throne, but that was too bad about him. I wanted him now, not
when he finally got around to paying me some attention. I was a queen and beautiful,
not some silly little maid, and if I couldn't have whom I wanted when I wanted him, I
usually decided against wanting the man after all.

"We thank you for the glad tidings you brought, General," I said as I reached
my throne and sat in it again. Clovan seemed to have been searching for what he might
say to dig himself out of the pit he'd fallen into, but I had no interest in anything he
might have come up with. "Have my seneschal send in the next petitioner."

With that clear a dismissal, Clovan had no choice but to bow and leave. I
glared daggers at his back as he went, hating the way I now felt like squirming on the
throne. My discomfort was all his fault, the blind and stupid fool, and it might even be
wise to consider a replacement for the man. I'd make a list of candidates later, when I
had the time.

The first petitioner to come in was a widow with a long and involved story
of misfortune that threatened to leave her and her children without a roof and starv-
ing. I usually listened carefully to stories like that woman's, and then graciously gave
the people involved the help they needed. The effort made me a popular queen in the
eyes of my people, and at the same time let me cut certain of my more affluent citizens
down to size. The moneylenders and landlords now knew they had to support me in
all ways if they didn't want me to find against them in various petitions, and that
increased my power over them.

Today, though, I seemed to have very little patience to listen to long stories.
The more I tried to pay attention to the woman and her woes, the more uncomfortable
I got. My body was now beginning to demand that it be satisfied, a driving demand I'd
never quite experienced before. Something had to be done, but not while I sat listening
to boring stories.

"Yes, yes, We understand your difficulty," I interrupted once I'd made up my mind. "You've come to your queen for help and you shall have it. Speak to Our seneschal, and tell him We said that you're to be assisted from the special fund. Also tell him that We'll resume seeing petitioners tomorrow."

I got up and left the throne while the woman babbled out her thanks along with an attempt to curtsey properly, dismissing her from my mind even before I left the room. My private apartments were very near, so it wasn't more than a pair of minutes before I was able to send one of my maids for the slave who was trained in giving massages. I used that slave often, both as a masseur and as a distraction, and distracting was what I needed most right now. My advisors, of course, turned a blind eye to the practice. A slave was never going to be approved by them as a consort, not to mention a possible king.

I had my maids undress me, and while I waited for the slave to be brought I wrapped up in a sheet and chased the maids out. Then I lay down on the wide couch I used when the slave served me, hoping that no one decided to clean the slave up before he was brought to me. I needed him to serve me as quickly as possible, and then I ought to be able to think and act coherently again.

The couch was covered in golden silk with white velvet trim, but the fabric seemed to tease my back and shoulders where the sheet failed to cover me. The touch was much too sensual for the way I felt, but rather than getting up again I tried to ignore the sensation. Think of other things, I told myself, think of something else until he gets here! Once he does, you'll be fine!

Not quite, a distant, rather amused voice seemed to disagree in my head. *Have you forgotten that if you fail to serve a man who desires you, you will find no easing from serving any other? Have you forgotten that all relief will be denied you until you bring pleasure to the one you must serve first?*

I sat up quickly to shake my head, determined to dislodge such ridiculous thoughts. I had no idea where they came from, but they couldn't possibly be true. I never served anyone, the objects of my desire served me. Where could that idea about serving possibly have come from?

I felt shaken over the incident, but then I realized it must have been caused by something like indigestion – or the need currently plaguing me. The suggestion couldn't possibly be true, so there was no need to worry about it. But I would have to see about having my chef punished. I, above all people, should never have to be troubled by indigestion...

A moment later a knock came at my door, and the slave I wanted was shown in. He wore nothing but a white loin covering and the steel ring around his left ankle that marked him a slave, but that only added to his attractiveness. His light hair and

eyes made him almost as handsome as Clovan, and my body flared with need as I looked at him.

"Mistress," the slave said as he began to get down flat on his face as was proper. "You sent for me?"

"I did, so stop wasting time with that nonsense," I all but snapped. "Come over here and prepare for your duty."

The slave rose from his knees with a perplexed expression on his face, but naturally didn't argue. He knew well enough which duty I meant, so rather than going to fetch massaging oils he began to remove his loin covering. It usually took him a short time to be ready for me, as though the honor of serving me was a suppressive force he had to overcome, but this time the thought of more delay was almost maddening. And yet I had no choice but to give him the time he needed. If I had him punished, the wait would be longer yet.

Once his loin covering was gone, the slave knelt on the couch beside me and reached for the sheet I'd been wrapped in. I'd already lain back again so I let him open the sheet, anything to make the time of easing come more quickly. The slave kissed my breasts gently, with due awareness of whose nipples his lips touched, but the fire flared in me again despite his care. I also moaned when his hand came to my womanhood, the place I burned with need, and it wasn't long before I couldn't bear any more delay.

"Aren't you ready yet?" I husked out, wanting to snap the words but finding the effort beyond me. "Here, let me see."

My hand reached down to his rod, which I was delighted to find as hard as I needed it to be. Because of that I pushed the slave to his back, then quickly straddled him. It took no more than a moment to have him inside me, and then I rode him harder than I'd ever ridden him before. He did his own moaning, of course, but his feelings were completely beside the point. Mine were the important ones, and my feelings were delighting in his presence inside me.

As great as my need was, I certainly expected it to respond rather quickly to the stroking I accomplished. I posted on the slave as though I rode a stallion instead, feeling the heat inside me mount toward relief, but that relief was never reached. Gaining the crest continued to elude me completely, and as the time passed the slave began to look more and more strained rather than wrapped in pleasure.

"Mistress, please hurry," he whispered at last, something of fear to be seen in his expression. "Please take your pleasure … as quickly as possible. I won't … be able to … hold out much longer."

"You had better hold out," I snarled, nearly beside myself with frustration as I continued to move up and down on his rod. "I can't – Never mind. Just don't let yourself go."

A sound came from his throat rather than words, but his expression turned even more strained. It might be true that I'd been riding the slave longer than I ever had before, but that made no difference. I was his owner, and he was bound to obey me.

And obey me he did, at least for a short while longer. I continued my effort to reach those heights I so needed to fall from, but suddenly the slave convulsed under me. He had reached the point of orgasm, and in no time at all I had nothing left to ride.

"You stupid fool!" I raged as I pushed myself off him. "How dare you take pleasure before giving it to your mistress? We'll see how much pleasure you get from being whipped!"

The slave made no sound at all as I wrapped the sheet around me again and then strode to the bell pull. He'd known what would happen if he failed me, and the fact that this was the first time he had failed meant nothing. After the whipping he would get, he'd know better than to fail a second time.

A maid appeared at once to answer the bell, and she had the guards in almost before I gave my orders. The slave was dragged away still naked, and I was left alone once more to throw myself down on the couch again in misery and terrible need.

If you fail to serve a man who desires you, you will find no easing from serving any other, that voice said again inside my head. *All relief will be denied you until you bring pleasure to the one you must serve first.*

"I refuse to believe that," I muttered, hating whatever was happening so much that I refused to listen to that horrible voice. "If the slave is useless, I'll take care of the problem myself."

It isn't often that a queen has to see to her needs by her own, solitary efforts, but every once in a while the occasion arises. This was that sort of occasion, so I put my hand down to the place that needed relief so badly and began to search for what I needed. I tried for quite a long time, but even the soreness my efforts produced did nothing to ease the raging need.

By that time I was in tears, and even applying a salve to ease the soreness didn't chase the tears away. Once the soreness was gone the need seemed even worse, and I just didn't know what to do.

If you fail to serve a man who desires you, you will find no easing from serving any other, that voice said for the third time inside my head. *All relief will be denied you until you bring pleasure to the one you must serve first.*

I screamed in fury and threw a vase across the room to shatter into a million pieces, but none of that accomplished anything to change the situation. It looked like I would have to do as the voice said, whether or not I understood the reasoning behind the need. I certainly couldn't continue on the way I felt now, so I had to go and use Clovan...

29

The clock said it was nearly noon, so I quickly began to make the necessary preparations to leave. Dressing without my maids to help was on the awkward side, but I didn't want anyone to know what I meant to do and where I meant to go. Once dressed I went to the door and stuck just my head out, then gave instructions that I wasn't to be disturbed under any circumstances. That order would guarantee my privacy for the next step, which I undertook as soon as I'd closed the door and put on a hooded cape.

One of the panels in my bedchamber popped open when I pressed the proper place on the molding, allowing me to step into the area behind the walls. The entire palace was honeycombed with narrow passages behind the walls, and I'd taken the trouble to learn those passages when still a girl. Being able to eavesdrop as I pleased helped to keep me on the throne, and now it would help me to get what I needed so badly.

General Clovan had been given a suite in a part of the palace not far from my own apartments. When I reached the panel that gave access to his bedchamber, I paused to peek through the tiny hole before entering. The chamber was empty, and that meant I could enter without anyone knowing about it. At the moment no one beside myself knew about the passageways, and I meant to keep it like that.

When the panel opened I stepped into the room and closed the panel again, then began to brush off my cloak. I'd worn it to keep the dust of the passageways off my clothes and hair, and also for another reason. When Clovan saw me, I wanted him to think that I'd come through the halls and had used the cloak to preserve my anonymity. It might have been possible actually to do things that way, but there was no sense in taking chances. If one of the servants had followed me, there would be no doubt about what I was up to.

The hall outside Clovan's bedchamber also led to his dining room and other parts of the apartment, so I walked to the proper door and opened it. When I stepped into the room I found Clovan, without his armor, just sitting down to his lunch, with a servant hovering beside the table ready to take his instructions. Clovan looked up at my entrance, and frowned when he saw that my face was completely shadowed by the hood of my cloak.

"Who are you, and how did you get in here?" he demanded at once as he rose to his feet again. "What – "

His words ended abruptly then, showing how quickly he understood the situation. Someone woman-size in a hooded cloak could only be the person he'd invited to lunch, so he dismissed the servant with orders about not being disturbed. Then he came toward me to close the door I'd left open behind me.

"I'm delighted that you accepted my invitation after all," he murmured once the door was closed. "How did you get past the guards out in the hall?"

"Is there anyone in your army who doesn't know me by sight?" I countered as I removed the hood. "I had no trouble gaining entrance, but if the guards on the door are the sort to gossip, I would appreciate your getting rid of them."

"None of my personal guard is prone to gossiping," he answered with a smile, accepting the story I'd told without question. "Here, let me take your cloak, and then we can have lunch."

"I'd much rather get to that reward we were discussing first," I disagreed as I let him take the cloak. "We can always share a meal afterward."

"I'm flattered by your obvious interest and definitely share it," he answered with amusement, putting my cloak over his arm. "Allow me to escort you to the proper setting."

He offered me his free arm, and when I took it he opened the door and led me back through the hall to the room I'd come from. His bedchamber wasn't nearly as large as mine, but it was still a decent size and nicely furnished. Clovan closed the door behind us, tossed my cloak onto a nearby chair, then turned to give me his full attention.

"Now there won't be any evidence of your presence left behind where one of the servants can stumble over it," Clovan said after gesturing to the cloak. "We'll keep it in here, and no one will be the wiser. To begin with, what I'd like to have is a taste of you."

He'd approached me closely by then, so his arms had no trouble circling me and pulling me to him. His lips lowered to mine without giving me the chance to accept his request or refuse it, his hand in my hair keeping me from pulling away. His kiss was very demanding, so much so that I found it impossible to hold back a moan. The need I felt kept growing worse and worse, and if it wasn't seen to soon I would certainly die.

"Well, that confirmed one of my theories," Clovan murmured when he finally let the kiss end. "I knew you were a hot little piece, and you certainly are."

"How dare you talk to your queen like that?" I demanded, so outraged that he would dare that it momentarily overcame what else I felt. "You can't – "

"My dear, you aren't here as my queen, but as a woman who wants entrance to my bed," Clovan interrupted with a good deal of amusement, his arms still around me. "If you expect to be treated as a queen, possibly it might be best if you went back where you came from."

If I'd had any choice at all I would have done just that, but I didn't have the choice. The terrible need gripping me had to be eased, and Clovan was my only hope of getting it done.

"Ah, so I was right a second time," Clovan said with a chuckle after studying me for a brief time. "For some reason I'm the one you want, and you're prepared to do whatever is necessary to get me. You won't find me arguing with your decision, so let's get on with it."

"Yes, let's," I agreed, anxious to have the time over and done with. "When you're ready I'll want you on your back, so – "

"No, no, my dear, I'm afraid not," he interrupted again as he stepped back away from me. "The only master in my bed is me, which means we'll do things my way. Do you agree?"

Once again I had no choice, but wasn't about to say so out loud. It would be much better if the man thought I was here willingly.

"Yes, as a matter of fact, I do agree," I said, as though struck with revelation. "I knew you were different from the others, and now I'll have a chance to see how different. Who knows, I might even learn to prefer your way."

"Then let's begin with showing you how my way works," Clovan said, his amusement continuing. "Come over here and I'll help you out of that gown."

I hesitated only an instant before following him to a chair he stopped beside. I didn't like the idea of disrobing first, but refusal was long since a lost option. I turned my back to let Clovan help with the buttons there, and a moment later was dropping my gown to the floor. That left me in nothing but the single long-sleeved under-dress the gown called for, and Clovan opened the under-dress's buttons as well before putting his hands to my shoulders.

"We'll leave this final article on you for the moment," the general said, his hand combing through my hair before his arm circled me. "You don't seem to have anything on under it, so there shouldn't be too many obstacles to my inspection. Let's make ourselves comfortable."

"In a chair?" I protested as the man sat and pulled me down onto his lap. "If you dislike the idea of using your bed, there *is* a wide couch over there – "

"Now, now, let's have no argument from you," Clovan chided with a mock frown, keeping me from rising off his lap. "We're in the midst of my teaching you my own way of doing things, and it won't be possible for you to learn it if you debate every move I make."

"Uh, yes, you're right," I allowed, abruptly remembering what I wanted him to believe. "It's just that I've done things my way for so long, that it may be hard for me to learn – "

"Not to worry," he interrupted again, his hands coming to my shoulders. "I consider it my duty to teach you what you need to know, and I don't believe in shirking my duty. Yes, this is much better."

Clovan was pleased because he'd moved the top of my under-dress down, exposing my breasts. The nipples were as hard as stone from the need savaging me, and when Clovan leaned down to lick and suck at my right nipple I nearly screamed.

"No, stop!" I ordered, pushing his face away with all my strength. "There's no need to arouse me as I'm already fully aroused, so why don't we – "

"Oh, dear, you're trying to resist the lesson again," Clovan said, this time making his tone sad. "I've already said that I consider this effort my duty, so let's make sure that there will be no dereliction. We'll begin like this."

"This" turned out to be a thin square of woven cotton that he'd gotten from somewhere, one that he gathered up into something of a ball. I had no idea what he meant to do with the cloth – until he pulled my hair so hard that I opened my mouth to protest. That was when the cloth was thrust into my mouth, and when I raised a hand to remove it again the general simply captured both of my wrists.

"No, no, the cloth will stay where it is for the time," he chided again, still ridiculously amused. "With that in the way, you won't be talking when you should be learning. And to make sure that the cloth stays where it belongs, we'll also do this."

The second "this" started with taking my arms out of the under-dress completely, and that despite my struggles to free myself. Once the under-dress was off, my wrists were somehow tied behind me with the sleeves of the under-dress. When Clovan had bound and gagged me to his satisfaction, he smiled at the way I kept trying to demand that he release me.

"Normally I'd have no idea of what you were trying to say," he told me as his hands smoothed my hair back. "This time, though, I'm sure I understand perfectly. You want me to continue with my inspection, and so I will."

I shook my head in horror as he lowered his face to my right breast again, knowing that this time I was completely unable to stop him. His tongue licked all around my nipple before he began to suck on it, and if it had been possible I would have screamed. His efforts added terribly to the need I felt, the need that continued to grow even without my being touched.

Clovan held me still while he thoroughly "inspected" my right nipple, and then he did the same with my left. The mewling I produced behind the gag should have struck him as pitiful, but all it seemed to do was increase his amusement. When Clovan finally raised his face again, I felt as though someone had set fire to me.

"Oh, yes, my dear, you did enjoy that, didn't you," Clovan murmured, the words easily heard even above the whimpering sounds I made. "Your body tells me you did, and a woman's body doesn't lie. But just to be absolutely sure, there's another way to find out."

I squirmed and writhed as I fought my bonds, well beyond desperate in my need to be eased, and Clovan's words had meant little or nothing to me. A moment

later, though, I tried to scream again when his hand moved beneath the skirt of my under-dress and began to slide up my thigh. He meant to touch me where my desperation was strongest, I suddenly knew, and I'd never be able to stand a touch like that. His hand moved higher up my thigh as I kicked and tried to avoid the touch by locking my legs together, but then –

"Well, well, what have we here?" Clovan murmured as I tried to scream even louder and thrashed around with all my strength. "A hotly throbbing and lovely nub, and just behind it a small cave producing the oil of desire. And from the feel of the oil, your desire for me is rather strong. Is that true, woman?"

I nodded spasmodically as his fingers continued to probe my need, whimpering and mewling as I kicked uselessly. I couldn't dislodge the hand torturing me so terribly, and that amused him even more.

"Now, now, it isn't necessary to flatter me," Clovan chided with a grin. "You can't possibly want me all that badly yet, not until I do my part to make it happen. Let's spend some time on that, and then we'll see."

A finger slid inside me then, a finger that wasn't nearly long enough or wide enough to do what I needed so badly. The finger slid in a short way and then withdrew, slid in and withdrew, and all the while Clovan's thumb rubbed at the "nub" he'd discovered first. In no more than a moment I found myself nearly cutting my wrists off as I fought to free myself, the sound coming from my stoppered throat close to one of madness.

"Yes, my dove, I know you're enjoying these attentions," Clovan murmured as he continued to drive me insane, again deliberately misinterpreting my reaction. "And if you're a very good girl, we'll get to the time of you serving me fully a lot more quickly. Do you want to get to that time more quickly?"

If I could have I would have refused to answer that idiotic a question, but refusal of any kind was totally beyond me. I nodded jerkily even as I shivered and suffered, and he smiled again.

"So you do want to get to the time more quickly," he confirmed aloud. "That should mean you're willing to be a good girl, and there's only one way to accomplish that end. You must obey me completely, without trying to argue or refuse. Are you willing to do that?"

I gave him the nod of agreement he knew I had no choice about giving, and this time he chuckled.

"I've heard it said that you're difficult to get along with, but so far I haven't had any difficulty," he said, smoothing my hair again with one hand. "Just to prove the point – and to show me how good a girl you are – I want you to stop kicking and struggling. You'll lie perfectly still no matter where my inspection takes me, and no matter how much you want to do otherwise. Do you understand?"

My miserably reluctant agreement to that widened his smile even more, probably because he knew how hard it would be for me. I would have jumped out of my skin if I could have, but now I was being ordered to lie still. I shuddered at the knowledge of what I would have to go through, and then fought to quiet all movement of my body. The way his fingers still moved on and in me set me to whimpering even more, but somehow I managed to lock my muscles tightly into nonmotion.

"Ah, what a really good girl you are," Clovan told me approvingly once I had accomplished what I'd thought would be impossible. "You obey me without argument, just as you're supposed to. Now let's see if you can continue to be a good girl."

His hand moved beneath the skirt of my under-dress as his face lowered to my right nipple again, and I closed my eyes even as I screamed into the gag. I knew I was dying from the ongoing torture, and although I was able to keep myself from moving I began to welcome the idea of death. Anything to stop that need from consuming me alive!

Clovan continued with his teasing for an eternity, and I have no idea how I kept from kicking and thrashing around. But somehow I did manage to hold still, and that despite the humming in my ears and the whirling in my head. I bit hard into the cloth of the gag to add to my efforts, deciding that I would keep on being successful no matter what. That, of course, was when Clovan suddenly ruined everything.

"Is something bothering you, my dove?" the monster asked as I screamed and kicked and thrashed just as I had earlier. The finger that had been inside my heat was now thrust into my bottom, and I simply couldn't bear the sensation. Somehow it made my need even worse, and I had to escape the feeling.

"Obviously something *is* bothering you, my dove, but something else is bothering me," Clovan said, clearly trying to sound sad. "You've disobeyed me, so you can't possibly want to get to serving me as badly as I thought. I was about to take you to my bed, but now you must be punished first."

Hearing that made me start to cry, but the tears did little good. Clovan's finger continued to poke at my bottom the way it had with my heat, and I just couldn't control myself. I wailed into the gag as I cried and kicked, but nothing stopped Clovan's probing until my head began to whirl faster and faster.

"Oh, dear, I think you're close to fainting." Clovan's voice seemed to come from a long way off, and it finally got through to me that his finger had left my bottom. "We don't want that to happen, do we, my dove? We want you fully awake and alert when you serve me, so perhaps we'd better get to that serving right now."

My senses began to clear as Clovan lifted me in his arms and stood up from the chair. I started to cry again as awareness of my surroundings strengthened, now knowing that being unconscious would have given me a short respite from the need

raging through my body. But Clovan didn't want me to have that respite, not when it had been clear while I lay in his lap how strong his own need had grown. He was now going to let me serve him, but only because of *his* need.

But I was about to get what I needed so badly, and the reason for that was completely unimportant. My eagerness increased as Clovan carried me a short distance, but to the wide couch rather than to his bed.

"This should do for my first taste of you," Clovan said as he put me down on the couch. "If you're a very good girl, I'll allow you into my bed later."

Outrage touched me faintly, that the man would dare to treat me as though I were a commoner, but the indignation faded even before it formed completely. I was about to get what I'd needed for so long, and every consideration faded before that one.

"Your body matches your face quite nicely," Clovan commented as he spread my knees with his hands and knelt between them. "But you *are* just short of plump, so we'll have to do something about that. I prefer slender women."

Again I felt the urge to be outraged, but Clovan raised the bottom of his tunic and leaned closer to me. My hands went to fists where they lay beneath me, an effort to make the man hurry and enter me. When I felt the touch of his manhood at the entrance to my desire I tried to rise up to meet him, but his hands holding my thighs in place kept it from happening.

"No, my dove, none of what happens between us will be your doing or decision," Clovan scolded, and now his tone had hardened. "That's part of the lesson you have to learn, the fact that I'm in charge. When I want a response from you, you'll know it."

I had no real idea what he meant, but the wildness in my head kept me from wondering about it. His manhood had begun to push inside me, but so slowly that I nearly went mad. And yet I had no choice but to accept whatever he did. His hands were clamped like metal to my thighs, allowing nothing but his slow penetration. He was as large and hard as I'd hoped he would be, and once his manhood was completely inside me he leaned down and took me in his arms.

"You're here for no other reason than to serve me," he said as his body now kept me from squirming around. "I have complete possession of you, and you're about to learn what that means."

As soon as the words were spoken, his body began to move. His manhood withdrew and then thrust into me, withdrew and thrust again, but just as slowly as his finger had. He stroked deep each time, but not nearly as fast and hard as I wanted him to.

"Now I'm allowing you to squirm as a woman should, but you still have no say over any other part of your service," Clovan told me as I whimpered in my effort

to get him to move harder and faster. "You will accept what you're given and respond to it as you should, but that's all you will do. If you had not dismissed me the way you did in your audience room this morning, things might be different. But you did dismiss me as though I were totally unimportant, so now you can pay for the insult."

But it isn't an insult for a queen to do that, I wanted to protest, but the gag still refused to let me speak. *You can't punish me for doing something that's my right!*

I would have shouted the words if I could have, but they would probably have been just as ineffective spoken aloud. Clovan simply continued to punish me with slow, almost leisurely stroking, and this time I thought I really would go mad. He was using me, as though what I needed was completely unimportant, just as he said I'd done to him.

Clovan continued his leisurely stroking so long that I began to cry again, but my tears were completely ignored. The raging need inside me had stopped growing, but what was left was monstrously large. I still very much needed to be eased, and the slow stroking wasn't going to achieve that end. I cried and squirmed under him, miserably unhappy, and almost missed it when the speed of his stroking began to pick up. But he also stroked harder, and that took my attention.

"Do you now feel my presence inside you more strongly, my dove?" Clovan asked when I made a sound of surprise. "You wanted this earlier, and now you have it."

I did indeed have his harder, faster stroking, and at first it was like water in a desert. My desperate need accepted the movement joyfully for a number of minutes, but then I noticed something else. Clovan had been using me so long – after my own use of the slave – that I seemed to be starting to feel sore. The need inside me hadn't lessened any, but soreness definitely seemed to be starting.

During the next few minutes, what had only been starting slowly began to grow. I still squirmed mindlessly at the stroking Clovan gave me, but soon part of the squirming became a protest. I told myself that the man couldn't possibly continue on much longer, and once he'd taken his pleasure fully then I'd have my easing. I clung to that belief with a desperation like the one I'd felt earlier, and suddenly Clovan smiled.

"My sweet dove, you're really enjoying serving me like this, aren't you?" he asked in a murmur. "I know you are, so I'm going to give you a real treat. I'm now going to give you what you wanted so badly when we first began."

This time I felt certain that I knew what he meant, and unfortunately I was right. He began to stroke me even harder and faster, adding immediately to the soreness in spite of the lubrication my body kept producing. I whimpered and tried to beg him to stop, but the monster knew exactly what he meant to do and so ignored my mumbling. He stroked so hard and fast that the soreness became a burning flame, one that fought with the searing need still holding my flesh.

Again I tried to scream, knowing I couldn't take much more of any of it, and some kind fate must have intervened. Clovan suddenly stopped his movement and stiffened, caught in the throes of orgasm, and his release triggered my own. My body spasmed over and over, the relief turning me ecstatic, and then I sank into satisfaction-filled darkness.

4

I awoke slowly, faintly curious because it seemed I'd recently done the same before. It also seemed that I'd slept for no more than a short while, which was just as odd. I always slept as long as I cared to…

My opened eyes added to the list of oddities with the fact that I wasn't in my own bedchamber, but then memory came to my rescue. I lay on the couch in Clovan's bedchamber, no longer bound and gagged and finally feeling completely eased. I was able to see Clovan himself sitting at a table not far away with his back to me, doing something hidden by his body. It was marvelous to realize that I no longer had to deal with the man, not in any way at all. He'd supplied what I needed, and now I could leave him to his "ways."

A disturbing question revolving around why I had reacted to Clovan as I had tickled through my mind, but I quickly pushed it away. Finding the answer could be done at another time in another place, after I'd dressed and gone about my business. My underdress no longer draped me even as little as it had, so I sat up to look around for it. I would have been pleased never to exchange another word with Clovan again, but my movement took his attention and caused him to turn in his chair.

"Ah, you're awake, my dove," he said as I continued to search the floor for my clothing, which seemed to have disappeared. "I've been waiting to tell you how delightful a time you provided for me."

I took my gaze from the floor to meet his, intending to tell him just how "delightful" the time had been for me, but the words died in my throat. Heavy desire once again filled his eyes, and my body reacted to that awareness at once by flaring with renewed need. It wasn't possible to deny that I was back to where I'd originally been, and I felt like screaming insanely.

"How can you possibly desire me again?" I blurted, the words rough-edged from the soreness of my throat. "Didn't you satisfy yourself only a short time ago?"

"Your beauty has always had the power to breed desire in me," he answered with the amusement I'd grown to hate. "A single glance is enough to make me desire you, especially when I'm able to see all of your beauty. How did you know?"

"Your... expression is eloquent," I temporized, not about to tell him the truth. "With that in mind, perhaps you would care to... sate yourself to the point where you're free of the desire. Since I'm still here, it would be foolish not to see to the matter."

"Oh, I mean to sate myself," he agreed with a small laugh, his gaze moving over me again. "After all, we haven't quite finished with your lessons. Are you still curious to learn about my way of doing things?"

"I hadn't realized there was more to the... lesson," I answered, fighting to keep from speaking between clenched teeth. "Join me here on the couch, then, and we'll see what more there is."

"All in good time," he countered with a strong gleam of satisfaction now showing in his light eyes. "You must learn that decisions such as those are mine to make, not yours. You also need a bit more experience with being obedient, so come over here and kneel beside my chair and don't speak unless you have my permission."

My jaw dropped in outrage at the suggestion that I behave as a slave would, but sudden memory kept me from trying to refuse the command. The renewed need inside me had already begun to intensify, and I wanted it seen to as quickly as possible. With that in mind I left the couch with great reluctance, walked to where Clovan sat, and then knelt to his right.

"Nicely done, my dove," Clovan said from above me, his hand coming to smooth my hair. "Before we're finished with you, you'll be a pleasure for any man to use. And you may have noticed that a certain soreness is no longer with you. I used a salve on you as you lay in a swoon, in the hopes that you would continue with my... reward."

I felt the heat of embarrassment flush my cheeks as I realized what soreness Clovan meant. So he *had* known what he was doing to me, and had brought the soreness to my womanhood on purpose. But he hadn't soothed my tender parts because of any "hopes." He'd meant all along to use me again, whether or not I cared to comply.

"I've just been finishing up my lunch," Clovan went on, his hand still stroking my hair. "You'll remember that I did invite you to join me, so you won't be surprised to learn that I saved you a bite or two. Here's the first of it."

I looked up expecting to be offered a plate of food that I would be required to eat on my knees, and the true situation nearly sent me into shock. Clovan held a morsel of food in his fingers, and it was painfully clear that I was expected to take it. With the need inside me growing constantly stronger I had little choice, but when I reached for the morsel Clovan's hand moved back out of reach and he shook his head.

"No, my dove, you aren't to touch the food," Clovan admonished me in a mock-stern voice. "You'll simply take what you're given and eat it like a good girl – won't you."

The last of his words hadn't been a question, and I needed no one to tell me that. The humiliation I felt was intense, but I still leaned forward and let him put the morsel of food into my mouth.

"What a good girl you're learning to be, my dove," Clovan purred as I chewed on what he'd fed me without actually tasting it. "I find myself truly pleased with you so that soon you, too, will be pleased."

My body reacted to that promise in the expected way, making it both easier and harder to accept the next two morsels of food. Knowing that my actions would soon bring me the easing I needed made it easier to accept the humiliation of being fed like that. But knowing that I would soon be eased made me want to squirm rather than chew, anticipation raising my internal heat. Even so I was able to notice that I had gotten hungry, so I raised my face for the next thing Clovan would feed me.

"No, my dove, you've already had all I want you to have," Clovan said with a satisfied smile. "As I mentioned earlier, you're much too close to the point of being plump and I do detest plump women. While you're with me we'll take care of the problem, and at the same time strengthen your lessons. Proper behavior will be rewarded, sometimes with an additional taste of food."

He reached for his wineglass then, leaving me to grind my teeth and wish that I were already what he considered plump. Having Arthis Clovan consider me unappealing would have been a boon from the gods, but not at this moment. Now my body needed the release he would provide, the release he had promised he would soon provide…

Clovan finished the wine in his glass slowly, so slowly that my knees were beginning to ache by the time he put the glass down. I'd started to suspect that his definition of "soon" and mine weren't quite the same, a fact my body protested more stridently with every passing minute.

"The silence in this room is very appealing," Clovan said as he rose to his feet. "For that reason we'll get on with what we both want. You may now stand up and follow me."

He stroked my hair again as he passed me, and it occurred to me to wonder if he wasn't treating me like a favorite dog. The thought put a growl in my throat, but the growl went unvoiced as I got painfully to my feet. The ache in my knees needed to be walked out, but the chair Clovan led me to wasn't all that far away.

"We'll spend some time here preparing ourselves for the actual encounter," Clovan said as he turned and sat. The chair was nicely upholstered, but the arms of the thing were so low that they might as well not be there. "Come to my lap, my dove."

The last thing I wanted was to be tortured by him again, but I wasn't quite as needy as I'd been the last time he touched and teased me. Trying to refuse would be pointless, so I moved closer to the arms he held up and let him pull me into his lap.

"I really admire the wide nipples you have on these beautifully large breasts," Clovan said once he'd settled me to his satisfaction. "I'd enjoy seeing what they look like when you aren't aroused."

He chuckled when the heat of humiliation reddened my cheeks again, showing that he'd intended to humiliate me. My nipples were just as hard as they'd been when he'd first seen them, telling him everything he needed to know. It was clear that I wasn't about to walk out on him, and the reason for that didn't matter in the least to him.

Clovan leaned his head down to lick and suck at my nipples, and although I couldn't hold back a gasp at the intensifying of my need, I made no effort to stop him. If I'd tried to stop him he would have simply tied me again, and I really didn't want to be tied. I hated the terrible helplessness one felt at being treated that way…

"Oh!" I exclaimed when Clovan's hand moved between my thighs, his fingers tickling more than stroking. My right hand had closed on a section of Clovan's tunic, and the cloth was now tightly trapped in my fist.

"You seem to be somewhat sensitive down here, my dove," Clovan observed as he tickled and watched me squirm. "That's all to the good, of course, but I think we can increase your sensitivity to a much higher degree. Doing that will also increase my pleasure, and we do want to increase my pleasure, don't we?"

The man actually waited until I nodded my agreement – my coerced agreement – and then he smiled as he urged me out of his lap. For an instant I was able to hope that we were going to the couch or his bed, but then the hope was crushed when he pulled me face down across his lap.

"I've discovered that the presence of a rather clever invention makes my use of a woman much more pleasurable," Clovan said, doing something at the side of the chair where my feet hung over. "Actually there's more than one clever aid, but we'll start with my favorite. Time enough for the others at another time."

He chuckled again to show how pleased he was, and a tremor of fear ran through me. The man meant to keep and use me for as long as he was able, which meant I had to do something to escape him. What I could possibly do wasn't clear, but there had to be something…

"No!" I shouted, suddenly impelled to try escaping his lap. He'd parted my nether cheeks and had thrust something into my bottom, a something that felt small and round. I had no idea what the thing was, but it had instantly turned me wild with added need.

"No, my dove, the proper response is 'yes'," Clovan told me at once, pushing me flat again before thrusting a second round something into my bottom. "When properly used, this toy adds sensitivity to a woman, something you should have already noticed. There are only two more spheres to be inserted, so lie still as you're supposed to. Or would you rather be tied again?"

The threat of being tied quieted most of the struggling I'd been doing, but that's not to say I lay completely unmoving. I couldn't keep from whimpering and squirming as the second sphere was pushed more deeply inside me to make room for the rest, and Clovan's chuckle sounded yet again.

"You needn't worry that these spheres will be lost inside you, my dove," Clovan said, drawing a moan from me as he thrust a third round thing into my bottom. "They're all connected with a thin but stout length of braided cotton, which will pull them out when I want them out. There, that's the last of them, and now we only have your punishment to see to."

"What – what are you talking about?" I asked unsteadily, desperate to reach back and pull those spheres out of me. I really wanted them out, but knew well enough that Clovan would never let me do it even if I tried.

"You were told not to speak unless ordered to," Clovan reminded me, an odd sleekness to his tone. "You disobeyed by speaking the word 'no,' disobeyed by trying to refuse my wishes, and now you've disobeyed again by asking me a question. That calls for quite a bit of punishment, don't you agree?"

Even without turning I knew he waited for my nod, so I closed my eyes and gave him what he wanted. The man was a monster in spite of the handsomeness of his face, and the monster inside wanted nothing more than to add to my torment.

"Now you're trying to be a good girl again, which is a step in the right direction," Clovan said as his thumb moved between my nether cheeks to make me mewl and squirm even more. "I'll be sure to keep that in mind as I punish you, but don't expect me to be lenient. You obviously need good reason to be obedient, and it's become my duty to supply that good reason. But I'm not entirely heartless, so here, put this in your mouth."

His hand appeared in front of my face holding a crumpled piece of woven cotton, the same sort of thing he'd used earlier to gag me with. My heart sank as I took the wad of cloth from him, then thrust it into my mouth. If he thought I'd need the gag to keep from speaking out again without permission, then I'd definitely need it. I had no idea what he meant to do to me, but it would certainly be unpleasant in the extreme.

"But that, my dove, is as far as my lack of heartlessness goes," Clovan said once the cloth was in my mouth. "I've given you help in remaining silent, but if you spurn that help and remove the gag to speak, then your punishment will be doubled. Do you understand that?"

I nodded to show I understood, and I certainly did. I couldn't speak unthinkingly, but nothing would stop me from removing the gag. If I went so far as to do that removing, nothing in the way of an excuse or protest would save me from the consequences.

"I'm pleased to see that you understand your position here," Clovan said with amusement clear in his voice again. "Now we can begin and make your position even more clear."

I was certain Clovan would have me stand up so that he could begin whatever his punishment was, but instead he put an arm around my waist to hold me firmly. I would have frowned with lack of understanding if I could have, but a moment later I no longer felt puzzled. What I felt instead was Clovan's hand, striking my bottom with a good deal of force. The blow stung quite a bit, but worse than that was what it did to the spheres inside me. I squirmed wildly as the need flared fire hot inside my body, and I would have screamed at the top of my lungs if I could have.

"I have no doubt that you've never been given a sound spanking before, my dove," Clovan said as he struck my bottom a second time and then a third. "I'm delighted to be the one to give you your first taste of such discipline, but I have the definite feeling that this won't be your last taste. If you're wise you'll learn from the experience and work very hard to avoid a second encounter before you're able to sit down again."

I tried to protect my poor, abused bottom with my hand, but Clovan's arm blocked the way and kept me from doing it. I couldn't seem to stop mewling around the gag, and I certainly couldn't stop kicking, or thrashing around, or bouncing. Clovan's hand kept striking my bottom, quickly bringing a throbbing ache to it, even more quickly driving me insane because of the spheres. I certainly had never been punished like that before, and would have been very grateful to have missed the experience entirely.

But Clovan didn't want me to miss it, a fact that couldn't be denied. His hand kept coming down over and over, making me want to wail and cry, making me want to beg for his use. The ache in my bottom turned to a burning flame, and still his hand kept coming down over and over again. More than once I'd reached for the gag, wanting to remove it to beg him to stop. Only the knowledge of how much worse speaking would make things kept me from taking that gag out, but only just barely. That spanking hurt as well as doing the job of driving me wild. To say I was desperate for the time to be over would be the understatement of the world.

"What a nice rosy red your seat has turned," Clovan said quite a few minutes after tears had begun to stream from my eyes. He also paused in the spanking, which made me very attentive. "Have you learned your lesson yet?"

I nodded vigorously to assure him that I had, but that only made him chuckle.

"I'm sure you think so, but I'm not quite as certain," Clovan disagreed. "Personally I believe that the spanking you've had until now isn't quite as sound as it should be. Consider the matter for a moment, and then tell me whether or not you agree."

I whimpered when I heard that and cried even harder, but there was just no getting out of it. The torture would continue, and with my full permission. Rather than wait for the monster to restate the matter he wanted a response to, I wearily – and fearfully – nodded my head.

"You've definitely made the right decision, my dove," Clovan said at once, proving that he'd been watching me closely. "We are doing this for your own good, you know, so a really sound spanking you will have."

I thought it was possible to brace against the next strike of his hand, but quickly learned that bracing was useless. Clovan wasn't simply spanking me, he was striking a bottom that had already been turned sore and burning. I tried to howl through the gag, again tried to protect myself with my hand, but neither attempt worked. I also couldn't keep those spheres from turning me mindlessly frantic, but I did have one victory. I managed to keep myself from removing the gag, overriding an intensely desperate need to do so.

It's possible to say anything you like through a gag with none the wiser, but that doesn't always turn out to be what you think it will. After several more very long minutes of having my seat warmed well beyond the point of burning – and of moaning with a need even greater than it had been earlier - I found myself promising Clovan anything he wanted if only he would stop spanking me. I would even have agreed to marry him and let him be crowned king rather than named my consort, which shook me even through the desperation.

I'd expected to curse the man and what he continued to do to me, but instead I begged to give him anything he wanted. I'd begun that ordeal thinking of the gag as just another bit of torture to bear, but it turned out to be a true saving grace. If not for that bit of cloth, Clovan would have had me even more completely in his power.

The monster continued with the spanking well beyond the point I thought I couldn't bear any more, but finally he paused again. I let myself think of the time only as a pause to keep the disappointment of additional punishment from crushing me, but I turned out to be mistaken.

"All that crying seems to have stopped up your nose, my dove," he said, clearly trying to sound concerned. "Why don't you stand up now and remove the gag, but I recommend that you not try to rub at your seat. It's not an order, mind, but I do recommend against trying."

I pushed off his knees slowly and painfully, then pulled the soaking wet cloth from my mouth. I had been having trouble breathing, but I would sooner have smothered than let the monster hear what I'd been saying. Once I was able to breathe again I couldn't keep from ignoring his advice about rubbing myself. My hand went back in an attempt to ease the burning, throbbing ache, but a single touch made me gasp and pull my hand away.

"Yes, those spheres do make a woman extremely sensitive to the slightest touch," Clovan said with that hateful amusement back in his voice. "Rubbing would be to my benefit, but certainly not yours. Kneel here in front of me until you have that sniveling under control."

He pointed to a place on the floor directly in front of where he sat, and I quickly got to my knees. I gasped again as I moved a bit too quickly, learning that my bottom didn't have to be touched for those spheres to affect me. I also knelt straight up, so that my bottom didn't come in contact with my heels.

"The next time I have to punish you like this, my dove, you'll also be required to sit on a wooden stool for an hour after the spanking," Clovan informed me in a light voice. "Between an aching seat and the spheres inside it, you won't find the time terribly pleasant. Do you mean to disobey me again?"

I shook my head without looking up at him, fighting to stop crying. He'd called the crying sniveling, and I knew that meant he disliked it. If he disliked it enough he might decide to give me a reason to cry, and I no longer had the gag to protect me.

"It seems that the sound spanking has done its job," Clovan said as he reached out to stroke my hair. "And you're even getting the sniveling under control, just as I wanted you to do. Are you ready to serve me?"

The way I nodded without hesitation must have been pathetic, but I was beyond caring. I needed to be eased so badly that even a burning bottom couldn't be considered.

"Then let's get to having you serve me," Clovan said, making my heart race with anticipation. "Slide yourself a bit closer to me."

I'd been all ready to get to my feet, but looking up showed me my mistake. Clovan had asked if I was ready to serve him, not if I was ready to be used. He'd lifted the bottom of his tunic to expose his manhood, showing that he was only partially aroused.

"You're to use only your lips and tongue on me," Clovan directed, watching as I moved closer to him on my knees. "Also, you may not lean on my thighs. Do you know what I want from you?"

I nodded hesitantly, knowing what he wanted but never having done it before. A touch of fear ghosted through me, brought on by the thought that I might not do it right.

"You seem disturbed, my dove, possibly by the worry that you might not please me," Clovan observed with an unexpected smile as he stroked my hair again. "It has surely come to you that any failure on your part would be a personal one, inasmuch as the following loss would be very much yours. I, however, have no doubts, so you may begin."

Clovan's amusement was very clear as I quickly leaned even closer to him, wishing I could crumple to the floor and cry instead. If I didn't please him – and arouse him completely – I would be the one to suffer, by not getting what I needed so badly. I had to please him for my own sake, and that made me much more nervous.

Clovan's manhood was large and long even when not fully aroused, and I began my efforts by touching the tool gently with my lips. His member stirred at the touch, apparently enjoying it, and that encouraged me to continue my efforts. My lips and tongue touched him again and again, kissing alternating with licking, and the tool slowly hardened and lengthened.

"You may now take it into your mouth and do some sucking," Clovan directed after a time, the words a bit short-breathed and slightly strained. "You'd best use caution, though, to keep from undoing what you've accomplished."

I took his enlarged member into my mouth as directed, but my nervousness had increased. I couldn't bear the thought of ruining all my work, but inexperience could well make it happen. My body writhed when the tool entered my mouth, begging that the member be put inside me in the proper way, but that wasn't yet to be. I licked the tip of the member and then began to suck as best I could, and although the member hardened and grew even more, inexperience became my ally rather than my downfall.

"Your lack of practice at this sort of thing is quite apparent, my dove," Clovan suddenly said with a sigh. "I can see that you'll need to be taught to please a man in the proper way, an effort I haven't the patience for at the moment. Release me and get to your feet."

I quickly did as I'd been told, wincing at what movement made the spheres do to me even as I worried. Did Clovan mean to torture me again, punish me – or ease me? I didn't dare hope for easing, not with this man, but when he stood up from his chair he took my arm and hurried me over to the wide couch.

"I find your squeaking a delightful form of protest, my dove," Clovan said with a chuckle once we'd stopped in front of the couch. "The spheres do make their presence inside you extremely well known, do they not? They'll also make your response to me a good deal livelier, so you may now put yourself on the couch on your hands and knees."

47

The idea of not needing to sit on the couch brought a lot of relief, so I gingerly climbed onto it on my hands and knees. The thought that Clovan might soon be inside me had me trembling and burning, so much so that I nearly missed his next instructions.

"That's far enough, my dove," he said, amusement returned to his voice. "Now spread your knees as far as they will go, and then rest on your forearms and touch your brow to the couch as well."

Spreading my knees wide was made difficult by the spheres, but I did my best before lowering my head to the couch. Resting on my forearms made the position much easier, but the quivering in my body turned to trembling when I felt Clovan's weight being added to the couch.

"What a delectable snack to offer a man," Clovan said with a chuckle as he approached me more closely. "The time will come, my dove, when you offer me this exact snack even in the presence of my officers, but that's for the future. At the moment I'm in the mood for a solitary ride."

I moaned as something touched my heat, not daring to look around to see if it was Clovan's finger or his manhood. I refused to put it past him to deny me even now, but I would do nothing to give him an excuse for it. I also writhed at the teasing touch, and the spheres inside me refused to let the writhing end.

"Yes, your response will be much more pleasurable for me this time," Clovan murmured, so close that he seemed right behind me. "I no longer have an interest in waiting."

I expected him to push me over onto my back and then enter me, but once again I was mistaken. I felt another touch at my heat, and then Clovan was thrusting inside me! I screamed at the unexpected size of him and began to straighten in protest, but Clovan's hand had tangled in my hair and now kept my head held down to the couch.

"The spheres also make you almost as tight as a virgin, my dove," Clovan said with a laugh as he continued to thrust into me to the root of his rod. "At a time like this a woman might well want to hold perfectly still, but you aren't being permitted that, are you, my sweet?"

I mewled and whimpered while he laughed, wild to discover that he'd spoken the truth. I wanted nothing more than to hold absolutely still for a time, but the spheres forced me to squirm even more than the touch of his body to my still-aching bottom.

"Oh, I do enjoy the way you squirm, my soft and desirable toy," Clovan murmured as he began to stroke in and out of me. "I mean to enjoy this ride to the very end of it, and then later I'll have another. First thing tomorrow we'll announce to your

advisors that you've agreed to become my wife, but not with me as your consort. You'll insist that I be crowned king, and by then I'll have filled your belly with the first of the many children I'll want. Between pleasing me in bed and caring for my get, you'll find yourself too well occupied to plot against me. Not to mention the fact that you'll be much too well trained to disobey in anything."

He laughed again as he continued to stroke me, and in spite of everything I shivered from a terrible chill. Clovan meant to keep me as his prisoner forever, and at the moment I could see no way to escape. Then all thoughts of escape disappeared as my body reacted even more strongly to his stroking, squirming and writhing and moving just as he wanted. I wailed helplessly as he made me feel more and more like a virgin being put to her first use, and that in spite of the oils of desire running out of me so thickly.

"Let's see how well this works with you," I thought I heard Clovan murmur. I had no idea what he meant – until I screamed at the indescribable sensation suddenly produced in me. I also bucked uncontrollably, and Clovan laughed aloud.

"Oh, yes, even better than with the others," Clovan said, sounding very pleased. "And just think, my dove: there are still three spheres left to be removed."

Whimpering and mewling seemed all I was now capable of doing. Clovan had pulled one of the spheres out of my bottom, and control of my movements was now even farther beyond me than it had been. His rod still seemed much too big, but it wasn't possible to hold still and simply accept his use. Between the spheres and my aching bottom – and the need I continued to feel – I had to squirm for the monster, no matter how wild the movement drove me.

Clovan continued on and on with using me, pulling out a sphere any time he thought I wasn't moving as briskly as I might. By the time the last sphere was gone I was nearly out of my mind, so much in need that I couldn't bear it and yet finding release impossible. I whimpered almost continuously from everything being done to me, but then, suddenly, Clovan stopped his thrusting to stiffen. He'd held off orgasm as long as he could, and now, with his release, came my own. My body exploded wildly for longer than I would have expected, and then the darkness came again.

5

I awoke unexpectedly fast with the feeling that I hadn't been unconscious long. I also didn't have to wonder what had been happening, the pounding of my heart doing well with underscoring the memory. Clovan had decided to make me his lifelong captive, and I had to find some way to escape. But first I had to find some way to keep him from wanting me…

I lay on my left side on the couch where Clovan had used me, afraid to look around until I heard the sound of snoring. Hope flamed inside me with that, and I turned very slowly to see that Clovan had indeed fallen asleep after his very lengthy "ride." He lay on the couch not far from me, his sprawl suggesting complete satisfaction, and I knew I couldn't waste this opportunity. I had to escape before he woke again.

The pounding of my heart as I inched toward the edge of the couch almost deafened me, but happily Clovan wasn't able to hear the thunderous noise. I made it to the edge and down onto the carpeting, almost gasping aloud when my bottom brushed the end of the couch. The ache Clovan had caused was still very much with me, but I managed to smother the gasp before it betrayed me. If Clovan caught me trying to escape, what I'd gone through until now would be a mere nothing in comparison to what he would do.

So I actually moved tiptoe as I looked around for my clothing. I was desperate to leave that apartment, but it took a moment or two before I realized that everything I'd worn there had disappeared. That included my cloak, which told me that Clovan was the one who had done something with the clothing. He considered me trapped as long as he kept me naked, and I thanked the gods that the monster had no real idea about how I'd reached his apartment.

The panel leading to the hidden ways was on the far side of the room, and I moved to it as silently as I possibly could. I couldn't keep from looking over my shoulder as my fingers searched for the spot that would release the wall panel, and for that reason saw Clovan begin to stir. I had no idea whether the man was simply turning

over or getting ready to wake up; as soon as my touch on the molding opened the panel, I climbed to my feet and stepped through into the passageway.

My first urge was to slam the panel shut to lock it, but I forced myself to show the sense to close it as silently as possible. The longer Clovan slept the better off I would be, and a peek through the view hole in the wall showed that I'd finally done the right thing. Clovan continued to sleep, which would give me an extra few minutes to think.

The dust and cobwebs of the passageway covered me quickly, but that was the least of my concerns. I still had no idea why I reacted to Clovan as I did, but there was no doubt that if he saw and wanted me again I would have to serve him no matter how I felt about it. And then Clovan would give my advisors the king they wanted, and I would become the monster's slave rather than his queen. The only plan I could think of at the moment was to run away to avoid seeing the man again, but where would I run to?

Walking barefoot on the filthy boards of the passageway was disgusting, but the distraction of that disgust suddenly gave me the answer to my problem. I knew someone who wasn't disgusted at all at going barefoot, not even now when he was a very old man. Forain had been an advisor to my father, and now, with my father gone, Forain had retired to my father's favorite hunting lodge. The old man had once promised to help me if I ever needed him, and I'd heard it rumored any number of times that he was an undisclosed but powerful wizard. If anyone could get me out of the mess I'd fallen into, Forain was the one...

By the time I reached my own apartment, my mind was fully made up. The hunting lodge Forain lived in wasn't far from the city, so I would go there at once. As soon as I was back in my bedchamber and had the panel closed, I ran to my wardrobe and pulled out an underdress. Scrambling into it covered much of the evidence of what Clovan had done to me, and then I was able to call for my maids.

"Have a small coach readied, and have the driver wait for me at the south entrance to the palace," I told one of my maids as soon as the bevy of girls was in the room. "And speak only to the head groom about my instructions. There's to be nothing of an escort."

The girl dipped into a quick curtsey and then hurried away to do as I'd told her, leaving the rest to help me dress. I chose a simple, gray woolen gown to go on over the underdress, and then stepped into low-heeled ankle boots. I had to be away from the palace as soon as possible, well before Clovan knew I was gone from his apartment. That was why I'd decided against an escort. Using some of the men Clovan had recruited and trained for my escort would be tantamount to telling the monster where I was going myself.

I was dressed almost as quickly as I wanted to be, and after taking another hooded cloak I left my apartment nearly at a run. Asking for the coach to be brought around to the south side of the palace had been nothing more than a ruse, spoken for the benefit of my maids. Clovan would certainly question the girls when he found me gone, and I wanted him to waste his time riding south after me. I meant to travel east once we were out of the city, as that was the direction in which the hunting lodge – and Forain – lay.

It was dark outside, and I kept to the shadows near the stables until I saw my maid hurry out on her way back to the palace, and then I walked inside. Stableboys were hitching a team to one of the small coaches, and a driver hurried into the stables still pulling on his gloves. He nearly walked right past me where I stood in the darkness, but that wasn't what I wanted so I stepped into his path.

"When the coach is ready, drive to the doors and then find a reason to stop," I ordered softly after pushing my hood back just a bit. "I'll get into the coach then, and once I'm in you can head for the east road – without mentioning our destination to anyone. Do you understand?"

"Y-yes, Your Majesty," the man stuttered, understanding nothing but the orders he'd been given. He performed a small, nervous bow as I stepped aside again, and then he was on his way to the coach that was being readied for him.

I melted into the shadows again, then tiptoed to the doors and slipped outside. I watched to make sure that the driver spoke to no one about the orders he'd been given, and he didn't. When he pulled the horses to a halt right near me in order to adjust one of his gloves, I slipped over to the door, opened it and clambered into the coach, then closed the door behind myself. Getting into the coach without help while wearing a gown was difficult, but I'd been discovering that it was possible to do many things if you really had to.

After closing the coach door behind me, I stayed on the floor of the coach until we were well away from the palace. I spent the time praying to the gods that no one would find it possible to stop me, and my prayers seemed to be answered. We followed the east road as it curved into the forest beyond the city without any sort of pursuit becoming visible, and only then did I take a deep breath and let it out.

I also got my skirts out of the way and tried to climb up on the coach seat, but that turned out to be a mistake. I gasped as my bottom came in contact with the seat, a seat I usually found rather comfortable. Right now Clovan's attentions made it impossible for me to sit properly, so I shifted all the way over and sat on my right hip as I leaned down on my arm. The position was far from comfortable, but at least I could see the darkened forest all around us.

I thought about telling my driver where we were going, but there was still more than two hours of travel ahead of us before we had to leave the road. For that

reason I decided to keep my destination to myself until the time came to share the information. If disaster struck and Clovan caught up to me, I didn't want him to know where I meant to go.

More than an hour went by with nothing happening, and that lack of happening helped me to relax a bit. We were making good time, so in just a little while I would order my driver to stop for further instructions. I would have to sit properly when I spoke to the man, and for that reason I meant to put the time off as long as I could. Sitting properly would hurt a good deal more than just the touch of the skirts against my bottom…

I suddenly heard a man's voice cry out in pain and fear, and a moment later my driver fell from the box at the front of the coach. The glimpse I got of him before he disappeared into the dark and distance showed that he'd been struck by an arrow, and by then I more than shared his fear. Had Clovan caught up to me? If not, then what was going on…?

The sound of horses hooves became louder, and then riders passed both sides of the coach going faster than it was. The riders disappeared from view, but a moment later the coach began to slow down. My vehicle continued to slow until it came to a complete stop, and by then I was back on the floor of the coach. If whoever had stopped me thought the coach was empty…

But the gods were no longer answering my prayers. I heard one of the riders dismount just before I heard the sound of a flint being struck, and a pair of moments later a torch flared in the darkness. Only then was the door in front of my face pulled open, and I heard the sound of deep laughter.

"Well, well, what have we here?" a male voice I'd never heard before asked pleasantly. "The coach isn't empty after all, and I think we've struck it rich."

"Who is she, Wender, can you see?" another unknown male voice asked from behind the first man. "That damned hood is in the way."

"It doesn't matter who she is," the man called Wender answered in a voice filled with amusement. "She's not likely to be someone's maid, not when she's traveling in a coach without insignia, so someone will pay us well to get her back. Ulm, get up on the box and drive this thing."

One of the men behind the speaker grunted in agreement, and then the door was closed again almost in my face. I say almost because I'd pulled my hood all the way down to disguise my features, but the effort had also worked against me. I had no idea what my captors looked like, but it seemed that I would have the chance to find out.

I spent only a small amount of time feeling relief over the fact that it hadn't been Clovan who had found me. The highwaymen who had captured my coach had first killed my driver, and that made them very dangerous men to be near. Also, I had

to find some way to buy myself out of their capture. If it came down to it, I'd rather be dead than returned to Clovan's tender mercies.

Once the coach began to move again, I returned to the seat I'd left. This time, though, I sat on my left hip and leaned on my left arm, getting as comfortable as possible before starting to think. I wasn't likely to have more than one chance to save myself, so the attempt had to be a good one.

The coach continued along the road for a short while, and then the driver turned off onto a track that was nearly invisible. We passed a man on a horse holding a large and leafy branch, and it suddenly came to me that the horseman intended to brush out all trace of the coach wheels. That would make tracking us almost impossible, even during the day. My captors seemed to be very well organized...

The track we'd turned onto made for a bumpy, uneven ride, and we stayed on the track for quite some time. In spite of the discomfort of the ride, the length of the trip let me think of a plan, so when the coach finally began to slow down I was as ready as possible to put my plan into action. We entered a torch-lit area of the forest that seemed to have a number of scattered and very large tents, tents that were covered over with leaves and things in a probable effort to disguise them. The coach pulled up to one of the tents and then it stopped.

I had to sit up on the seat then, so it was a positive relief when a man came over to the coach and opened the door. It was really too dark to see the man's face clearly, and I'd made sure my hood shadowed my own features. When the man offered me a hand to help me out of the coach, I took it without hesitation. Once I stood on the ground, the man took my arm and led me into the tent. The shelter was divided by a number of hangings, and I was led through a small maze of cloth corridors until we reached an inner part. The area was made private by a hanging of cloth, and was lit by a lamp standing on a small table in one corner.

"All right, this is where you'll stay for a while," the man said, his voice proving him to be the one called Wender. "Now let's have a look at you."

"Wait," I said, holding up a hand to stop him from coming closer. "You first have to know that my uncle is a very rich man, and he'll be willing to pay in gold to have me back unharmed. If you really are willing to ransom me, I'll tell you where he is – as long as I'm left hooded."

"Oh, I'll ransom you, all right," the man Wender said with something of a laugh. "There's no such thing as having too much gold, but maybe your uncle can come close to making that sentiment untrue. First, though, I *will* have a look at what I'll be ransoming."

I started to insist that I be left hooded, but the highwayman had no interest in listening. He stepped closer and threw my hood back with both hands, and I had the

chance to see that he was an ugly man before I closed my eyes. If he recognized me, which was all too likely, my plan would be in ruins.

"Well, now I can see why your uncle will pay gold for you," Wender said after a moment, his tone thoughtful. "In his place, I would certainly do the same. Especially if he isn't quite your uncle, but something a bit more... intimate."

"What – what are you talking about?" I asked unsteadily even though I thought I knew what he meant. He *had* recognized me, and thought it would be my chief advisor who would pay the ransom. I opened my eyes to glance around, hoping to find some place to run to –

"What I mean is that the man is more likely to be your lover," Wender returned dryly, actually managing to shock me. "Any unmarried woman who looks like you has to have a wealthy lover, otherwise she would have a husband."

"How dare you say that to me?" I demanded, finally meeting the man's gaze. "Are you suggesting that I'm a –"

"A high-class whore, yes," Wender said with a mirthless smile, finishing the sentence I hadn't been able to. "Do you think you can deny it?"

At the moment I wasn't able to deny anything, but not because of humiliation or indignation. The relief I'd felt to realize that Wender didn't recognize me after all had been drowned in the shock of discovering that the man clearly desired me. The expression was as obvious in Wender's eyes as it had been in Clovan's, and my body had immediately responded to that desire. It was what I'd gone through with Clovan all over again, but how could that possibly be?

"How nice to hear silence rather than empty protests," Wender said, his tone still dry. "It looks like we understand each other, which is all to the good. Your... uncle will have the chance to buy you back, and until that happens you'll have certain chores assigned to you. If you behave yourself and do as you're told, you won't find the time unbearable."

"What sort of chores?" I asked suspiciously, trying to fight my rising need. The man *was* ugly, and I'd never be able to bring myself to –

"I've needed my section of the tent cleaned up for quite a while," Wender answered as he gestured to the area we stood in. "Tomorrow you'll take care of the cleaning, and then you can help with other things that need doing around the camp. And, of course, you'll sleep in here with me."

I looked around at the mess I'd managed to ignore until then, not quite believing the man was serious. I'd never done any cleaning, and had no intentions of starting now. As far as also sleeping there went...

"Since I'm worth gold to you, the least you can do is give me my own place to sleep," I pointed out reasonably. "I won't be here all that long, so – "

"You'll be here as long as I want you here," Wender interrupted, his tone milder than the words. "Your value to me in gold won't be changed by where you sleep and whatever else you do here, so don't try to claim that it will. I'm going to get something to eat. Take that cloak off and sit down and wait for me."

He brushed past me to the hanging that closed off the cloth corridor, and the next moment he was gone. I felt hungry enough to take a step after him, but then common sense stopped me. If he'd been prepared to feed his captive he would have taken me with him, so I was obviously meant to stay hungry for a while. Maybe I would be lucky enough to die of hunger, and then all my problems would be solved...

It was chilly outside but stuffy in the tent, so I unhooked my cloak and tossed it aside with all the depression I felt. Wender was one of the ugliest men I'd ever seen, tall and spare with a long face and plain brown hair and eyes, but my body said it couldn't wait for him to get back and use me. I'd felt sure that I would be able to refuse an ugly commoner like Wender, but the heat inside me was in the process of building just as it had with Clovan. Whatever curse had befallen me, I would have to let that common trash use my body or die of the need.

There was a small section of tent floor I might have used to sit down on, but sitting still wasn't something I could do without wanting to howl. Instead I simply paced back and forth in thought, trying to find a way out of all my problems that didn't call for my death, and Wender's sudden return was startling.

"Just relax, no one's going to hurt you," the man soothed quickly as he stopped short. I'd jumped and gasped at his unexpected appearance, and the reaction seemed to disturb him. "Here, I brought you something to eat."

He held out one of the two bowls he carried, smiling faintly when I blinked at him with lack of understanding.

"Did you think I was such a savage that I'd feed myself and not you?" he asked, still holding out the bowl. "Those of us out here may not be upper class, but we also aren't barbarians. Here, take it and sit down and eat."

I would have refused the crude meal if I could have, but having eaten almost nothing since breakfast had left me ravenous. I accepted the bowl and took the wooden spoon from it, then took a cautious taste of the meat and vegetables concoction the bowl held. The food was nothing like the works of art my master chef produced, but the taste didn't immediately poison me so I began to gulp down the rest.

"If you swallow it whole you'll be sick," Wender cautioned from the place he'd moved to with his own bowl. "Why don't you sit down with me, and we'll have a nice, leisurely meal."

"I'm too hungry to eat slowly, and I don't want to sit down," I answered around a mouthful of the food. Also, if the man changed his mind about being generous and took the food back, I wanted to have as much of it finished as possible.

"You know, I think I'm just as hungry, so I'm going to do it your way," Wender commented after a very slight hesitation. "Then, if you do get sick, you'll have company feeling that way."

I didn't quite believe he meant what he said, but the man hadn't been lying. He stood where he was and began to shovel in his food as quickly as I was doing, and ended up finishing only a minute or two after I did.

"Yes, that stew was even better than it usually is, so it was worth stuffing down," Wender said once he returned his spoon to an empty bowl. "Sometimes we have bread to go with the stew, but we ran out of flour yesterday. Would you like a drink of water?"

"Yes, thank you, I would," I answered, putting down my own empty bowl. I would have preferred a glass of wine to a simple drink of water, but if those people didn't have bread they weren't likely to have anything decent in the way of wine.

"Ladies first," Wender said as he brought over a crude waterskin. "And don't worry, I filled it fresh from the stream myself this afternoon."

His ideas of fresh weren't quite the same as mine, but I still accepted the waterskin, uncorked it, and then took a swallow. If I pretended to be on a hunt the way I used to be as a child with my father, I should be able to do whatever was necessary. Two more swallows of the tepid water settled the stew I'd eaten, so I recorked the waterskin and handed it back. Wender took a longer drink than I had, and once he was done he returned the skin to the place he'd gotten it from and then looked at me again.

"It's getting late, so we might as well get bedded down for the night," he said, studying me in a casual way. "My blankets and pallet aren't new or particularly fresh, but they're better than nothing. You're not going to get up on a high horse and pretend to be outraged or shocked, are you? About lying with me, I mean."

"Would it do me any good?" I countered, refusing to let the man see how badly in need I was. "For all you really know I'm a virgin, but your prejudices have already made up their mind differently."

"You know, that's absolutely true," he agreed with a thoughtful nod as he continued to study me. "With a woman having your beauty it isn't very likely, but it still might be true. Why don't we find out?"

I had no real idea what he intended, but taking a step back from his sudden advance did me no good at all. The outlaw grabbed me and pulled me to him, then put one arm around my waist and one around my legs. Two heartbeats later I was face down on the tent floor with one of Wender's knees in my back, and then I felt his hands on my skirts.

"It's fairly easy to find out whether or not a woman is a virgin," Wender said as he began to raise my skirts despite my attempted struggles. "I'm not a physician, but

I still know what the examination consists of. Oho, so this is why you didn't want to sit down. Get punished for being naughty, did you?"

I didn't answer the miserable peasant, but I still couldn't stop my face from flaming red with humiliation. The results of Clovan's spanking were obviously still very visible, and I hated the peasant for finding that fact amusing. Then I gasped and squirmed involuntarily, all thoughts of simple humiliation gone.

"It pains me to give you the sad news, young lady, but you aren't a virgin," Wender said dryly as his fingers probed deeply inside me. "I'd even venture to guess that you have more than a little experience with accommodating a man, so my original estimate of you was fact rather than prejudice. Would you still like to argue the point?"

Arguing anything was out of the question when it was all I could do to keep from mewling. Wender continued to tickle and stroke me for much too long, but finally he let me go and stood up.

"Fact rather than prejudice tells me you're more ready for my attentions than I would have expected," Wender commented as I pulled my skirts down before starting to get to my feet. "Would you like to tell me why that is? Surely you haven't fallen in love with the handsomeness of my face."

"Hardly," I answered with a sound of scorn as I straightened, then silently cursed my unthinking tongue. Wender didn't seem to be the sort to leave a question without poking at it, and he wasn't.

"Then why are you so ready?" Wender persisted, looking down at me in a way I could feel. "Surely you aren't always this ready…?"

"I suffer from a woman's curse and a man's blessing," I told him bitterly without looking up. It was the only excuse I could think of that wouldn't give the man more information than I wanted him to have – although he already had far too much. "The situation should amuse you as much as it does most men, so feel free to laugh as you will."

"A woman as beautiful as you, always ready for a man," Wender said, more musing than amused. "That really is a blessing for men, and it isn't polite to laugh at a blessing. Here, let me help you out of those clothes."

He came close to help with my buttons, and it wasn't long before my gown and underdress lay in a heap on the tent floor. I felt the outer chill a good deal more like that, but Wender took my arm before I began to shiver.

"My blankets are over here, so get into them before you catch a draft," the man said, leading me to a place to the right of the area entrance. "I'll be with you as soon as I'm out of my own clothes."

The blankets were old and dirty, but I still slid between them and lay on my belly. I hated to stand around naked in front of a man, but Clovan had made me do it

and so would this peasant. As soon as Wender thoroughly understood that I couldn't refuse him, it would be the time with Clovan all over again…

"All right, move over," Wender said from where he knelt beside the blankets, interrupting my bleak and bitter thoughts. "I said I'd let you share my blankets, not take them over."

The man had gotten out of his clothes, and even as I shifted over to let him get under the blankets I couldn't help but notice how ready he was. Heavier need flared throughout my body with that observation, but the feeling wasn't as urgent as it had been with Clovan.

"Tell me why you got that pretty round bottom spanked," Wender said once he was settled beside me. "You must have misbehaved rather badly to earn that heavy a punishment."

"I spoke when I was told to keep silent, and I tried to protest having something done to me that I found almost unbearable," I answered sullenly as I studied my hands. "Now you'll know what excuse to use when you do the same."

"I probably *will* end up having to warm your seat a time or two, but when I do there will be a reason for it, not an excuse," Wender corrected immediately. "Was it your… uncle who did something almost unbearable to you?"

"No, it was someone who took unfair advantage," I said, turning my head to frown at the man beside me. "Are you trying to say you're not doing the same?"

"Certainly," he agreed, a faint smile on his ugly face again. "If you like, all we'll do is share these blankets to sleep. Is that what you want?"

"No," I grudged after a moment, finding it impossible to ignore the demands of my body. "As if you thought I could answer any other way."

"No, I knew you'd have to… accommodate me," he admitted as he put his hand on my back under my hair. "And I'm also forced to admit that I consider the situation one of the strongest examples of justice I've ever seen. Most women with beauty like yours make the men in their lives do the dancing. With you, though… "

He didn't have to finish the thought, not with the way I had begun to move around just from the touch of his hand to my back. I was the one being made to dance, and I hated that fact.

"Are you going to claim that you don't deserve to have this problem because you never used your beauty as a weapon?" Wender asked when I remained silent. "Can you honestly say that you never took advantage of being beautiful before you understood what position you were in?"

"What's the good in being beautiful if – " I began, about to demand, cutting off the thought before I said the wrong thing. If my beauty made me a slave to every man who saw me, where was the benefit to *me?*

"What's the good in being beautiful if you can't take complete advantage of it?" Wender asked, finishing my question with what he thought I'd wanted to say. "Well, my guess would be that you're being given the chance to learn an important lesson. Taking advantage of things beyond someone's control is unfair, which is a lesson some people never learn. How are *you* doing with it?"

"I don't have any idea what you're talking about," I muttered, speaking the absolute truth. I didn't know what he meant, and what's more didn't want to know.

"Then maybe, if you're very lucky, you'll find out," Wender responded cryptically. "Now you can turn over onto your back."

I blew out a breath and began to turn over, but discovered at once that lying flat hurt. I had to raise my knees to keep my bottom from coming in contact with the blanket and the ground beneath it, even with the cushioning of the tent floor in the way.

"It will probably be another day or two before you can sit down again," Wender commented as he watched me. "Take my advice and don't do anything to earn yourself a spanking from *me,* or you'll still be standing at the end of the sennight."

I could feel embarrassment reddening my cheeks again, but the peasant didn't care. He leaned down to kiss my nipples as his hand went between my thighs, and all I could do in response was moan and squirm.

"You really are a hot one, aren't you?" Wender murmured as he shifted to a place between my legs. "I think I'm going to regret it when your 'uncle' pays your ransom."

I moaned again when I felt his rod begin to search out my heat, and then he was thrusting inside before taking me in his arms. He held me close as he started to stroke deep and hard, giving me what I needed without making me beg. I'd been certain he would do as Clovan had, but for some reason he didn't. It hurt when his body came in contact with my bottom, but he didn't seem to be touching me on purpose and the squirming I did seemed to please him. It pleased him so much, in fact, that he kissed me, something Clovan had not done either of the times he'd used me.

That, I think, was the most disturbing part of it all. The man kissed me as though he wasn't simply putting me to his use, and somehow that made the time better for me. I put my hands to his arms and let my body respond to his stroking as fully as it wanted to do, and a sense of time passing disappeared from my awareness. For the first time in what seemed like forever I was given actual pleasure, and then his release brought on my own.

"Thank you, that was delightful," Wender whispered once the shuddering stopped, leaning down to kiss me a final time. "Now I think we'd better get some sleep, otherwise we'll be falling off our feet tomorrow. Sleep well."

He reached over to turn down the lamp on the table near the blankets, and once we were surrounded by darkness he moved around to get comfortable. I turned to

my left side away from him, trying to understand why he'd thanked me. I hadn't had any choice about serving him, so where did thanks come in? The question seemed perfectly simple, but I found sleep before I found an answer.

6

I discovered that it was morning when a big hand shook my shoulder. The lamp had been turned up again, and by its light I was able to see Wender crouching beside the blankets. The man was fully dressed again, and he sent me one of his faint smiles.

"Breakfast is here, so you'd better get up and dressed," he said once my eyes were on him. "You have a lot to do today."

"What are you talking about?" I asked with a groan as I started to sit up. I felt stiff all over, and although sitting still wasn't completely comfortable, I was able to do it.

"I'm talking about getting this tent area cleaned up," he replied as he studied me. "And you need to move around to work the stiffness out of your body. I take it you've never slept on the ground before."

"Not quite," I answered dryly, moving my shoulders one at a time to ease the soreness. "And I see no reason to clean up a mess that *you* made. If it bothers you so badly, clean it yourself."

"I have more important things to do with my time, but you don't," he countered, his tone still mild. "And if you're looking for a reason to do as you're told, I'll give you one. If you haven't made what I consider satisfactory progress by lunch-time, you won't be given anything to eat. The same, of course, will go for supper."

"So you *are* a barbarian after all," I commented as I got to my feet and headed toward my clothes. "I should have known better than to believe you last night."

"Not doing what you're supposed to has to bring *some* penalty," he said, and I heard him rising from his crouch. "Would you prefer that the penalty be another spanking instead? If you're completely recovered from the last one, it shouldn't be as bad as I thought it might be."

I glared at the beast after slipping into my underdress, hating him for the amusement he only just showed. He knew I would never choose to be spanked even if I were fully recovered from what Clovan had done to me, and there was a second thing

to hate the man for. Desire for me had touched him again, which meant it touched me as well.

"You don't have to make the decision right now, not when you have hours to think about it," Wender said, still obviously amused. "And if you do the chore assigned to you, the decision doesn't have to be made at all. Do you need help with those buttons?"

I did need help, but I didn't have to say so. Wender came over to button the dress I'd pulled on, while I repressed a double shiver. I'd never worn the same clothing two days in a row, and most often hadn't even worn the same thing for an entire day. But this was the only clothing I had, and Wender's nearness was bad enough with me being fully clothed. If I'd been naked…

"There, now you're all ready for breakfast," Wender murmured from very close behind me, his big hand coming to spread itself out on my middle just below my breasts. "Are you hungry?"

"Y-yes," I managed to get out, finding it impossible to move away from him. I knew that touching me like that gave the man pleasure, and I needed to give him pleasure.

"Then let's get it eaten before it turns stone cold," Wender said, taking his hand away and moving past me to two bowls standing on the floor. He bent to retrieve the bowls, then turned to hand one of them to me.

"At least this time you can sit down to eat," he said as I took the bowl, back to being amused. "It remains to be seen what later will bring. Is something wrong?"

"My shoes are gone," I said, finally having noticed the disappearance. "I'm sure I left them right here with my clothing."

"You did," Wender agreed as he folded down to the floor with his bowl. "Since you won't be going outside for a while, I took the liberty of putting them away. If you do a good enough job of cleaning up this mess, you just might find the shoes in the process."

I growled low when I heard that, but could do nothing about the situation other than sit down opposite the man. He'd hidden my shoes in that tent area, and if I wanted them back I'd have to work to find them. Or I could simply search until I found them, ignoring what I'd been told to do. That would mean nothing more to eat, or the inability to sit during a meal. Since I still would have preferred to rest on my hip rather than on my bottom, choosing to be spanked was definitely not something to be considered.

I diverted myself from unpleasant thoughts by glancing into the bowl I held, wondering what the thick whitish substance could be. I'd never seen anything like it before, especially when I'd been expecting eggs at the very least.

"Taste it before you decide you don't like it," Wender said, probably because of the expression on my face. "I added some honey for you, so let me know if the effort was worthwhile."

I had no real desire to eat the whitish substance, but I was somewhat hungry and this might well be my last meal for a while. I used the wooden spoon I'd been given to take a very small taste, and immediately found myself surprised. Beneath the sweetness of the honey I could detect what seemed to be sweet butter as well, both additives making the whitish substance really tasty. It was also still nicely warm, so I began to eat in earnest.

Wender said nothing while we ate, but his gaze never left me. By the time the meal was done I was close to squirming where I sat, even though I'd looked away from the man. He was certain to leave my need to grow even stronger, an added incentive for me to clean up his mess.

"Come over here a moment," Wender said after getting to his feet. "I'd like to check on something."

I had no idea what he meant to do, but there was no sense in trying to refuse him. So I put my empty bowl aside and stood, and then moved the pair of steps necessary to reach him. He put his hand under my chin to raise my face, and the next thing I knew he was kissing me. It wasn't possible for me to keep from responding to his kiss, and after a very short time he ended it.

"So you *are*... interested again," he said, letting my chin go so that his hand might stroke my hair. "I thought you might be, so we'll have to take care of it right now. I really do have things to do this morning, and I won't be back here until lunchtime."

I think I was more stunned than surprised, especially when Wender was gentle in leading me back to the blankets. It was almost as though what he meant to do was for *my* benefit rather than his own, and I didn't understand that. No one around me had ever done anything for me unless their own interests were involved, and this peasant couldn't possibly be any different. Of course, he did want to ransom me, so that was probably why he was so concerned. If anything bad happened to me, he would be out all that gold.

But the memory of my real value to the outlaw did little to distract me from the way he picked me up in his arms before putting me down on the blankets. I wouldn't have been surprised to be pushed or knocked down, but being deposited gently and carefully was disturbing. Then Wender leaned down to kiss me again briefly before he moved over to my legs.

"It's silly to get undressed and then dressed again, so this time we'll be less formal," Wender said as he pushed my skirts up to my waist. "We can do it the right way tonight, when we go to bed."

By then he'd opened his trousers, and his desire was much more obvious. As usual the need had been growing in me, so I swallowed whatever vague protest my mind had started to form. Being with a man while fully clothed made me feel like a maid stealing time with her lover in a closet. But the touch of Wender's manhood to my heat made me ignore the feeling, and then he was thrusting inside me. The sensation was even better than usual, and then he began to stroke deep and hard.

It wasn't all that long before Wender found release and thereby gave me mine, but I still lay unmoving for a while after the delightful spasms ended. My eyes were closed as I clung to the wonderful feeling of complete satisfaction, but after a while I sighed and opened them. Wender had withdrawn some time earlier, and was undoubtedly waiting to threaten me again about what would happen if I didn't do the "chore" he'd assigned me. I looked around, braced for the nonsense – but the tent area was empty.

"He's gone?" I muttered, looking around again just to be sure. "Why would he leave without a word?"

I couldn't think of an answer to that question for a moment, but then a couple of answers came to me that couldn't possibly be true. He couldn't have left me alone to enjoy my satisfaction in peace, as though he really had done what he had for my benefit. And he also wouldn't have left me to do what I'd been told to without pestering, just as though I were a responsible adult. My advisors had never done that, and neither had my father. Why would a virtual stranger consider me responsible?

The questions those supposed answers bred were worse than the original question, so I pushed the whole horrible mess out of my mind and simply concentrated on straightening my skirts. There was no need to wonder why I'd been satisfied, not as long as I had been. That was quite enough to let me enjoy the peace and quiet.

But my enjoyment of the peace and quiet didn't last very long. Peace and quiet are fine when you have something to do in them, otherwise they quickly grow boring. I got up and paced around for a short while before sitting down again, but the boredom refused to go away. If I had something to read, or could find the shoes that would let me take a walk outside…

I brightened a bit at that thought, but finding anything at all in the mess around me would be almost impossible. For that reason alone I moved to the cluttered area beyond the blankets, and began to go through what I found there. Dirty clothes lay right next to ones that seemed clean, boots were scattered here and there, and beneath it all I found encrusted bowls with spoons stuck in them. Truly a horrible mess, and one that needed sorting if anything at all was to be found.

I sorted everything in the corner beyond the blankets, then moved to the area beyond the table that stood near the head of the blankets. I found additional

blankets that were more worn that the ones we'd slept in, a few more articles of clothing, another bowl and spoon, a boot that made a pair with one I'd found earlier, and a single book. But the book had nothing but poems in it, so my search wasn't yet over.

I'd found a set of empty saddlebags and a worn but heavy coat and had just started on the clutter thrown in front of the third wall of the area when I was interrupted. I heard the sound of someone coming in through the hanging, and turned to find that Wender had returned.

"Why are you back so soon?" I asked, resting on my heels as I pushed the loose hair back from my face. "Did you forget something?"

"I'm back because it's lunchtime," he answered, gesturing with the two bowls he carried as he looked around. "That means it isn't 'soon,' and I'm really impressed. You've done a marvelous job so far."

"Don't be silly, I haven't done any 'job,'" I corrected with a small laugh. "I was looking for my shoes and for something to read, and sorting things out helped me to look. It's as simple as that."

"Ah, now I understand," Wender said with a nod as he left the entranceway and moved to the center of the area. "I suppose I was confused because things look neater now. Would you like this bowl of stew, or are you too busy 'looking' to want to stop?"

"It's odd, but I *am* hungry again," I decided aloud, surprised that I would be. "I suppose more time has passed than I realized."

"Time has a habit of doing that every now and again," Wender agreed, handing me my bowl when I rose and walked over to him. "Enjoy it while it's hot."

We both sat down with our food, and it was another silent meal. The stew took care of my hunger, but other than that it didn't taste freshly made. While I ate, a few questions occurred to me, so once I'd emptied my bowl I asked the first of them.

"Why are you and those others living out here in the forest as outlaws?" I put, gaining Wender's attention. "Why aren't you all back in the city working at jobs, or on farms doing something productive?"

"We were working at jobs in the city or on farms," Wender answered, surprising me with sudden bitterness. "We all had lives we enjoyed, but then that new general the queen put in charge of her army changed that. He wanted to show the queen 'progress,' I suppose, so he started to send out press gangs to force men into the army. If anyone tried to refuse he was cut down as an 'example,' so there was nothing left to do but run. I usually prefer fighting to running, but not when the odds are so heavily against me."

"General Clovan uses press gangs?" I said with a frown, the first I'd heard of the practice. "But that will ruin things for the country. How do you keep food coming

in on a regular basis – or get necessary city jobs done – if the men usually doing those things are in the army or on the run?"

"So far he hasn't taken enough men from essential places to cause a crisis, but that's bound to change," Wender said as he put his own bowl aside. "Clovan is a fool who can't see any point of view but his own, and his aim is to have the largest army possible. He'll just keep putting more and more men into uniform until there's no one left to feed and support them. If he'd paid out enlistment bonuses instead of forcing men to join up, he would have had more recruits – without other jobs – than he knew what to do with."

I closed my teeth on the words that wanted to come out, a protest that Clovan *was* supposed to have paid out enlistment bonuses. He'd been given the gold for bonuses, and I didn't have to wonder where the gold had gone if not for the purpose it was meant. Clovan was obviously a very ambitious man, and that made it even more important than ever that I reach Forain and rid myself of the curse.

"I hadn't realized it sooner, but you haven't asked me my... uncle's name and where he can be found," I said, looking up at Wender again. "And I'll need writing materials if I'm to send a note. He probably won't pay over the gold unless he's convinced that I'm your prisoner, so a note will be essential."

"Are you saying you've decided to take over this kidnapping effort?" Wender asked with an odd amusement behind the words. "Before I decide whether or not to allow that, you'll have to tell me how much experience you've had with previous kidnappings. This isn't a job for an amateur, you know."

"This also isn't a joke," I pointed out rather sharply, understanding nothing of his attitude. "I have no intention of spending the rest of my life in this tent."

"No, you're probably eager to get back to the good life, where people take advantage of you," Wender said rather distantly as he got to his feet, stepping closer to pick up my empty bowl. "Well, I have no intention of keeping you in this tent for the rest of your life, so you needn't worry on that score. We'll get around to writing the ransom note when it's safe to deliver it, which won't be for a couple of days yet. Meanwhile, you still have a job to finish."

He said his piece while walking over to the dirty bowls I'd found, and once he'd picked them up he left the area. I watched him go with my mouth open in outrage, furious that I couldn't tell the man why I was in such a hurry. But I shouldn't have *had* to tell him about hurrying, he should have been more than eager to get his hands on the ransom gold. I didn't understand why he wasn't that eager, not when he had to know I had no interest in staying with him. Or even was able to stay if I did have the interest...

Once again I had to push away disturbing questions, but this time I had no patience for an orderly search through the rest of the mess the area held. I threw things

aside until I found my shoes and put them on, at the same time finding a small cache of books.

The books no longer held an interest for me once I was able to go outside, but pushing aside the hanging closing off the area showed me a maze of cloth corridors. One of those corridors led to the outside, but the others could have led anywhere including a place I'd hate to find myself in.

I debated whether or not to take a chance, then decided to choose the safe path. I'd noticed nothing from Wender in the way of desire for me, so for a time I was free of the curse I'd been living with. Maybe the curse had run its course the way a sickness does, but that remained to be seen. For now I'd try to be patient and see what the future brought.

I let the hanging fall closed again, then went back to the small collection of books. There were two more slender volumes of poetry, but there were also three volumes of fiction. I chose one of the volumes of fiction, then went back to the blankets, made myself comfortable, and began to read.

I'd interrupted my reading once to refill the oil in the lamp from the supply of oil I'd found, but I was still with the book when I heard the soft sound of someone approaching. Despite being absorbed in the book I'd been able to notice getting hungry again, so when Wender entered carrying two bowls I put the book aside.

"It's about time," I observed as I got up and went to him to take one of the bowls. "I'd almost decided you meant to starve me after all."

"No, I would have mentioned it if I had," he said, glancing around as he spoke. "What happened to keep you from finishing up the sorting and looking?"

"I found what I was looking for, so no more sorting was necessary," I responded, peering into the bowl. "This smells like pork mixed in with the vegetables, I'm happy to see. I love pork, and I was getting very tired of whatever was in that stew."

"So you spent the afternoon reading instead of sorting?" Wender pursued as I put the first spoonful of food into my mouth. "Because you wanted to read but didn't want to sort?"

"Um hum," I agreed around the mouthful I'd taken, also sitting down. Wender nodded as well, all his questions answered, and then he took his own place on the floor and began to eat. After a moment or two Wender began to study me as he ate, possibly because I'd been moving around a bit in discomfort. Desire had been clear in the man's eyes when he first walked in, and my reaction to that observation proved that the curse was still very much with me.

"We'll have some water first," Wender said once his bowl was empty, putting the bowl aside and getting to his feet. "After that we'll get to the other matter."

"What other matter?" I asked his back as he went toward the waterskin. "What are you talking about?"

"I'm talking about the spanking you're due," he answered as he returned to his original place with the waterskin. "You do remember discussing the point with me?"

"I – of course I remember," I said, feeling confused – and suddenly a bit worried. "But that was just talk and didn't mean anything. You have no right to do anything like that to me."

"Of course I have the right," he countered as soon as he'd taken a long swallow of water. "I made it perfectly clear what you were supposed to do, and also made sure that you understood the choice you had if you didn't see to your responsibilities. You had the choice between going hungry and getting spanked, and that empty bowl by your knee says you decided not to go hungry. You also admitted that you deliberately decided to leave your chore uncompleted, so there isn't any point for you to argue."

"But there is," I disagreed immediately, not about to accept his dictum. "I'm not here voluntarily, so you had no right to assign me any sort of chore. Just as you have no right to punish me, especially if you want that ransom note written. I don't owe you a thing."

"I have a feeling you believe you've never owed anyone a thing," he commented as he offered me the waterskin. "You've probably been told all your life how beautiful you are, and that letting people see your beauty is reward enough for them. And that as beautiful as you are, you can do anything you please."

I felt the urge to answer his ridiculous charges with full agreement, since I *had* been taught those things. But something in his manner made me uncertain, so I ignored the offered waterskin to study him with lack of understanding.

"What's wrong with being taught the truth?" I asked after a moment, really wanting to know. "And if people are willing to let me do anything I please because of my beauty, why shouldn't I do as I like?"

"There's *nothing* wrong with being taught the truth, as long as it *is* the truth," Wender countered with a sigh. "You *are* a very beautiful woman, but that alone doesn't give you the right to do as you please. Only small children think they might get away with doing as they please, but adults know better. The things you were taught have kept you a child, holding you back from adulthood."

But does that also apply to queens? I wanted to ask. Isn't a queen entitled to do as she pleases? And doesn't a beautiful queen have twice the right? At another time I probably would have put the questions, but right now I didn't think I wanted to hear the answers...

"The truth you should have been taught isn't as simple as what you *were* taught," Wender continued, still sounding sad and sober. "Beautiful women do get away with doing as they please more often than unattractive women, but the time always comes when their beauty doesn't impress someone the way it does everyone else. That person looks for more than beauty in a woman, and if he doesn't find it he begins to lose interest in her. Do you want to spend the rest of your life with people who care nothing more about you than the way you look?"

"Isn't that what people do anyway?" I asked, even more confused than before he'd begun speaking. "Isn't beauty the only thing most people are interested in finding?"

"Only very shallow people care about nothing but surface appearance," Wender responded with another sigh. "I agree that beauty of face and body attracts attention more quickly than inner beauty, but that's only a physical attraction that usually starts to fade after a time or two of being physically satisfied. Has anyone ever wanted to be in your company just to talk without also – and foremost – wanting to bed you?"

I tried to think of someone who fit that description, but aside from other women and men who were very old there didn't seem to be a single example. For some silly reason that fact disturbed me, so I responded in the only way I could.

"Why would I be interested in talking to men?" I put, tossing my head with disdain. "With as little sense as they usually make, I'd just be wasting my time."

"For your sake I hope you don't really mean that," Wender said with a headshake. "That would make you as shallow as the men who seek you out with only one thing in mind. And now that I've thought about it, I've decided not to spank you after all. A woman with some depth to her would learn from the experience, but a shallow woman would learn nothing. I'll get some extra blankets, and you can sleep on the other side of the area."

"Wait!" I said as he began to get to his feet, now studying him a good deal more closely. "You're going to... bed me first, aren't you? I mean, you were interested when you first came in... "

"But now you can see that I've lost that interest," he said, smiling down at me in a humorless way. "That should tell you I'm one of those poor unfortunates who think more about a woman than just how beautiful she is. I really did believe there was some hope for you, but now it looks like I was kidding myself. And if you need to be seen to that badly again, I can send for one of my men."

"No, I don't want one of your men," I said as I looked away from him, feeling completely defeated. His original desire had started my need, but his losing desire hadn't done the same for me. Using another man would do nothing to satisfy me, I'd learned, so all I had to look forward to was denial without end.

"But none of it was my fault," I felt compelled to add, knowing I couldn't possibly make things worse. "At lunch you acted as if what I did was my choice, and you brought supper without first telling me you were unsatisfied. If other men let me do as I please and only want to bed me, you're not as different as you think."

I still couldn't look at the man, but his silence said he wasn't pleased with what I'd told him. I expected him to get angry and maybe even hurt me, but his true reaction came as a surprise.

"You know, you have a point," he conceded in a thoughtful voice. "I did... 'go along with the joke' at lunchtime, which probably led you to believe I'd do the same tonight. And I *have* been more interested in bedding you than in talking to you, even though I didn't ignore the talking altogether. But saying that 'none' of what happened was your fault isn't the truth, and I'd like to know if you can admit that."

"All right, so I deliberately stopped doing that stupid 'chore'," I found myself admitting, still without looking at him. "I expected you to let me get away with not doing it just as people have always done, because I *am* beautiful and you wanted to bed me. But you stopped wanting to bed me, which has never happened before. I didn't know I'd get less beautiful from not doing as I'm supposed to..."

And if that was true, that people get less beautiful when they don't do as they're supposed to, then I could finally understand why my advisors wanted a king instead of a queen. Kings aren't expected to be beautiful, so they *are* expected to act properly.

"I'll admit you just surprised me," Wender said, his hand coming to my hair as he crouched to my left. "I never expected you to take responsibility for what you did, and I certainly never expected you to learn that very difficult truth about beauty. It looks like there's some hope for you after all, and with that in mind..."

His words ended as he sat himself on the floor beside me, and the next instant I was being pulled across his lap. I yelped in protest, having no idea what he was doing, but a moment later I found out.

"When it looked like there was no hope for you, a spanking would have been a waste of effort," he said as he raised my skirts all the way up to my waist. "Now, though, a good spanking will give you reason to learn how to accept responsibility – and what will happen if you don't. I'm beginning to be really proud of you."

"You're what?" I demanded incredulously, then couldn't keep from voicing a loud "Ow!" His hand had started to come down on my bottom, and without the presence of spheres to distract me I felt the stroke completely. I also felt the next stroke of his hand, and the third, and the fourth... By then I stopped counting and simply wailed as he struck, his hand coming down briskly over and over and over.

My bottom felt red and throbbing before he was done, and tears streamed down my cheeks. He hadn't let me protect myself with my hand, and his own hand had

felt like wood on my poor abused bottom. It was much too long before he let me up, and when he did he took my face in his hand while I rubbed at the ache he'd caused.

"I said I was beginning to be proud of you, and I am," he repeated, making me meet his gaze. "That means I won't hesitate to give you a spanking when I think you need one, to be sure you give me more to be proud of. Now: do you want your own blankets to sleep in tonight?"

I hesitated a moment before shaking my head, but not because I had a choice and not because I didn't have a choice, either. The hesitation had come about because I'd realized that no one had ever before said they were proud of me, not my mother before she died, not my father before he died, not my advisors, not anyone. The concept made me feel so very strange, and also made me want to serve Wender whether or not I had to. He was still a very ugly man, but that observation was beginning to mean less and less...

Wender comforted me until my tears stopped, and then he helped me get out of my clothes. The one reservation I had about having him bed me was the added ache it would bring to my bottom, but once his own clothes were gone and he'd joined me in the blankets, the reservation stopped being a consideration.

I had the feeling that Wender wanted me to remember the spanking and so he wasn't particularly careful when he began his use. At first I whimpered and whined a little, but after a very short time I felt more pleasure from having him inside me than I felt discomfort from his punishment. I quickly became lost to his stroking, and when I finally gained release it was more than just release. I also felt more pleasure than I ever had before, but fell asleep before I could wonder why.

7

This time I awoke when Wender left the blankets, but I lay still pretending to be asleep until he dressed and went out of the area. I'd awakened in the night with questions buzzing around in my head, and I wanted some time alone to consider them.

Once I was alone I turned to my right side and rested my head on my arm. Wender hadn't turned the lamp up to more than the glimmer necessary to find his clothes, and that seemed to be typical of him. Ever since he'd taken me captive he'd gone out of his way to be considerate, and I could no longer tell myself that it was just the ransom that interested him. He hadn't yet asked for a name to send the ransom note to, and somehow I didn't expect that he would.

Just yesterday I would have wondered what else he might be after, but today I seemed to know. He wanted to help me become an adult rather than an overindulged child, and the realization of that brought tears to my eyes. He really had looked beyond my beauty to the woman beneath, and what he saw there interested him more than just my looks. The only problem was, nothing could ever come of his interest...

If, just a few short days ago, someone had told me that I'd regret being a queen, I would have laughed in that someone's face. I'd had no idea that it was possible to regret being so important, that I would some day find the position keeping me from what I most wanted in life. Even if I managed to get rid of the curse making me the slave of any man who wanted me, how was I supposed to keep Wender in my life? And I did want him in my life, I'd never been so sure of anything before...

But what could a man like Wender be to a queen? Oh, he was intelligent enough and obviously educated, but my advisors would never approve him as my consort, even if the man himself agreed to it. And would a man of pride agree to be little more than a woman's bedwarmer? Even if the woman involved needed his smile, his gentle humor, his patience – and his punishments?

I closed my eyes against the pain I felt, wishing I could have lived out my life in the shallowness I'd known until now. Shallowness has the great benefit of bringing nothing of real pain, not even the awareness that something is missing. I'd have to tell

Wender how wrong he was to denounce the shallow as unworthy of consideration. He had no idea how lucky people like that were…

My tears began to come harder, misery holding me even tighter than Wender had last night, but then a sudden thought came. It was true that I was a queen, but that didn't mean I had to stay a queen. Oh, I first had to straighten out the mess Clovan had been making and then get rid of the good general, but after that there was nothing to stop me from abdicating in favor of one of my cousins. Either of them, both male, would make my advisors much happier than I made them, and then everyone could be happy.

By the time I reached that conclusion my tears were all gone, so I got up to get into my clothes. Sitting didn't hurt as much as it had after Clovan's efforts, but I still had a faint reminder that Wender had punished me. And that he would do it again if he thought he had to, an idea I didn't care for at all. I couldn't help dreaming about a bath and having my maids dress me in fresh clothing, but that was only a dream and not as important as a different dream. So I forced myself back into the same old worn clothes with nothing more than a grimace for their odor, turned up the lamp, then got to work straightening out Wender's mess.

By the time Wender got back with our breakfast, I'd made a respectable start on sorting out the rest of the mess. Wender walked in carrying the usual two bowls, but stopped short when he saw what I was doing.

"Excuse me, ma'am, but somehow I've walked into the wrong tent," Wender said with raised brows. "This can't be the same place I came from just a few minutes ago, and you can't be the woman I left asleep. That woman doesn't believe in doing chores."

"Well, if I'm not that woman then I shouldn't be doing this," I countered from my knees after pushing my tangled hair back. "If it's someone else who'll get punished for not doing what she should, then I might as well go back to reading."

"You have an excellent point, so I surrender," Wender said with a laugh of delight as he came more fully into the area. "I'm in the right place after all, and the woman I left asleep has really finally awakened. Or are you doing this just to get out of being spanked again?"

"Why would I do this just to get out of being spanked again?" I asked very dryly as I got up and walked over to him. "You know how I love to be spanked… "

"Yes, I noticed that through all the howling and struggling you did," Wender came back, his tone just as dry as he handed me a bowl. "Maybe I ought to agree to spank you every day just to keep you happy, and possibly even twice or three times a day."

"Only if you're interested in how you would look *wearing* your meals," I countered, weighing the bowl in my hand. "If you *are* that curious, tell me now while I'm feeling so agreeable."

"No, no, curiosity has never been one of my major failings," he conceded with a grin, one hand held up toward me. "I'll agree not to agree to anything if you'll agree not to be so agreeable."

At that point I couldn't hold back my amusement, and Wender joined me in laughing at the nonsense. I didn't understand how I could have found anything enjoyable before I met the man, but I didn't say so out loud. I just sat on the floor near him while we ate, enjoying his nearness and the softness in his gaze. There was desire behind the softness, but there was also something else that affected me even more strongly than the desire. I wasn't quite sure what it was, and didn't have the nerve to ask.

"That's much better," Wender said at last when he put his bowl aside. "I was really hungry this morning, and couldn't wait to get some food into me. And I meant to ask sooner how your clothes are holding up. I've been putting out fresh clothes for myself at night, but you haven't been able to do the same."

"I also haven't been able to bathe, a lack that will soon drive everyone in this camp to running for the border to the next kingdom," I pointed out. "If you send that ransom note – to a man who isn't my lover – you'll be able to afford to buy me new clothes and a bathtub."

"And why would a man who wasn't your lover pay a ransom for you?" Wender asked, the words a good deal more casual than the look in his eyes. "Something like that would make very little sense."

"Not if he was my late father's very close friend," I pointed out, having thought of the change of plan while I'd been sorting. "He'll pay gold for my freedom gladly, and he might even be able to do something about what's going on in the kingdom."

"If he had enough power to do something, he would have used that power by now," Wender pointed out, his gaze softening again. "Either he doesn't have the power, or he doesn't want to use it, something you need to understand to keep from ending up very disappointed."

"He's retired, so he may not know what's going on," I said, wondering if that was why Forain hadn't tried to speak to me. "In any event, he has the ear and trust of the queen. I think the chance in approaching him is worth taking."

"And you think he'll listen to someone asking for gold to ransom his old friend's daughter?" Wender mused, now showing a bit of amusement. "You don't think he'd have the messenger arrested and tortured instead to find out where the girl is?"

"If my note doesn't call the gold a ransom, why would he have the messenger arrested and tortured?" I countered with full innocence. "He would simply be lending gold to the daughter of his friend, and once she had the gold she could leave it behind while she went herself to speak to the man. And her leaving the gold behind would mean that she had to come back…"

"Of course," Wender agreed, the silliest smile now on his face. "No one would leave good gold behind… "

He leaned his face down to kiss me then, and my desire for him flamed so high that I threw my arms around his neck and returned the kiss for all I was worth. His own desire flamed just as high, and a moment later we were down on the floor with Wender above me. When he thrust inside me I tried to devour his lips, but his own efforts at devouring turned mine into great pleasure.

We moved together for a very long time, and when release came it was sweeter than it had ever been before. I held to Wender until the tremors left my flesh, and he kissed me one last time before doing the same.

"This time I take with you in the morning may well be a bad habit," Wender murmured as he adjusted his clothing. "If it is, though, it's a bad habit I don't want to break. I'll try to find you some clothes to wear, and they may not be the best but at least they'll be clean. I won't be back for lunch, so I'll have someone else bring it to you. Stay here in the tent, and I'll see you when I get back later this afternoon."

He gave me a brief peck on the lips before taking the bowls we'd emptied and leaving with them. I felt so good that it took a moment for me to realize that he still hadn't made arrangements for me to write that note to Forain. I sat up feeling sudden annoyance, knowing I was letting Wender waste far too much time. With every day that passed, Clovan was becoming more firmly set in his place. If I wanted to remove him from that place, I had to act as quickly as possible.

But Wender was already gone, and I had no hope of following him through that maze of halls in the tent. I got to my feet to finish adjusting my skirts, then took a deep breath to banish the annoyance. There was nothing I could do about reaching Forain until Wender returned, but when he did… The next time we discussed the matter I would refuse to take no for an answer.

I turned to my still-unfinished task, but before very long it was finished. All the dirty clothing was piled together, the clean clothing folded near the paired up boots and shoes, the dirty bowls and spoons stacked, and the other odds and ends arranged neatly in their own places. I'd never done *anything* like that before, so I'd had no idea how satisfying it was to be finally finished.

I refilled the oil in the lamp again, then sat down with my book. Reading was pleasant and somewhat diverting, but after a short while I became aware of how bored I'd been growing. Being confined to a small area in a tent for days wasn't something I was used to, and I began to doubt that the confinement was something it was possible to get used to. The air had taken on a definite tinge of unwashed people and clothing, and I felt stiff from lack of real exercise.

By the time a woman appeared with a bowl of something for my lunch, I had put the book aside and was pacing around the area. Thoughts of the time being wasted

had returned to me, along with what felt like a brand new concern. I'd made up my mind to abdicate the throne, but until I did the people of the realm were mine to take care of. The longer Clovan was left where he was, the more harm he would do. I had to get to Forain, and as quickly as possible…

"Wender asked me to bring this food to you," the woman who appeared through the hanging said with a smile as she proffered the bowl. "It's pork again, and he said you like pork."

"Yes, I do," I answered with a tentative smile of my own, walking over to her in order to take the bowl. Eating the same thing for two days in a row was also becoming tiring, but there was no real need to mention that. Then I had a thought that did need mentioning.

"I wonder if you could do me a favor," I said to the woman as I took the bowl. "I feel silly about it, but I'm not sure how to get out of this tent. There are so many corridors, and turns, and sections… Could you tell me which way to go?"

"Of course," the woman answered with the same friendliness. "When you leave this area you go left, then left again. At the next branching you go right, and the entrance is only a short way straight ahead."

"Thank you," I told her warmly. "Now I don't have to feel foolish any longer. And thank you also for the food."

"My pleasure," the woman acknowledged with a nod, and then she turned and left. Once she was gone I finished the reheated meal quickly, took a swallow of the really flat and tepid water, and then picked up my cloak. The cloak had been under the last of the things I'd sorted, and I'd nearly forgotten about it. I'd decided to wear it – and its hood – on my walk, to show that I wanted privacy.

Once the cloak was on I brushed the hanging aside and went left, then turned left again when the choice became available. The next time I turned right, and just as the woman had said, the entrance appeared about fifteen feet ahead of me. I walked to it quickly and stepped through, and then I was outside.

The day was a really pretty one, and the air was fresher than I could ever remember it being. I took a satisfyingly deep breath as I strolled away from the very large tent, seeing only a few people around the disguised camp, and those mostly women. Wender had obviously gone somewhere with the men, which immediately made me worry. The life of an outlaw was far from safe, and the sooner I was able to set things to rights, the sooner Wender would be able to go back to whatever he'd been before Clovan's policies ruined his life.

I wandered around for a while just enjoying the pretty day, and then I came across a trail that looked to be well used. Curiosity about where the trail led made me follow it, and in just a few minutes I came to a beautiful lake. The trail led right down to the lake bank, then widened to both left and right. The water was a lovely blue-

green that made me yearn for a bath again, but the air was a bit too cool for that. And it was just as well that I couldn't take a bath, since I had nothing in the way of clean clothes to change into.

I stood looking at the lake for quite a while, enjoying the peace and quiet, finally deciding it was time to go back to the camp. If Wender returned and found me gone he might worry, and I wanted to spare him that. I turned and began to walk back up the trail, but after no more than half a dozen steps I stopped short with a gasp. A man had suddenly appeared in front of me, a man I didn't know.

"Well, well, Wender's treasure alone at last," the man drawled as he looked down at me. "He keeps telling us that you're just someone's maid after all, but some of us don't believe that. At least now I can get a good look at you."

I tried to step back from the man as he reached for my hood, but he moved too fast. He threw the hood back and grabbed my arms to keep me from running, and his expression changed to a slowly growing grin.

"Now I know why Wender kept going back to his part of the tent," the man said as he stared at me, the heat growing hotter in his gaze. "He had something worth going back for, something he should have shared but didn't. I don't really blame him for not sharing, but I'm entitled to my fair portion. Let's step over here, onto the grass."

"No, you can't!" I started to protest as he dragged me to the left. "I don't – "

I'd started to say that I didn't want his attention, but let the rest of the words go when I realized that that wasn't true. His desire had ignited mine, and if I didn't serve the man then I'd have no peace. I hated the idea of letting the man near me, hated having anyone other than Wender touch me, but all choice had been taken away from me.

The stranger pushed me down to the grass on the side of the road, his hands immediately going to my skirts to thrust them up out of the way. When he saw that I wore nothing under the skirts he became even more excited, and as soon as he'd opened his pants he brought his rod to me. His fingers probed my privates briefly before he positioned himself, and then he thrust deeply into me.

"Ah, girl, you're a treat, you are," the stranger muttered as he grasped my thighs with his hands. "One look at that face of yours and I was ready, and this body just added the topping. You should enjoy this more than you enjoyed Wender's rides. I'm a hell of a lot better looking than that tall and ugly mutt."

He laughed at his own humor, and then he began to stroke hard and fast. I thought I felt too miserable to respond fully to the man, too miserable over what he'd said about wanting me after a single look. I hated the curse that had been put on me and the way it made me a victim of every man who saw me, but that didn't stop me from

needing what the stranger provided. I moaned as he added to my growing need, bringing another laugh to the man as he looked down at me.

I closed my eyes in an effort to pretend that it was Wender who had me, but the effort was useless. The stranger seemed to sense the depth of my need, and suddenly he slowed his stroking until I made a sound of protest.

"What's the matter, girl, aren't you getting enough of me?" the stranger asked in a murmur as he moved his hands to my arms to keep me from rising up. "I can see you need a whole lot of cock, so if you aren't getting enough you just ask for more. But you'd better ask nicely, or I might not give it to you. Go ahead, ask me for more."

My head moved back and forth in silent protest, but my wanting nothing at all of the man didn't change the fact of the curse. The stranger was barely stroking me now, and I simply couldn't stand it.

"More," I was forced to say, hating myself as I did it. "Please, give me more."

"Yes, you really want your ride from Tilloh," the man murmured, enjoying my torment as much as my use. "Tell Tilloh you want and need him, and then beg again."

I had no choice but to do as the man demanded, and he made me repeat the words three times before he began to stroke harder again. I was nearly in tears by then, but the man didn't care. He continued to use me for much too long a time, and when I was finally granted release it was more bitter than pleasurable.

"That was really good, girl," Tilloh said as he took himself off me. I lay with my eyes closed to keep from having to look at him, but the satisfaction was clear in his voice. "Make sure you take another walk here tomorrow at this time, and I'll make sure I'm on guard duty again. That way you won't mind Wender's plunking half as much as you do now."

Tilloh chuckled to himself as he walked away, and I made sure he was gone before I straightened my skirts and stood up. It had come to me that I had to tell Wender the whole truth about the curse plaguing me, and then I would not have to meet that awful Tilloh again. If I stayed in the tent until Forain found something to cure me, and made sure my hood stayed up when I went out –

"Did you enjoy yourself?" a voice said suddenly, but this time it was a voice I recognized. I'd replaced my hood as soon as I began to walk the path again, but I pushed it back to see a Wender struggling to control his anger. He stood to the right of the path near a tree, and his gaze blazed down at me.

"Wender, you don't understand," I said, immediately heading for him. "It wasn't my fault, because – "

"How about that?" Wender interrupted in a tone that was almost savage. "We've now found something else that isn't your fault. You know, for a while there I thought there was something real growing between us, but now I can see that I was a

fool. You needed your... ego stroked and I wasn't available, so you went out looking for a man who was. If you're going to tell me he forced himself on you, forget about it. I heard what you said to him while he used you, and force doesn't add that much sincerity."

The bitterness in Wender's voice was almost as strong as what I'd felt, and some of what he'd said had really hurt.

"You can't really believe I went out to find a man," I protested, shaking my head a little. "I went out to get some fresh air and exercise after being cooped up for so long, and that man did force himself on me. I wanted nothing to do with him, but – "

"If you really wanted nothing to do with another man, you would have stayed in the tent the way I told you to," Wender interrupted again, his expression stony and cold. "You can't make me believe that you don't know what looking at you does to a man, especially since we discussed the point. Wearing that cloak and hood was as good as shouting to get attention, since there isn't a man around here who wouldn't consider the hood a challenge he had to answer. You wanted to attract the attention of men, and you might as well admit it."

"That isn't true," I whispered, feeling tears begin to fill my eyes. "Please, Wender, I swear it isn't true, and you have to listen to me. There's something you don't know that makes all the difference, so let me tell you – "

"No, don't bother saying anything else," Wender cut in again, his face and voice now weary with hurt. "I shouldn't have talked myself into believing that a woman like you would find more than passing interest in a man like me. I can't cope with your... hobby, so let's just forget about my daydreams. I'll get some paper and a pen so you can write that note, and as soon as we have the gold you'll be released. Until then I'll find another place for you to stay, and in fact I'll go looking for one right now."

He turned away from me then and simply walked away, acting as though he hadn't even seen my tears much less cared about them. I watched him until he disappeared, sobbing into my hands, and I couldn't bear the pain. I'd wanted so much to be with that man, but he hadn't even listened when I tried to tell him the truth. If I'd meant to him what he'd meant to me, he never could have done that...

I went to the tree Wender had been standing near, then circled it to sit down behind it. I cried for quite a few minutes, and by the time the tears ended I'd finally figured out the truth. It was a painful, humiliating truth, but at least I could see it now.

Wender had only pretended to feel something for me, most likely in an effort to keep me from trying to escape. For some unknown reason he hadn't been able to send his ransom note sooner, but now that he was ready to do it he'd found an excuse to step back away from me. He'd been absolutely right to say that a woman like me couldn't possibly see anything in a man like him, and he'd made sure to voice the observation first to save himself the embarrassment of being rejected.

"And I *would* have turned my back on him as soon as I was home," I muttered as I wiped my eyes on the cloak. "I can have my choice of attractive men, so why would I want one as ugly as Wender? I'm much too beautiful for someone like him, and he just saved me the trouble of having to say that myself."

The longer I thought about that sentiment, the more I believed it. That was the real truth I had to keep in mind, and I rose to my feet determined not to forget it. Wender could wait for me to get back until he turned blue, but I wasn't going back to that tent. I would circle the camp and find the road, and then I would walk to the hunting lodge where Forain now lived. I remembered that we'd left the road only a short distance from the hunting lodge's turnoff, so the walk would not be far at all.

"And once I'm cured of the curse and back in the palace, there are some chores that need seeing to," I muttered as I made my way into the surrounding forest. "The first chore will be to cut Clovan down to size, but the second will be ridding my realm of certain outlaws. Yes, hanging them will be best, I think, as an example to others about refusing to serve their country."

That decision made me feel really good, and I didn't even mind that the sun was going down and making the forest dark to walk through. In fact the sun was going down really fast, bringing a heavy, sleepy-making darkness, a darkness that gathered me up in its skirts…

"What a shame, child," a deep voice said near a dozing Meriath. "You almost learned the proper lesson, but then you turned and marched away from it. Now you need to begin all over again, but not in the same situation, I think. A different circumstance will hopefully produce different results, so let us begin."

Meriath had no idea what the voice was talking about, and even being almost completely asleep didn't keep her from dismissing the words for another consideration. In addition to being sleepy, Meriath felt the remnants of a terrible loss. She had no inkling of what the loss entailed, but it was truly terrible and very painful. If she'd been awake she might have begged to have the loss repaired, but instead she fell deeper into the cradling darkness…

8

"Meriath, wake up!" a low female voice hissed, interrupting a delicious dream. "You've already slept half an hour later than everyone else, and the kitchen mistress has been looking for you."

"Oh, Tellia, you always worry, worry, worry," I said with a yawn as I stretched. "The kitchen mistress will find me when I get to the kitchen, so why worry about it?"

"I worry because I'm a slave, and that's what slaves do," Tellia countered with a sound of vexation and a shake of her head. "At least, that's what the rest of us do. How can you have grown to the size you are without having learned that you're also a slave?"

"It doesn't matter that I'm a slave," I answered with a smile as I sat up on my pallet. "The only thing that matters is that I'm very beautiful, and if my last master hadn't died suddenly he would have freed me. He treated me like a queen while he lived, and now that I've been sold into *this* household the same thing will happen. As soon as the master notices me, I won't ever have to work in the kitchen again."

"And in the meantime you've been teasing the boys who work in the stables and on the ranch," Tellia said, her head to one side. "You know how much they all want you, but you just smile and turn your back on them. How do you expect to get away with that?"

"There's nothing to get away with," I responded with a shrug I'd been told was very … expressive. "Male slaves know that the master always has first refusal on any of the girls. Until the master decides he doesn't want me – which he won't do anyway – none of the slaves will dare to touch me. Believe me, I know how these things work."

"You hope you know how they work," Tellia corrected dryly with another headshake. "Right now you'd better get dressed and over to the kitchens. The master will want his breakfast soon, and you're the one he wants to bring it so he can get a look at you."

"And after I've been here only three days," I pointed out with a smile I knew would annoy Tellia. "Who was it who told me it could be a month or more before the master even knew I'd been bought?"

Tellia rolled her eyes before turning and walking out of the tiny area she and I shared with two of the other kitchen girls. With her dark hair and eyes she was pretty enough in an ordinary way, but no man would ever treat Tellia like a queen. The master probably hadn't noticed *her* for a month or two, but she and I weren't in the same class.

I hummed to myself as I dressed in the low-cut blouse and thin skirt I'd been allowed to bring with me from my dead master's house. The blouse was a pink that added a nice tint to my cheeks, and the skirt was a pastel print with patches of pink that matched the blouse. It had been my previous master's favorite outfit, and I'd make sure it was my new master's favorite as well. At least until he bought me others, that is.

It took only a minute to brush my long blond hair, and then I made sure to smooth the smile from my face before going to the kitchens. The kitchen mistress was an ugly old woman who enjoyed giving slaves a difficult time, especially pretty slaves. I'd quickly learned to stay out of her way, and would continue to do so until the master took me out of the kitchens and gave me a real room all to myself.

Slipping into the large kitchen area unnoticed wasn't hard, nor was finding a simple chore to do. Goblets had to be arranged on trays so they could be brought out to the eating areas, and not all the trays had been filled yet. I busied myself with doing that, and it wasn't long before the kitchen mistress discovered me.

"Where have you been, girl?" the nasty old woman demanded as she stopped near me. "If I didn't know better, I'd think you slept late in the morning."

"I've been right here, working, Mistress," I answered in a small voice, keeping my eyes modestly down. "Did you want me for something?"

"Yes, I did and still do," she answered, her tone saying she didn't quite believe me. "You'll be taking your master's breakfast to him this morning, and it's being put on a tray right now. It's a lucky thing I found you when I did. If I'd had to go searching while the food grew cold, you would have learned what punishment means in this house. Come along now."

"Yes, ma'am," I answered meekly, then followed along after her. If Tellia hadn't awakened me when she did I might have had some trouble, so it looked like I owed the girl a small favor. Once the master put me in the place I belonged, I'd use my influence to get Tellia something or other…

The master's breakfast tray was all ready, so I took it while another of the kitchen girls ran ahead to open doors for me. I would have been happier if the girl carried the tray while I opened the doors, but I couldn't even tell the girl to take the tray once we were out of the kitchens. The girl was certain to run crying to the kitchen mistress as soon as I no longer watched her, and I wasn't completely safe from the

kitchen mistress yet. So I carried the heavy tray all the way up to the second floor where the master had his rooms, and simply stood waiting while the girl knocked on a door.

"Come," a deep male voice said in answer to the knock, and the girl opened the door for me. I stepped into a sitting room decorated more darkly and heavily than my old master's sitting room had been. The furniture was covered in leather and weapons hung on most of the walls, and a small table with two chairs stood to the back and left, near the windows in the opposite wall.

The master himself stood near a large desk to the right, and he looked up when I came in. He was a big man with light hair and eyes and was also very ordinary in appearance, and when he looked at me the desire in his gaze touched me like something physical. I suddenly felt more need than I ever had before, but that was perfectly all right. Once the master finished his breakfast, I'd be able to show him just how desirable I really was.

"Put the tray on the table there, slave," the master said, gesturing toward the small table with two chairs. "As soon as Lord Espelle finishes dressing, you'll be able to serve us."

I felt somewhat confused, but I took the tray to the table as ordered and turned around once it was down. The girl who had been opening doors for me was gone, so I was able to satisfy my curiosity.

"I thought you were my master," I told the man with a smile that warmed the look in his eyes. "If you aren't, then who are you?"

"I'm in charge of the stable and ranch slaves, and my name is Brazzan," the man replied with faint amusement. "Aren't you being the least bit forward for a kitchen slave?"

"Forgive me, Master Brazzan, but I've always been terribly curious," I answered with a sigh that the man took immediate note of. "It's wicked of me, I know, so I really do try to curb the habit."

"I think you'll have some help with that," the man Brazzan began, but the rest of what he might have said was interrupted by the appearance of another man from an inner room of the apartment. The newcomer was big and very ugly, with a craggy face under thick, dark hair. He also had very light eyes, so light that they seemed downright chilling.

"That has to be the new slave," the newcomer said after only glancing at me and the curtsey I quickly performed. "Have you had the time to learn anything yet, Brazzan?"

"Actually, I have, Espelle," Brazzan answered, the faint amusement still with him. "It's easy to see why her former owner indulged her to the point of stupidity, and

I expect it to take some time before she learns better. She was with the man for most of her life."

"She was definitely with him when she blossomed," Lord Espelle said with a grunt of agreement. "I expect you to see to it that her presence makes very little trouble on the ranch. My agents paid far too much for her, and if I don't get more than a little use out of her I'll have lost money. Let's sit down to breakfast, and you can give me your report on the new section I just opened for grazing and planting."

The two men walked to the table and sat, and I nearly forgot that I was supposed to serve them. My new master seemed less impressed with me than he should have been, but that had to be only because he hadn't yet used me. The need that had started only a few minutes earlier seemed to be growing, but that had to be a good thing. My discomfort would be seen to as soon as the master finished breakfast, and my eagerness would just add to the performance.

I took the food from the tray and put it in front of the two men, then stepped back and waited to see if they had any other orders for me. I also expected them to look at me while they ate, but all their attention seemed to be on the conversation they held. Brazzan spoke about the extra male slaves he would need to work the new section just opened, and Lord Espelle made additional comments. I just stood and squirmed a little as I waited for them to finish.

If you fail to serve the first man who desires you, you will find no easing from serving any other, a voice said suddenly in my head. *All relief will be denied you until you bring pleasure to the one you must serve first.*

I almost jumped in startlement, hearing a voice in my head out of nowhere. And what the voice had said made no sense at all. All men, free as well as slave, who looked at me desired me, so what could "first" have to do with anything? I must have been imagining things, but what could possibly have made me imagine something like that?

I shrugged to myself when no answer came, and then had to push away a vague and distant feeling of loss. It was almost as if someone very far away was crying on the inside from some memory or other, the tears ignored because the loss had been completely denied. I'd experienced a loss myself, the loss of promised freedom and the marvelous life my old master would have given me, but *I* wasn't crying. I'd still have what I'd been promised, but from my new master instead. After all, I had so much to work with…

I smiled to myself as I waited for the two men to finish eating, but all too soon the smile disappeared behind growing discomfort. The need inside me was growing faster and hotter than it ever had before, and I really disliked the experience. It had always been the men around me who squirmed with helpless need, and even worse was the fact that my condition was noticed.

"Your newest slave seems to have worked herself up to being ready for your attention," Brazzan said to Lord Espelle with amusement as he pushed his emptied plate away. "Do you intend to use her before starting the day?"

"Yes," Lord Espelle answered as he pushed away his own plate, relieving my mind to a great degree. "I want to know if the fool taught her anything useful, and you can watch her performance to see what she still needs to learn. In addition to what we've both already seen, that is."

"Yes, it's obvious she was either never taught proper slave behavior, or was allowed to forget it," Brazzan agreed as he lifted his teacup. "I'll take care of that first thing, along with the rest of whatever she needs."

"Good," Lord Espelle said as he rose from the table. For my own part, I was beginning to feel more than a little upset. These men weren't acting the way men around me usually did, and I couldn't understand why. My old master had loved everything about me, but these two –

"Over here, girl," Lord Espelle said as he took my arm in a big, uncaring hand and pulled me with him to a wide, cotton-covered pallet on one side of the room. "Down there, and be quick about it."

I knelt on the pallet despite my intense confusion, having no idea what was happening. If Lord Espelle meant to use me, why hadn't he taken me to his bedchamber? And how would Brazzan "watch" my "performance" when I'd be used in the usual privacy?

"And don't forget to find her something more appropriate to wear," Lord Espelle added as he pushed me over onto my back and reached for my skirt. "All this cloth just gets in the way. All right, girl, let's see what you can do."

My new master had pushed my skirts all the way up by now, and had also begun to open his trousers. When he freed his manhood I couldn't hold back a gasp of surprise, so much larger than my old master was he. Lord Espelle chuckled at my expression, then grasped my thighs and positioned himself at the entrance to my desire. I really did need his attention badly by now, but Brazzan had left the table with his teacup and now stood to one side watching us. I was just about to protest the lack of privacy when Lord Espelle's thrust inside me made me cry out.

"At least she's nice and tight," Lord Espelle said as he leaned his hands on my shoulders to hold me still. "But she's also wet enough to take a man of any size, so I ought to get some enjoyment out of this."

"Yes, I can see she isn't doing much in the way of moving for you," Brazzan said after sipping at his tea. "She doesn't seem to be used to a man of size."

Lord Espelle grunted a sound that seemed to be agreement, and then he began to stroke in and out of me. The movement was what I needed, and after a moment I moaned with how good it felt. I also began my own movement of encourage-

ment after suddenly realizing that everything wasn't lost yet. When Lord Espelle found out how satisfying my use was, he would change his mind about all those terrible things he'd said...

Lord Espelle continued to stroke me for quite some time, but his own eventual release did nothing for mine. My need had continued to grow as I was being used, and when my master withdrew it was all I could do to keep from demanding that he continue until I found the same satisfaction.

"The girl knows almost nothing," Lord Espelle said with disgust as he arranged his clothing, shocking me deeply. "The look of her sets a man's fires going, but she does nothing to add to the pleasure of putting them out. You have your work cut out for you with her, Brazzan, and she'd better be a fast learner. Even slaves deserve better than that."

"She's worth spending some effort on," Brazzan answered as he studied me, his expression thoughtful. "I noticed that she tried to do it right, but obviously didn't know how. And she's still hot, so she shouldn't mind when they stand in line at first. I'll let you know if I make any real progress before your next business trip."

"Yes, do," Lord Espelle agreed as he strode over to take up his teacup and finish the tea in a single swallow. "I'll see you later."

Brazzan nodded, and a moment later Lord Espelle was gone from the room. I sat up on the pallet and adjusted my skirt while feeling horrible humiliation, understanding nothing of what was happening. My new master had used me, but rather than want me even more the way he should have, he'd said awful things about me and then had left. And the need I felt was growing stronger by the minute...

If you fail to serve the first man who desires you, you will find no easing from serving any other, the voice said again in my head. All relief will be denied you until you bring pleasure to the one you must serve first.

I looked up to see Brazzan studying me again, and a terrible thought occurred. He was the one who had seen and desired me first, and if that unknown voice was right I had to serve *him* in order to find easing. But how could that be? Brazzan wasn't my master, so what good would it do to please *him*...?

"You look upset, slave," Brazzan said suddenly, interrupting my inner demands and questions. "Are you having trouble understanding what just happened with your new master?"

"There must be something wrong with him," I whispered, finding that the only possible explanation. "My old master was always more than pleased, so – "

"No, that's not the answer," Brazzan quickly cut in, his tone firm and definite. "There's nothing wrong with Lord Espelle, the wrongness lies with what you were taught. Your old master was a very shy man who became enchanted with his

extremely beautiful girl slave. I'm willing to bet that you were the only slave – or woman of any sort – that he ever used."

I nodded a bit to show that Brazzan was right, but still couldn't understand what that had to do with anything.

"Yes, I thought so," Brazzan said with satisfaction when he saw my nod. "I'm also sure that he constantly told you how beautiful you are, and promised to give you anything you wanted if only you allowed him to appreciate that beauty. He would have called it appreciating your beauty or something in the same vein, rather than calling it using your body."

I nodded again, this time warily.

"Of course my old master appreciated my beauty, but what he did to me he called worshipping," I told Brazzan. "Why shouldn't he have…?"

"He shouldn't have because it gave you a false picture of real life," Brazzan said, turning to get a chair to pull over. He sat where he'd been standing, and went back to studying me. "You are a very beautiful girl, but there are countless beautiful girls in this world. Quite a few of those girls are slaves, so their beauty isn't in any way denied to men. Just as your own beauty won't be, after you learn that you need more than simple beauty to get along."

"I don't understand anything you're saying," I protested, close to wailing out the words instead of speaking them. "I don't understand what's happening, and I don't know what I'm supposed to do now – unless Lord Espelle sells me to someone like my old master. He can do that, can't he?"

The sudden thought became a true, flaming hope, but Brazzan's headshake quickly destroyed it.

"Lord Espelle won't ever sell you to someone like your old master," Brazzan told me in a tone I couldn't disbelieve. "Espelle hates the idea of some fool falling under the spell of a girl with nothing but attractive looks, so he certainly won't do anything to make the situation happen a second time for you. If you don't learn to be the kind of slave he wants you to be, he'll sell you to one of his tenant farmers who use girls to work their fields."

The shock his words brought was the worst yet, and I sat staring at the man openmouthed while my thoughts whirled in all directions. This couldn't really be happening to me, it had to be a bad dream of some kind…

"You're not the first beautiful slave to find reality so hard to believe," Brazzan said, just about reading my mind. "You'll probably be the best of the group we have here, but only if you do a good job learning what you'll be taught. Are you going to work at learning, or will I be wasting my time?"

"I'll – learn whatever I have to," I said, suddenly determined to get even with my new master. I wasn't useless or worthless or any of the awful things he'd called

me, and when I learned all there was to know I'd have the great Lord Espelle begging for more. And before I gave it to him, I'd make him free me…

"I'm glad to see that you have the right attitude," Brazzan said, for some reason with a touch of dryness in his tone. "I'll find you the proper clothing, and then we'll get started on the first of your lessons."

"Please, master, wait just a moment," I said as Brazzan got out of the chair, urged to the effort by what I continued to feel in the way of need. "Please let me serve you before you send me back to the kitchens. If you don't, I'll end up being punished for ruining some chore while being distracted by thoughts of you. You can't really want that to happen, can you?"

I gave him the look that my old master had found so appealing that he'd never been able to deny my request. I expected Brazzan to react no differently, but all the man did was laugh.

"A bit of punishment would probably do you no end of good, but you don't have to worry about it at the moment," Brazzan told me through the laughter. "You were assigned to the kitchens only until Lord Espelle got back from his last business trip, which he did late last night as you should have noticed, so you won't be going back there. And before I let you serve me I'll have to see some progress in your learning. Come along now."

Brazzan headed for the door and then out of the room, making me scramble to my feet and run to keep up with him. I hated the way he'd laughed at me, but if that strange voice in my head was right I needed the man to ease me. I hurried after him, and saw him glance back as he walked up the hall, and then he stopped short.

"All right, girl, it looks like we'll have to start your lessons with the basics," he said, his sigh tinged with annoyance. "When you're told to follow, you do it with your eyes on the feet of the one you're following. When the feet stop, you stop, and when they continue on so do you. You don't prance along examining the scenery, you look at nothing but the feet in front of you. Do you understand me?"

"I understand, Master," I agreed, resisting the urge to say I'd never had to do anything like that before. But until I became absolutely irresistible to these men, I'd probably have to do any number of things I'd never done before.

"I hope you really do understand," Brazzan said, his tone having turned harder. "Right now you're obeying even though you're sulking, but after a short while you might decide to see just how serious I am. To save you the wait, let me tell you right now: If I catch you looking anywhere but at my feet, you'll get your first real punishment. Is that clear?"

"Yes, Master," I said at once, not even glancing up to say the words. It was more than clear that the man wasn't joking, and I had no interest in finding out

whatever his punishment would be. I just began to wish really hard that I could have gotten my freedom before my old master had died…

I was led down the steps to the front hall of the house, then through a hall to one of the back doors. I saw nothing of where I went, only the floor I walked on and the feet I followed, and then we were outside. It was a warm and pretty day out, but I also didn't get to see that. I was led past the barn and the barracks building for the male slaves, forced to run every few steps in order to keep up with the briskly moving Brazzan. He slowed once we were past the barracks building, and then I was being led into another, smaller house.

"This house is mine, and it's where you'll get most of your training," Brazzan said once we were inside, pausing in the front hall to turn to me again. "Close the door, and I'll show you where you'll sleep and then start your lessons."

And then, hopefully, ease me, I thought as I turned back to the door to close it. I was careful not to raise my head or eyes, not even a little. The need I felt just kept on growing stronger, and soon I knew I'd probably be willing to do anything at all to get release. I hated the thought of being in that position, but I wasn't being given any choice…

Once the door was closed I was led through a hall to the back of the house, and then into a room. From what I could see of it, the room was just as small as the one I'd shared in the master's house. This one, though, held only two pallets rather than four on its wooden floor.

"At the moment there's only one other girl in this room, but that could change at any time," Brazzan said. "Wait here while I get the proper clothing for you."

I stood and waited with head and eyes down, having the definite feeling that Brazzan might come back more quietly than he'd left, just to catch me looking around. At another time I might have chanced it, but right now it was all I could do not to hop from foot to foot. I did take the opportunity to rub at myself a little, but that did no good at all. What I needed was Brazzan's use, and that as soon as possible.

"All right, you can look up now," Brazzan said as he came back into the room. "And you can also get out of those clothes."

"I'll put them away somewhere, where no one will be bothered by them," I said as I began to get out of the skirt and blouse. "They're the only things I have left from my old master, so – "

"So you won't be keeping them," Brazzan interrupted, his tone now more gentle. "The clothes won't do anything but remind you of a time that will never be again, so for your own good you're better off without them. You can't adjust to your new life if you cling to the old one."

Brazzan seemed to be waiting for me to add something, but I was too angry to do more than simply get undressed. That skirt and blouse added to my beauty more

than anything I'd ever worn, and I'd wanted to keep the clothing to use once I was finished with their foolish training. But Brazzan didn't want me to have the things, so I had to give them up. Well, I'd have to get even for that right along with everything else.

"Now put this on," Brazzan said, handing me what he'd been holding as he took my clothes with his other hand. "All the girls wear them, and it ought to suit you especially well."

The cotton … item he gave me had no sleeves or collar, and it tied at my left hip. Even closed the top of it covered my breasts only loosely and skimpily and left a wide vee, and the bottom of it came down no more than to the top of my thighs. My backside and private parts were only barely out of sight, and tugging at the tiny skirt did nothing to make it longer.

"What goes on over this?" I asked Brazzan, wondering why he hadn't given me everything at once. "I've never worn underclothing before, and I don't think I like it."

"You've been sheltered as well as spoiled, haven't you," Brazzan observed with amusement as he looked me over. "That's not underclothing, so nothing goes on over it. It's designed to make you more attractive to the men who use you as well as more accessible, and you'll be given others like it once we see how you do in your lessons. If you do well, the shifts will be of cotton, like the one you have on now. If you don't do well you'll wear shifts made of burlap, to let everyone know that you haven't been pleasing. And you won't like the burlap shifts at all."

This time I couldn't find anything to say, at least nothing that wouldn't get me beaten. I'd never before been made to walk around almost naked, not when my master had wanted the sight of me kept all to himself. But my new master wasn't the same, and as humiliating as the situation was I'd just have to put up with it, at least until my new master saw things like the old.

"You know, I don't think I've ever seen a female slave pout as much as you do," Brazzan commented, studying me again. "It's almost as if you don't know what that steel band around your left ankle means… Have you looked around this room as I said you were free to do?"

"Of course," I answered, again understanding nothing of what he meant. "This room has nothing but two pallets in it, with a blanket on each pallet."

"You seem to have missed the other thing this room has," Brazzan said, turning to look at the wall to the left of the doorway. "It's just possible you don't recognize what that object hanging on the wall is, so I'll give you a hint. It isn't a decoration."

"I know a switch isn't a decoration," I said, still lost about what point he was trying to make. "I don't know why it's hanging on the wall like that, but obviously different households keep their switches in different places."

"Yes, they do," he answered softly with something of a smile. "Go and get that switch and bring it to me."

He was hardly so far from the switch that he couldn't have gotten it for himself, but I wasn't yet in a position to argue his silly orders. So I went and got the thing from the hook it had been hung on, and brought it to him. The switch was long and thin and made of wood, of course, but it also looked almost polished. I had no idea who would polish a switch, but there was no arguing how strange the people in that household were.

"Good," Brazzan said as he took the switch from me. "Now show me how easily you can reach to your ankles without bending your knees."

I raised my brows and shook my head a little as I complied again with his odd orders, growing resigned to understanding nothing of what the man was about. It was possible he wanted to see how limber I could be, so I wrapped my hands around my ankles just to show that I could. If that made him decide to use me more quickly, the way I'd been made to feel really silly would be worth it.

I was just about to ask if Brazzan was satisfied when a sharp, stinging pain flashed across my bottom. I was so stunned I froze for a few heartbeats, my hands closing convulsively tight around my ankles. A second flash of pain unfroze me enough to cry out, but a third, even more painful stroke came before I was able to release my ankles and quickly straighten.

"That surely has to be your first taste of the switch," Brazzan said as I jumped around rubbing at my bottom, tears streaming down my face. "Do you want your second taste right now, so soon after the first?"

"No, Master, please," I begged, suddenly terrified that he would switch me again. My old master had never let anyone switch me, and it hurt more than I'd ever imagined possible. Even with rubbing, the pain in my bottom increased, the whole of it blazing hotter and hotter.

"Then I suggest you kneel to me the way a proper slave is supposed to," Brazzan said, all amusement gone as he ran his free hand over the switch. "You do know how to kneel properly, I take it, even though you usually don't bother?"

I'd never been required to kneel properly, but I certainly did know how it was supposed to be done. So I lost no time kneeling in front of Brazzan, my hands at my waist and my head bowed deferentially. It had usually amused me to see other slaves being made to kneel like this, but suddenly there was nothing to be amused about.

"Spread your knees and feet so that you can settle down between your heels," Brazzan directed from where he stood above me. I complied immediately, taking care not to touch my bottom with my heels, and he made a sound of partial satisfaction.

"You'll need to practice quite a bit more before that looks completely right, but for the moment it will do," Brazzan said, clearly ignoring the tears still streaming down my face. "From now on you'll kneel properly every time you see me or Lord Espelle, as well as to others who will be pointed out to you. This is the position you should have taken after serving your master and me earlier, and normally you would have been punished for standing around instead, impatiently waiting for us to finish eating. The only thing that saved you then was the fact that we knew how little you'd been taught by your former master. We showed you patience, but that patience is at an end."

All I could do was sniffle and squirm, the ache in my bottom adding itself to the need inside me. I didn't know why these terrible things were happening to me, but I knew how much I hated them.

"Another thing you'd do well to change is the way your thoughts reflect on your face," Brazzan went on. "Pouting when you feel displeased and looking put out when you're given an order are unacceptable attitudes, and from now on you'll be punished anytime I see those attitudes. You'll also cry less … obviously, as though you expect to get something with your tears. The only thing that part of your act will get you is another taste of the switch. Is all that clear?"

"Yes, Master," I whispered with a sniffle, more miserable than I'd ever been in my life. At this rate, it would take forever to learn what I had to in order to make my new master treat me the way my old master had. I now understood just what Brazzan meant, but what I didn't know was how long I could stand being treated so badly.

"I always start gently with new slaves, trying to make them understand what I expect from them without using punishment," Brazzan said. "In your case I offered more than one chance, but you ignored them all in favor of going on as if nothing around you had changed. None of your lacks will be overlooked from now on, and if you let yourself forget that you'll be helped to remember. You'll spend the rest of this morning practicing your kneeling, and after lunch your more advanced lessons will begin. Right now take yourself over to your pallet, which is the one behind you."

I got to my feet as quickly as I could, and hurried over to the pallet behind me. I knelt on the pallet in the proper way, and Brazzan followed me more slowly.

"Yes, I see that you do know the right way to behave," he said, looming over me like the promise of doom. "I expect to see a lot more of that kind of behavior from you, and if I don't then I'll give you that help I mentioned. Now you can get to your hands and knees in the middle of the pallet."

I moved quickly to do as he said, and heard him move behind me. When he knelt down he put the switch on the pallet next to me, and a moment later he touched me intimately.

"I can see that all your squirming isn't just from the punishment," he said as I gasped – but stayed right where I was. "I'm going to take some use from you now, but probably not in the way you're used to being treated. If you do well with your lessons I'll let you participate next time, but right now you'll just be used like the lowly slave you are."

And then he presented himself to my heat, entering me so quickly that I almost gasped again. Being used like that was terribly humiliating, as though I were an animal rather than human, and it was also somewhat painful when he came in contact with my aching bottom. His hands on my middle held me in place while he took the use he wanted, and if I hadn't been so badly in need I probably would have cried again.

But rather than crying I moaned, needing his attention too badly to want to refuse it even if I could have. He stroked me fast and hard, seeing to his own need rather than to mine, but when his desire was satisfied mine quickly followed. It had never been like that for me before, needing to wait for my master to attain release before I found pleasure of my own. When Brazzan withdrew, I wanted nothing more than to fall flat on the pallet and bury my face in my arms. But I hadn't been given permission to move, and so I didn't.

"Lord Espelle was right," Brazzan said as he got to his feet. "You do have a lot to learn, and you'd be wise to do that learning quickly. Stand up."

I scrambled to my feet, but stood with head down and hands folded at my waist. Brazzan made a sound of grudging satisfaction, and then the switch was being held out toward me.

"Return this to its place on the wall, and then come back here," Brazzan said, that same distant tone in his voice. I took the switch and put it back on its hook, and then hurriedly returned to stand in front of the man who had made me feel so miserable.

"Kneel down again," Brazzan ordered, and I made haste to obey. "You'll be practicing kneeling properly until lunchtime, remember, when I'll have someone bring you something to eat. After you've eaten your real lessons will begin, and you'll obey the man who comes to teach you as if you were obeying me. He'll have my permission to punish you if you don't try your best, and so will the others who come to train you. Try to keep that in mind if you want to avoid standing up for your entire training period."

I hadn't been asked for a response, and Brazzan didn't wait to see if I would give one anyway. He simply strode out of the room, leaving me to practice…

9

The forever I'd worried about earlier began a lot more quickly than I'd been expecting. Kneeling in one place for hours makes the passage of time crawl by on hands and knees, and by the time I heard someone walk into the room I could no longer feel my legs at all.

"Well, well, what have we here," a male voice drawled as the footsteps came closer. "At first glance it looks like an obedient girl slave."

A pair of bare feet stopped in front of me, and I noticed with surprise that the left ankle attached to the feet had a steel ring closed around it. That meant the new arrival was a slave rather than free, which also made him someone I had no interest in knowing.

"Master Brazzan told me to bring you this food, and also to let you get up," the slave continued. "That means you can sit down and get comfortable to eat, and once you're done we can start your lessons."

"*You're* going to start my lessons?" I blurted, surprised and not very pleased. "I thought it would be – "

I'd started to look up and move as I spoke, but I didn't get very far with any of it. As soon as I tried to move, my legs began to scream with pain. That made me cry out and push myself to the side to sit, forgetting that I might not want to sit. It turned out that falling down flat would have been a better idea, as my bottom was still much too tender. I turned to my side moaning with pain from more than one source, and the slave standing above me crouched down and put aside the bowl and cup he carried.

"I'd guess you were in that position for more than just a few minutes," the slave said as he reached to my legs. "Hold on a minute, and I'll see if I can help."

He began to rub my left leg then, and although the pain was terrible I did start to get feeling back. After a minute he shifted his attention to my right leg, which took less rubbing before the feeling began to come back. When I started to struggle to my feet the slave helped, and once it was possible to stand without falling I looked up at the slave – and got a surprise.

"I've seen you before, I think," I said, studying his very handsome face. "You came into the kitchen once or twice."

"I wanted to get a look at the newest slave," he answered with a nod. "I knew I'd probably be the one to train you, and I was curious. I'm Claidon, by the way."

This Claidon had reddish blond hair and green eyes, a square, masculine face, and an excellent body. He wore a sleeveless tunic that came down to mid thigh on him, making the clothing a better fit than what I wore. For some reason I felt surprised that he'd helped rather than hurt me, but the thought wasn't worth pursuing. Those green eyes looked down at me with something of desire, and to my disgust my body reacted instantly with renewed need.

"I'm sure you're mistaken," I told Claidon with a small headshake as I looked for and found the food he'd brought. "You can't possibly be the one who will train me, so you'd better get the misunderstanding straightened out while I eat. I have to get trained as quickly as possible so the master will be really pleased when he uses me."

"You think you're being trained for the master?" Claidon said as I picked up the bowl and began to eat what it held. "Who told you that?"

It was a pleasant surprise to find that the bowl held a vegetable stew rather than simple soup, and there were even small pieces of chicken mixed in with the vegetables. I'd missed this morning's porridge, so I ate hungrily for a moment or two before answering the slave's question.

"Why would anyone have to tell me that I'm meant for the master?" I countered reasonably. "Can you honestly say there's another slave in this household as beautiful as I am, not to mention more beautiful? If not, then it stands to reason that the master will want me for himself as soon as I'm completely trained."

"Hasn't anyone told you how things work on this ranch?" Claidon asked, folding his arms as he looked at me with what seemed to be pity and sympathy. "The master already has his favorite slaves picked out, and although they're exquisitely trained they're no more than pretty. The master doesn't believe in making a beautiful slave one of his favorites."

"But that's ridiculous," I said with a small laugh of disbelief as soon as I'd swallowed. "Of course he'd want a beautiful slave, assuming she was just as exquisitely trained. That's the way I'm going to be, so run along and get the confusion straightened out. Once you do, I'll even let you use me. As a reward, you understand."

I congratulated myself silently for arranging things so neatly. I knew I did have to serve this stupid slave, but when I did he'd think I was doing him a favor. I went back to eating my food, and almost missed the way he shook his head.

"When Master Brazzan told me I'd have my hands full, I didn't know how right he'd be," Claidon said with a sigh. "I don't know where you got all those foolish ideas, but you'd better get rid of them as fast as possible. You *are* beautiful, and that

means you're meant for the male slaves who work this ranch. Some of the overseers will probably use you as well, but for the most part you'll serve the slaves."

"That can't possibly be true," I denied with my own headshake, suddenly losing interest in what was left in my bowl. "Who ever heard of free men giving beautiful women to slaves?"

"We have," Claidon responded at once, the serious expression he wore trying to make me believe what he said. "Master Espelle's slaves rarely try to run away, because he treats us better than low class free men live. If a slave works hard he gets fed well, has a private place to sleep, and is given the use of women he'd never have a chance to touch any place else. There was once even a slave who ran away from his own master to come here and try to pretend he was one of ours."

"I don't believe a word you're saying," I stated, refusing to notice the cold clutch of fear inside me as I put down the bowl and the food I no longer had an appetite for. "I'm too beautiful to be given to slaves, and that's all there is to it."

"What do you think beauty is for?" Claidon countered, his tone now filled with annoyance. "The only purpose beauty in a woman has is to attract men to her use. If the woman is free she can use her beauty to marry well and maybe even to manipulate her husband, but if she's a slave she's more likely to be used as a reward. That's what Master Espelle uses beauty for, so you'd better get used to the idea."

"I won't listen to your lies," I said, putting my hands over my ears. I'd already turned my back on the fool, and now I moved two steps away from him. Claidon had to be lying, and that's all there was to it. "I don't want to hear any more, so go away right now."

That lump of ice inside me that I refused to notice had even dampened the need I felt, letting me demand that the slave leave. Even if for some reason Brazzan came back and decided to switch me again, that would be better than listening to the awful untruths of a vicious slave.

"You leave me no choice," Claidon said, the words low and muffled because of my hands being over my ears. "Before I can teach you anything, I have to have your attention. I think in just a little while I'll have that attention."

I had no idea what he was talking about, but it didn't matter because he left the room after saying his piece. I glanced around to make sure he was gone before freeing my ears again, and then I went to the cup he'd brought with my food. I didn't want any more of the food, but I needed the water the cup held. I drained the cup completely, then went to my pallet and lay down on my belly. As soon as a free man came to train me, I'd get on with my plans.

I expected to have something of a wait, but it wasn't long at all before a woman walked into the room. The new arrival was much too large and wide to be anything but free, but before I could move to my knees in deference to her position she

strode over and bent down to take me by the hair. I squeaked a little as I was pulled to my feet, and then squeaked even more as she dragged me out of the room. Her hand in my hair kept me bent over and running to keep up, and I wasn't turned loose until I was taken to another room in the house.

But I wasn't turned completely loose even then. The woman led me to a small frame that stood less than waist high on me, and then bent me over the top of it in a rounded depression. Claidon was there to buckle leather cuffs around my wrists, so that when the woman let my hair go, I was still bent over the frame and unable to straighten.

"Claidon tells me that he needs to get your attention," the woman said from where she'd moved behind me. "I think this will do the usual efficient job."

Again I had no idea what was being said to me, but unfortunately I quickly found out. I gasped when something smooth was inserted rather deeply into my bottom, and then the gasp turned to a scream. Something warm and wet was being poured into me, something that was extremely unpleasant.

"Oh, stop making so much noise," the free woman scolded as the warm liquid continued to fill me. "Warm water won't kill you, at least not where it's currently going. There, now to make sure it stays where it's been put."

The smooth thing was taken out of me, but something else was put immediately in its place. The new thing wasn't quite as smooth, but it was thrust in deeply between my nether cheeks.

"Now, that cork doesn't come out until Claidon says it can," the free woman told me, coming around to take me by the hair again. "I'd already begun to feel an awful need, one that wasn't caused by the desire of a man. "If the cork does come out without permission, the next time I put water in your bottom you'll be tied so that the cork *can't* be taken out. Then you'll be left in a corner for at least half the day, more than enough time to make you wish you'd obeyed the first time. Do you understand me, girl?"

"Yes, Mistress, I understand," I whispered, hurting from the way she forced me to look up at her.

"Good, so don't bother saying later that you didn't understand," the free woman told me with a smile of satisfaction. "Claidon, free her wrists."

The slave came forward to unbuckle the straps, and when I straightened I held to the form for a moment. I really needed to have that cork taken out, but all I could do was stand there and squirm.

"Now for the next thing you need to be told," the free woman went on. "Claidon has been put in charge of you, and you're to treat him as if he was free. You won't call him master, but you will do everything he tells you to. Let me see you kneel to him."

The slave stood watching me with folded arms and an amused expression, and kneeling to him proved to be very humiliating as well as uncomfortable. But I still had no choice about doing it, and once my head was bowed, the woman made a sound of limited satisfaction.

"Your idea of proper kneeling is just short of being improper, girl," the woman said. "But that's something else for Claidon to see to. Right now I want to hear you tell him that you were bad, and ask him to punish you."

"I – I was bad, Mas – ah – Claidon, so I'm … asking to be punished," I got out, feeling that I'd been more than punished by what had been put inside me. I couldn't keep from moving where I knelt, and the efforts of the warm water were even coming close to making me forget the growing need I felt.

"You've earned the punishment, so you'll get it," Claidon answered. "Right now, though, you have a lesson waiting, so get to your feet and follow me."

"And if Claidon needs to ask me to intervene again, girl, you'll regret it even more than you do now," the woman said as I struggled to my feet. "There's more than one way to handle a girl who's too full of herself, and none of them is pleasant."

"Yes, Mistress," I said as I hurried after the slave, keeping my eyes only on his feet the way I was supposed to. If I hadn't been so horribly uncomfortable, I would have been certain that what happened around me could be nothing but a nightmare…

Claidon led the way back to my room, and once we were inside he stopped and turned to me.

"We'll start with something simple," he said, obviously getting right down to business. "Look up now, and show me how you let a man know that you want to serve him."

I did look up at him, but only with confusion.

"I don't understand," I said, continuing to find it impossible to stand still. "The only one I ever served was my master, and for him I just had to be there. I can take the cork out now, can't I?"

"No, you can't," Claidon denied, nothing of sympathy to be seen in his expression. "You'll have to show me some real effort before I even think about letting you relieve yourself. Come closer, and find a way to let me know that you want to serve me – without putting your desire into words."

I moved closer to the slave, but hadn't the least idea of what to do next. The need to have that cork out was growing stronger and more urgent, which finally gave me the idea of stroking my hand down Claidon's arm.

"That doesn't tell me anything," the slave said at once with a dissatisfied headshake. "You could just as easily be trying to get my attention to say something. What you want to do is touch me with your body, and if I don't push you away you then

touch my body – but not my arm. You won't have any luck with making me want to use you with my arm."

A blush warmed my cheeks at the sarcastic tone he'd used, but I had to obey him. I stepped even closer and rubbed my body against his, and then I touched his manhood through the tunic skirt.

"You're not convincing me," Claidon pronounced after a very short time. "The movement of your body is supposed to tell me that I've aroused you, not that you itch and need a post to scratch against. And the movement and presence of your hand should be sensual and delicate, not clumsy and demanding. Try it again."

I wanted to whimper and stomp my feet as I bounced, but instead I tried again. And again, and again, over and over, until I stroked Claidon's body with mine and tickled his manhood with my fingers underneath his tunic skirt. I was only just able to understand the difference between what I'd originally done and what I'd been made to do when Claidon called a halt.

"All right, you've made a tiny amount of progress so we'll stop for a short while," he said, bringing me instant hope. "You still have a very long way to go, so don't think you've learned it all."

"As long as I can take this cork out," I muttered, immediately reaching behind me. There was a waste urn in one corner of the room that I hadn't seen earlier, but before I could hurry over to it Claidon took my arm to stop me, both from going and from touching the cork.

"Did you hear me say you could take the cork out?" he asked, looking down at me soberly. "I really don't think you did, because we still have another matter that needs to be taken care of before it's time to consider the cork."

"Oh, please, tell me what it is so I can do it!" I begged, tears starting to form in my eyes. "I'll die if I have to wait much longer!"

"No, you won't die, but that's a definite improvement in your attitude," he said, a bit of amusement showing in his light eyes. "What has to be taken care of is your punishment, the punishment you asked for. Come over here."

He moved a step or two away before folding to the floor in a sitting position, his hand holding an odd thing he'd taken from his tunic belt. The odd thing had been hanging on the belt, and looked like nothing more than a foot-long length of thin, narrow wood. I really had no idea what he meant to do, but I quickly got to my knees beside him. If he meant to humiliate me with a review of all my mistakes and lacks, I just hoped he didn't go on for very long.

"I doubt if I'll have to do much before you get the point," Claidon said as he took me by the arms and pulled me across his folded knees. "It wasn't hard to notice that Master Brazzan gave you a bit of discipline, which ought to make this punishment

even more convincing. From now on, any time you don't obey my orders quickly and completely you'll get more of the same."

By then I was very much afraid that I knew what he meant to do, and unfortunately I was right. He moved aside the tiny skirt covering my bottom, and then I howled at the first stroke of the thin wood as it hit my seat. Not only did it really hurt after the switching Brazzan had given me, but it made me even more aware of the cork bottling up my desperation. Without thinking I put my hand back to protect myself, but Claidon seemed to be waiting for the reaction.

"Sorry, little girl, but you won't be getting out of it that easily," Claidon said after taking my wrist and holding my hand and arm out of the way. "You need to know exactly what will happen if you misbehave, and also need to learn that disobedience won't be overlooked. For your own good I'm going to be very thorough."

For my own good...! But it wasn't very good when the second stroke reached my aching bottom, and I howled again even louder to prove the point. I was also forced to squirm around, more and more as the number of strokes increased. That thin strip of wood was on the flexible side, but that didn't stop it from hurting every time it smacked onto my bottom flesh. The ache in my seat turned into a fire, and the fire raged higher with every stroke. Tears ran down my face in streams as my bottom burned hotter and hotter, but Claidon just kept adding fuel to the fire.

By the time the punishment was over, I had nothing left in the way of control of myself. I cried sobbingly as Claidon lifted me from his lap and back to my knees, needing desperately to rub at my bottom. But Claidon held both of my hands once I'd been returned to my knees, and refused to let me rub.

"Have you been given permission to rub yourself?" he asked, a stern edge to the question as he held my wrists. "You know the answer to that, so stop trying to pull free. Doing something without permission will just get you another spanking. Do you want another spanking?"

I shook my head fast and hard, knowing I'd die if he put me back across his lap again now. But I wouldn't die, of course, I'd be punished a second time instead, even if dying was the better option. I felt completely miserable, and the continued presence of the cork made it all a thousand times worse.

"That's better," he said when I stopped struggling even as feebly as I'd been doing. "Now I want you to kneel there properly for a while, how long depending on how well you do as you've been told. You're not going to be allowed to get away with anything, and that's a lesson you've needed to learn for a very long time."

I put my hands to my waist and bowed my head, ignoring the tears that continued to flow down my cheeks – and the urgent need to remove that cork. I was beginning to learn the lesson Claidon considered so important, but there was another

thing I'd learned even more quickly. I'd never realized just how lucky I'd been to be with my old master, and I missed him terribly now.

My old master hadn't just given me things because of my beauty, he'd really and truly been more than fond of me. I missed that now, the awareness that I meant something special to someone, and the lack had turned more painful than what Claidon had done. I was no longer special to anyone for any reason, no longer thought of with a smile or touched gently. My old master was dead, and no one else cared anything about me.

I knelt in place for what seemed like a very long time before Claidon finally gave me permission to go to the waste urn. Once the cork came out, everything else inside me seemed to do the same. Once I was through at the urn I went back to where I'd been and knelt down again. With the greatest urgency finally taken care of I became aware of my need again, but pressing as that was it didn't seem to matter. I also wanted to cry again, but for some reason the tears didn't come. Maybe it was because I'd always hated wasting my time…

"I have to admit that you've made a good deal of progress with kneeling properly," Claidon said, the first words he'd spoken in a number of minutes. He'd made himself comfortable on my pallet, and studied me from there. "Are you thinking about the lesson I taught you?"

"Yes, Claidon," I answered tonelessly without looking up, giving him the response I knew he wanted. It would have been pointless to mention what was really occupying my thoughts, so I didn't.

"I'm glad to hear that," the slave said, his tone odd in some way. "Do you still believe that being beautiful gives you rights that others don't have?"

"No, Claidon," I said, really wishing I could cry. I would have traded my beauty – and anything else I could get my hands on – just to be back with my old master, but a frightening thought had come to me. Would my old master really have cared as much about me if I hadn't been beautiful?

It was possible he wouldn't have, and that idea left me absolutely desolate. Without my beauty I would have – and be – nothing at all, and I'd heard people say how quickly beauty fades. I'd laughed without feeling concern when I'd heard about beauty fading, but now I wondered how long it would be before I became that complete and utter nothing…

"Is something wrong?" Claidon asked after a short pause, the oddness in his tone having increased. "You don't seem to be the same girl you were just a few minutes ago."

"No, Claidon, nothing is wrong," I lied without hesitation. There was nothing that hadn't been wrong the entire time without my being aware of it.

"You're probably just reacting to the first real punishment you've ever had," Claidon decided aloud, his tone now sounding much more brisk and certain. "As soon as the pain in your bottom eases, you'll be back to telling me how the world should be run. With that in mind, let's return to your lessons before the reversion comes."

He got to his feet and came over to me, then had me also stand up. Being that close to him made my desire for his attention increase, but the urge seemed weighted down with the despair filling me. I was supposed to do as I had earlier, using my body and hands to show that I wanted his attention; I did want his attention, but I just couldn't make myself move the way I was supposed to. Claidon waited until I'd tried three times, and then his right hand captured my left.

"You're back to being nothing but a living block of wood," he scolded, displeasure clear in his voice. "What's wrong with you?"

"Nothing, Claidon, I'm sorry," I mumbled, trying to pull myself together. "I'll do it again and this time try much harder."

He made a reluctant sound of agreement and let my hand go, but my next attempt was worse than the previous ones. I didn't need to be told that, and this newest failure was just too much. The tears I'd wanted earlier came now on their own, and I crumpled to my knees sobbing with the terrible pain.

I suppose I expected Claidon to punish me again, but he knelt beside me instead and took me in his arms. I really needed to be held gently, but for some reason being held like that made me cry even harder. I sobbed so deeply that I thought I would break, and Claidon held me tight and murmured comforting sounds as I clung to him.

It took quite a while for the storm of tears to pass, and it left behind the heavy wind of shuddering and trembling. Claidon had been holding me with one hand to my back and one to my hair, and I heard him sigh.

"Are you feeling any better now?" he asked softly as he continued to hold me. "I'd like to know what brought that on, since it's fairly obvious you didn't start to cry on purpose just to manipulate me."

"It was nothing," I mumbled hastily, moving out of his arms and wiping at my eyes with the back of my hand. "I'm sorry I was so bad at my lesson, and I'll try to do better the next time. If you'll just give me another chance –"

"Girl, stop," Claidon interrupted, but his hands were gentle when they came to my arms to keep me from rising. "And I'm tired of calling you 'girl.' What's your name?"

"Meriath," I answered in a whisper, finding it impossible to look at him.

"Meriath, what made you cry isn't nothing," he told me in a firm voice that nevertheless was also gentle. "It's what's keeping you from doing the lesson correctly, and at the same time it's probably what's making you kneel in the proper way. Tell me what's changed you so much."

I didn't want to put my feelings into words, but he refused to let me stay silent. He alternated between ordering and coaxing until I nearly started to cry again, but instead of tears it was words that came pouring out. I admitted out loud the terrible pain filling me, and when I finally limped to the end of it he sighed again.

"I don't know how much of a favor I'm doing either one of us, but I have to tell you that you're not nothing," he said as he put a hand to my face. "It sounds as if your old master really did love you, but he's not the only one capable of feeling love. It may not seem like that to you now, but there are people on this ranch who can love. And when you find yourself loved again, you won't have to wonder if it's you or your beauty that's causing it."

"I don't understand," I said, still almost drowning in misery. "How can it be anything *but* the beauty causing it?"

"It won't be the beauty because you're not the only beautiful girl here," he explained patiently. "And it won't be simple physical attraction, because you and the others can be used by anyone who wants you. It's possible to get to the point of being … so used to beauty that you discount the outer appearance and look only for what's inside. I happen to know that from personal experience."

"But there's *nothing* inside me," I protested, really believing what I said. "How can anyone love someone filled with nothing?"

"It isn't nothing," he disagreed with a very tender smile. "If you were empty and not worth knowing, you would have cried about how badly you were being treated, not about no longer meaning something to someone. That difference in attitude makes all the … difference, and tells me you're more than worth knowing."

He leaned forward and gently touched his lips to mine, more of a reassurance than a kiss. For some reason I'd been expecting nothing but harshness from Claidon, and his gentleness was almost a shock. I stared at him, wishing I could find the words to tell him how much his help meant to me, and then I realized I didn't need words. Actions meant more, so actions he would get.

I looked into his face as I leaned toward him, gently brushing his body with mine. At the same time I put my right hand to his chest, then slowly stroked the hand down him until I reached his manhood. While cloth remained between us I barely touched him, simply letting him know that he'd been caressed. Then my hand continued to move down his thigh until it reached the bottom of his tunic, only then slowly beginning the ascent by going up the other thigh.

By the time I touched Claidon's manhood again, it had turned into his desire. His rod had stiffened almost magically, and when his hands came to my arms again they were no longer completely gentle. He pulled me closer with controlled strength, and the kiss he gave was no longer just a gesture of support. I opened my lips

to his demand, and he drank from my soul for quite a long while before raising his head again.

"I think you've learned this first lesson well enough to deserve a reward," he said, his voice faintly husky behind his smile. "We'll move to your pallet, and you'll show me if you were sincere about wanting to serve me."

He took my hand and we stood up together, and a few steps later we sank down onto the pallet together. My bottom was still tender from what he'd done to me, but I wanted him so much that I didn't care. He opened my shift and slid it off me, then began to kiss my breasts right where we knelt. I moaned as my body flared high with even greater desire, and held to his arms to keep from falling over.

At some point he lowered me to my back, but I was so deeply involved in the pleasure he gave that I only noticed when he entered me. I cried out as I clasped his welcome presence with my inner muscles, and then I joined him in moving to that rhythm that can't really be taught. It has to be first experienced from true desire, from your need to merge yourself with the man above you. When you feel that desire and need, all things become possible.

Claidon stroked me for a deliciously long time, and when release finally came it was something of a disappointment in spite of its glory. I hadn't wanted my time with him to end, but he didn't just withdraw and get up again. He took me in his arms and held me close, then kissed me gently on the forehead.

"That was very well done, but you look exhausted," he murmured, precious concern clear even with the softness of the words. "You've had a long, hard day, so get some sleep before we go on to the next lesson. Go ahead, close your eyes."

"Yes, Claidon," I murmured in return with a smile I felt all the way down to my toes. "I won't disobey you again."

"Of course you won't," he told me with a chuckle as I snuggled against him. His arms tightened to a wonderful snugness, and I was asleep before I knew it.

10

I woke up expecting to find Claidon still near me, but I lay alone on the pallet. Instead there was a girl in the room, standing near the second pallet. She was dark-haired and dark-eyed with a full figure, and was, without a doubt, beautiful.

"Well, it's about time you woke up," she said, her smile taking the sting out of the words as she closed her shift. "I'm about to go to breakfast, so I almost woke you. I'm supposed to tell you to stay here rather than go with me. You aren't allowed to walk around alone yet."

"All right," I said instead of arguing, which had been my first impulse. "Do you have any idea how long I'll have to wait? I seem to have slept through supper last night, and I'm starving."

"Claidon will probably be by as soon as he's finished eating," the girl answered with a small shrug. "He's the decent sort, and anything he does to you is usually for your own good. It took me a while to learn that, but it really is the truth."

She gave me another smile before heading for the doorway, and I couldn't help but notice how gracefully she moved. It was almost as if she were a walking invitation, and that without any men being present. I wondered what she did when men *were* around…

I got up and used the waste urn, then put on my shift and tied it. Then I sat down on my pallet to wait, but quickly changed my mind. Sitting wasn't all that painful any longer, but it still wasn't completely comfortable. Claidon hadn't held back much using that wooden strip on me, and that on top of what Brazzan had done made it a much better idea to wait lying on my stomach. Time dragged by while my empty insides rumbled their protest, but finally Claidon walked in carrying a bowl.

"You have no idea how good it is to see you, and for more than one reason," I said with a smile as I got to my knees on the way to standing up. "I'm so hungry I could eat this pallet."

"Meriath, you're misbehaving," Claidon said in a warning tone, stopping me before I stood. "What position are you supposed to take when you see me?"

"Oh... I forgot..." I answered lamely, quickly putting my hands to my middle and bowing my head. I'd been told that Claidon was to be treated as if he were a free man, and he'd probably comforted me the day before because that would make training me easier. "Please forgive me, Claidon."

"I'm allowed to overlook one small mistake at your stage of training," he said as he came closer to where I knelt. "But that's *one* mistake, which means the next one has to be punished. And I know you're hungry, but that's the way you're supposed to be."

I didn't understand that, but I also didn't ask. I hadn't been given permission to speak freely.

"Today you get to eat as a reward for performing properly," Claidon said, now sounding more pleased than he had. "You won't find any of it easy this first time, but if you do well your hunger will be completely satisfied. For the moment, raise your head."

I did as he said, and he crouched in front of me to put a wooden spoon to my lips. The spoon had porridge on it, presumably from the bowl, and if the porridge wasn't hot it was at least still warm. It was humiliating to be fed like that, but I still emptied the spoon each of the four times it was offered to me. After the fourth time Claidon put the spoon back into the bowl and then put the bowl aside.

"That's all I'm allowing you right now," he said, his hooded gaze studying me closely. "When you do as well as I know you will, you'll be allowed more to eat."

"Yes, Claidon, thank you," I said, lowering my head again. The four swallows of porridge I'd had weren't nearly enough, but arguing wouldn't have done the least good.

"Now you're doing it just right," he said, giving me an approving pat on the head. "Stand up and follow me."

I had to swallow down a small bit of anger, but I still got up and followed him out of the room. I hated being treated like a trained pet, but that's all I really was to the people in this household. So I continued to follow Claidon in the proper way without vocal protest, and was taken to a room not far from where I'd slept.

"You can look up now," Claidon said. When I did I saw a room with a wide bathing tub sunk into the floor, and two female slaves standing near the tub. The slaves wore thin skirts and blouses rather than shifts, and neither one of them was particularly attractive or what might be called slender.

"These girls will bathe you and wash your hair," Claidon said with a gesture toward the two. "After this first time you'll be responsible for bathing and washing yourself, so pay attention to how thorough they are. All right, go ahead."

The two came forward to where I stood, and a moment later my shift had been taken. Then they guided me to the tub, or possibly I should say they moved me

toward it without waiting for me to do it myself. I was "helped" into water that was decently hot, but the pleasure of it didn't last long. Both women took up brushes that weren't quite hard enough for scrubbing floors, but the things were certainly hard enough to scrub *me*.

After wetting me thoroughly, the women poured some liquid soap on my body and then began to scrub with the brushes. They washed everywhere, and everywhere included my breasts and even between my legs. I whimpered a little and tried to move away when one of the brushes paid too much attention to my bottom, but that proved impossible. Each woman held to one of my arms, and they made sure to keep me just where they wanted me.

They kept up the "bathing" until I thought I'd have no skin left, and then they sat me down and one of them washed my hair. At least that part of the process felt good, but as soon as the soap was out of my hair I was pulled from the tub and wrapped in towels. The two women were brisk about wiping me dry, especially when it came to my hair – which needed drying the most.

The towels that had dried me were put on the floor, and I was made to kneel on them. Then one of the women brought over a small jar and the other a comb. While the one with the comb started on my hair, the one with the jar dipped her fingers inside it and brought them out covered with a white cream of some sort. The cream was then put right into my womanhood, making me straighten with a gasp over how cold it felt. That same woman dipped her fingers again, then did the same to my rear. I gasped and straightened a second time, but then it was over.

"You'll soon be glad to know that you're almost ready to get on with things," Claidon said as he crouched to my left, his expression serious. "That cream is kept on the shelf near the soap, and you're to use it any time you feel you need it. You'll know when that is, and how well you can rely on its help. In the meantime, keep firmly in mind the fact that you aren't permitted to touch yourself in any way."

I didn't like the sound of that, but didn't bother to ask what he was talking about. I knew I'd soon find out all about it, and I wasn't wrong. The woman combing my hair was still at it when I suddenly felt a faint itching between my legs and inside my bottom. I squirmed a little, trying to take care of the itch without using my hands, but the movement didn't work. The itch intensified only a little more, but that still left me feeling more than a small bit uncomfortable.

"You're doing fine, so keep on doing it," Claidon said encouragingly, putting two of his fingers to my cheek as I closed my eyes for a moment. "You're going to serve some of the men today, and the first time is always hardest for the girls. The cream will make you eager rather than nervous, and will also keep you from being hurt from overuse. We'll be getting started with it in just a few more minutes."

I didn't think I needed his support and encouragement when he had to be only pretending, but I soon discovered it was more of a help than I'd expected it to be. The woman combing my hair took her time about finishing, and my hands had turned to fists before she was through. I needed a lot of brisk rubbing to take care of that itch, and I'm sure she took her time because she knew that and wanted to make it worse for me.

When Claidon ordered me to follow him again, I knew it was to keep me from offending the two women even with a nasty look. I would have enjoyed glaring at the two on my way out of the room, so it wasn't a very happy slave who followed with her head down.

"I can almost hear you muttering under your breath, so stop it," Claidon murmured after slowing down enough to put me only a step behind him. "If you'd given those women any excuse at all, they would have asked to have you disciplined by one of the masters. They enjoy doing that to new girls, so consider yourself lucky that you didn't give them an excuse."

He moved back to the proper distance ahead after saying that, leaving me to squirm from more than the itching. Claidon's concern must have been for nothing other than doing his job right, so why did it have to seem like more…?

I was led through back halls of the rather large house, aware of the fact that Claidon glanced back at me a time or two. I don't really know where I expected to be taken, but walking into an empty room with a door did come as a surprise. Adding to the surprise was the fact that Claidon waited until I was inside and then closed the door himself. It would have been more… proper if he'd had me do the closing, but then he added even more surprise when he suddenly took me by the arms and shook me.

"Meriath, do you really want to work your life to an early end in some farm's fields?" he demanded in a hiss, startlement forcing me to look up at him. "The masters aren't sure whether or not you'll ever be useful here, so if you don't learn what you need to it won't be me who's blamed. Do you think you can forget your anger long enough to really understand what I just said?"

"How… did you know I was angry?" I asked, the only question I could put with abrupt confusion swirling around me, and then I thought of another. "And why would you care what happens to me?"

"From the way you're holding yourself, even someone who was mind-damaged would know you're angry," he answered, and at least he stopped shaking me. "The men you serve will also know it, and then the master will be told. "No one will expect you to be accomplished yet, but you should be showing a certain eagerness to do as you're supposed to. If you're angry and bitter instead of eager, you'll never show the kind of attitude the masters want and you'll be sent away. Do you want to be sent away to slave in the fields by day and some farmhand's bed by night?"

"No," I muttered, more than aware of the way he'd neglected to answer my second question. "But what difference does it really make? On a farm I'd mean very little, but here... Here I don't even mean that much, not when the men have their choice among lots of pretty girls. Maybe I *should* ask to be sent to a farm. That way the whole painful mess would be over much more quickly."

"You mean you'd be dead," he stated, and anger suddenly flared in his light and beautiful eyes. "Now you've done it. Kneel to me, slave!"

His anger was frightening, so much so that I quickly got to my knees in the proper position. A moment later he was seated cross-legged in front of me, but when I saw him holding that slim wooden paddle I didn't even have the time to grow nervous. The next heartbeat I was pulled face down across his lap, and then he'd pulled up the skirt of my shift and was applying that strip of wood to my bottom.

"I never want to hear you say something like that again," he growled, spanking me really hard. "If you do you'll know what to expect, a paddling of at least twenty strokes."

My old master had gotten a lot of pleasure out of teaching me how to count, but at the moment pleasure was nowhere in sight. I wailed and squirmed at every stroke of that paddle, finding the former discomfort in my seat quickly growing to an ache. I nearly spoke out when Claidon reached a point that should have been the twenty strokes he'd mentioned, but I wasn't quite that stupid. I endured an additional three swats of the paddle, and then Claidon paused.

"Is that twenty strokes, slave?" Claidon asked, his tone still filled with anger. "Answer me quickly."

"It is if you say it is, Claidon, and it isn't if you say it isn't," I told him at once, giving the answer I knew he expected. Confusion tossed me around so badly that I almost put my hand back to rub at my bottom, but some vestige of caution kept me from adding to whatever I'd done to earn the punishment.

"It delights me to see that you know who's in charge," Claidon said, something of anger still to be heard. "I say that we're five short of the twenty, so I'll give them to you now. What do you say?"

"Thank you for correcting me, Claidon," I whispered, the only thing I was permitted to say. I wanted nothing of another five strokes of the paddle, but five was better than fifty or more.

"You're completely welcome," Claidon answered, and then he proceeded to give me the rest of the correction. Each slow stroke of the thin paddle slapped hard against my bottom to make me gasp and squirm, but at least there were only five of them. After the fifth, Claidon took me by the hair and moved me back to kneeling.

"Are you ever going to mention being dead to me again?" he demanded as I kept my gaze properly down. "Are you ever going to even think about wasting your life?"

"No, Claidon," I lied in a whisper, fighting hard not to cry. His pretense at caring was more painful than the spanking he'd given me, but I didn't mention that.

"You'd better not," he growled, and then the growl disappeared. "If I happened to be a free man I'd tell you that you've become the most precious thing in my own life, but I'm not a free man and you're not free either. For that reason all I can do is my duty, and make sure that you do yours as well. If you were sent away, I – don't know what I'd do."

I shouldn't have looked up at him then, but I simply couldn't help myself. It hadn't occurred to me that he couldn't speak out about his feelings because he was as much a slave as I, and I didn't know what to say. Not that there was much I *could* say, considering the circumstances.

"I take it from your expression that you may now be willing to do your best at the task assigned you," Claidon said, putting a gentle hand to my face. "Am I correct?"

I nodded to acknowledge that, the gesture necessary in the face of the difficulty I found in speaking. I wanted to throw my arms around his neck and beg him to hold me, but I knew without needing to be told that this wasn't the time or the place.

"Good," Claidon said in approval, his nod on the grave side as he took his hand back. "You would have been happier seeing to the task without a sore bottom, but even that should help you. Just remember that if you perform well enough to please the men, your life here will be rather pleasant. You'll have a clean, dry place to sleep – if you aren't told to spend the night with someone who has earned an extra reward – and you'll have plenty to eat from a variety of decent dishes. There are a lot of free men and women who can't claim a life with benefits like those."

I nodded again, unwilling to argue even if he would have permitted it, and this time the nod made him smile.

"Then let's get on with it," he said, rising to his feet. "Once this task is over and done with, I'll be able to get on with training you more completely."

I also rose to my feet, then followed Claidon out of the room. The faint itch from the cream was still with me, so getting to the task was something I didn't mind in the least.

We hadn't been far from our destination, so we entered another room only a short way down the hall from the one we'd stopped in. I knew at once that there were others in the room even if I couldn't see them with my head down, so when Claidon snapped his fingers I quickly knelt in the proper way.

"Yes, that one will do," a strange male voice said, one I was certain belonged to a free man. "This is the sort of girl you'll be permitted to use, men, assuming you work well and please your taskmasters. Once you earn the privilege you won't lose it again, unless you do something to earn punishment. Do you like the looks of her?"

"Yes, master!" came in more than one male voice, a hearty agreement with laughter behind the words.

"This first time you'll only be allowed a partial taste of her, as an incentive to do your best and earn complete use," the free man went on with a chuckle. "You must also be careful not to damage her, now or in the future. A damaged girl is a loss to all of you, so every male slave on the ranch is alert for one of their number who might restrict their privileges with misuse. Remember that, and you won't have any problems with your fellow slaves."

The agreement this time was more restrained but still strong, which should have been encouraging to me. In a definite way it *was* encouraging, but I'd realized something that took much of the pleasure out of everything else. The men in the room weren't to be allowed full use of me, and that had to mean –

"All right, girl, shift to your hands and knees, now," the free man directed briskly. "If you like you can lean down to your forearms, but don't lie flat."

I moved to my hands and knees without looking up, but didn't lean down any farther. The free man directed the first slave over to me, making him pause to grease himself before allowing him to begin. There were three of the slaves and the time wasn't too bad, not when I needed the rubbing they gave. There just wasn't much in the way of complete pleasure, but there was definite relief when I was ordered back to kneeling.

"All right, men, you can go to your assigned chores now," the free man told the others. "Now that you know what obedience and hard work can earn you on this ranch, your efforts should be a match to those of the rest of our slaves. And once you've earned the privilege of full use, you can try to earn the added reward of a full night with one like her. That takes really special effort, but it's far from impossible. Think about it."

The very restrained acknowledgment from the slaves said they were already thinking about it, and then I heard them leaving the room. Once they were gone, the free man made a sound of amusement.

"It won't take them long to earn full privileges," he said, probably to Claidon. "Not that it takes *any* of the slaves very long. Everyone wonders why Lord Espelle has so little trouble and so great an amount of work out of his slaves, but only because they refuse to see what's right in front of their eyes. As long as they keep the pretty ones for themselves, they'll never do as well as we do here. All right, boy, you can take her to

where the others are waiting now. Tell Brazzan that she squirmed well enough to do the job right."

"Yes, master," Claidon acknowledged in a very neutral voice. "On your feet and follow me, girl."

I rose quickly and began to follow Claidon, but the free man spoke again before we were out the door.

"Oh, and check back with me after supper tonight," he ordered Claidon. "If I haven't been put in charge of the first shift for one of the night crews, I want her brought to my quarters at bedtime. One of the nice things about my job is that I don't have to *earn* having her for the night."

"Yes, master," Claidon said again, and then we were back in the hall. If Claidon hadn't sounded very happy with the last of his orders, my own reaction was a good deal more intense. I wanted to spend the night in Claidon's arms, not in those of a stranger…

But we hadn't been given the choice, so we simply moved on down the hall until we came to another room. This one was also occupied, and when we walked inside I heard a voice I recognized.

"Ah, Claidon with the girl Meriath," Brazzan's voice came, sounding pleased. "You men are lucky to exercise your newly earned privilege with a girl as pretty as that. She isn't fully trained yet, of course, but is that really going to bother you?"

"No, master," came with laughter in two different voices, voices that sounded extremely eager.

"I didn't think it would," Brazzan said, still sounding amused. "Step forward, girl, and look at the men who have earned the right to have you serve them."

I stepped forward as ordered, then looked up at the first of the two men who stared at me. The man was ordinary in looks and build, but the hunger in his eyes was far from the same. His very obvious desire made my body flare, but it was still all I could do to smile at him. The smile was for Claidon's sake, to show that he was doing his job well, and the effort turned out to be effective. The second man was just as plain and just as hungry, and my smile seemed to add to the hunger in both of them.

"That's not bad for a beginner," Brazzan said, and I assumed he meant my smile and the way I held my body. "Let's see what else you've learned, girl."

I walked closer to the first of the two slaves, and then I moved my body against his in the way I'd been taught. I let my left hand tease its way down the man's body, but it never reached its ultimate objective. The slave grabbed me by the arms, then looked imploringly at Brazzan.

"Master, please let me take her now!" he begged, his hands painfully tight around my arms. "Your permission, master, please!"

"Go ahead," Brazzan granted his request with a small laugh, and the slave didn't hesitate. He threw me to my back on the floor, and an instant later he was between my thighs and fumbling at my womanhood. In spite of the need his desire had bred in me, I didn't enjoy his sudden thrust inside me. He immediately began to stroke hard and fast, and it wasn't long before his release came. Mine came right after his, but again it wasn't the pleasure it should have been.

The second man had been granted a nod from Brazzan, so as soon as the first left me the second was in his place. The second took longer, making me squirm from the ache in my bottom, but that just seemed to add to his pleasure. He also reached climax and brought about my own, and when he rose to his feet I lay still for no more than a moment before kneeling in the proper way. The itch was gone from me entirely, but that was the best that could be said for the episodes.

"Congratulations, men," Brazzan said to the two, who had been smiling with satisfaction before I looked down and away from them. "You have now been officially granted your privileges, so go and enjoy them. But don't get sloppy in your work habits, or you'll lose the privileges a lot faster than you earned them. From now on, you need no one's permission to enjoy one of the girls."

"Thank you, master," both of the men said with what sounded like real gratitude, and then the two were leaving the room. Brazzan, like the other free man, waited until they were gone, and then he laughed.

"You've also earned congratulations, Claidon," Brazzan said warmly. "The girl is still on the clumsy side, but she now shows real promise. And in addition to that, she's also kneeling properly. How many times have you had to punish her?"

"Only twice personally, master," Claidon responded in the neutral voice that was becoming usual with him. "She really is beginning to come around, and I expect you to be pleased with the results of her efforts."

"I'm sure I will be," Brazzan agreed, and I heard a sound as if he'd clapped Claidon on the shoulder. "Keep up the good work, and let me know if there are any problems you need my help with."

"Yes, master," Claidon said as the free man strode to the door and out, leaving us alone. "All right, girl, now you can follow me back to your sleeping room."

I got to my feet and did follow him, and he stayed silent the entire way. My thoughts swirled so badly that I almost didn't notice, and his turning to me came as something of a surprise.

"You did very well, girl, and I'm proud of you," Claidon said with a sigh as I knelt after belatedly noticing that we were already in the room. "Just keep up the same good work, and everything will be fine."

"Will it?" I asked, surprising myself by speaking the words aloud. "The masters told all those men what they would get if they worked hard and obeyed

orders, but I seem to have missed what reward I would get if *I* did the same. Or is the reward one of being allowed to continue to serve everyone's pleasure but my own?"

"Your reward is not being sent to the fields and the beds of farmers," Claidon said as he crouched in front of me to take my face in his hand. "I thought we had that part of it straightened out."

"I thought we did too, but part of me seems to have a mind of its own," I said as I gazed at him sadly. "I might be able to learn to do what they want me to, but I'll never be able to *keep* doing it. They aren't being fair, and I find I can't forgive them for that."

"They don't have to be fair, not when they're free and we're slaves," Claidon countered, his expression one of disturbance. "Can't you be satisfied with what we'll be able to find from time to time together? If we aren't too obvious about it, the masters will let it continue without punishing us."

"If that's enough to satisfy you, I envy you," I said, really meaning the words. "I can't imagine that it will ever be enough for *me,* so there's no sense in prolonging everyone's misery. Take me to one of the masters now, and I'll tell him that I refuse to spend my life serving men until they no longer want me. Maybe he'll be kind enough to kill me rather than send me to a farm."

"Meriath, no!" Claidon cried, throwing his arms around me and holding me so tight that I had trouble breathing. "I somehow knew you would never be able to – Please, you promised to obey me and never to speak about dying again! Do I have to punish you for lying?"

"I think you also know that punishment won't change my mind," I whispered, holding him as tightly as he held me. "I want to be with you always, Claidon, but I was wrong to think even for a moment that I could face the sort of life they have planned for me. Most likely it would only be for a few years until my beauty faded, but what would happen if that beauty didn't fade fast enough? Even a few years would seem like a lifetime, so the thought of it going on even longer... I just can't face it."

Claidon said nothing as he clung to me, and I felt like crying my heart out. I'd only just met him and had even more recently discovered what he meant to me, but my trying to do as the masters wanted would only make things worse for him. He would try to excuse my lack of progress and eagerness, an action that would do nothing more than earn punishment for him. I couldn't let that happen, no matter what the price.

"All right, then there's only one thing to do," Claidon said suddenly, as though making up his mind aloud. He leaned back to look me straight in the eye. "We have to run away from here. If we're careful and very lucky, we can lose ourselves in the deep woods where they'll never find us. Are you brave enough to try?"

"It's better than just letting them kill me, but what do you mean we?" I asked, suddenly aghast. "You don't have to risk your life, and I don't want you to. You can tell me where to go and what to do, and I can – "

"And you can get lost or be found immediately," he interrupted with an impatient gesture. "No, I'm going with you, and there isn't any risk involved. Without you I have no life, so staying here alone would be pointless. We'll leave right after lunch."

Claidon's mention of lunch made me remember how hungry I was, but I didn't have long to wait. Claidon went and brought the food back for us to eat in the room, and afterward we "practiced." I would have been happy if I did nothing else in my life than give him pleasure, and Claidon seemed to feel the same about me. We enjoyed each other thoroughly, and then it was time to go.

Just about everyone was still in some dining hall eating, so we were really optimistic about our chances of getting away. We walked along briskly at Claidon's suggestion, letting anyone who happened to see us think we were on our way to a job we'd been given. We made it away from the vicinity of the houses and barn and other buildings and even across a field, and as soon as we reached the woods we began to run.

It wasn't easy running through the woods, but we kept it up for hours. When we couldn't breathe any longer we were forced to stop for a rest, but the excitement hadn't died in either one of us. I glanced around at the clearing we'd stopped in, seeing the way sundown was almost upon us.

"Once it gets dark our chances will be even better," Claidon said after a moment of simply breathing. "These woods aren't very deep, but the real thing shouldn't be too far away. We'll keep going all night, and when morning comes – "

"When morning comes, you won't be able to see it," a terribly familiar voice said, and then there were men stepping out of the trees all around us. The one who had spoken was Brazzan, and he laughed without humor when Claidon stood himself in front of me.

"Being so protective of the girl was only one of your mistakes," Brazzan said, stopping a few feet away to lock eyes with Claidon. "You shouldn't have fed her quite so well at lunch, not at her stage of learning. And you also shouldn't have believed the rumors you heard. Most of our slaves have no interest in running, but for the few who do we let it be known that the 'deep woods' is where they have to run to. Actually, there *are* no deep woods, but there *is* a road that circles around. It let us get here on horseback ahead of you, to give you a proper greeting when you arrived."

"This wasn't his idea, it was mine," I said, trembling with fear but still refusing to be silent as I looked at Brazzan around Claidon. "If you're going to blame anyone, it has to be me."

"Oh, I won't be blaming him," Brazzan said with a smile in my direction. "I'm going to be hanging him, as an example to anyone else who might be thinking of running. You I'll deal with when we're back at the ranch."

I screamed then and tried to hold onto Claidon so they'd have to hang me as well, but men came forward to pull us apart with rough, uncaring hands. Claidon, gray-faced, also refused to let me go with him, shouting something about doing whatever was necessary to stay alive. I fought whoever held me as others dragged Claidon to a tree that already had a rope dangling from it, and I couldn't stop screaming.

"No, don't kill him!" I shrieked, struggling so madly that a second man had to come over to help the first hold me. "I'll do anything you say if only you don't kill him!"

"You'll do anything I say anyway," Brazzan told me calmly from where he stood, watching his men start to put the noose around Claidon's neck. "Slaves don't bargain with free men, not about anything at all. Stand there quietly now and watch the fool die, and know that his death is *your* fault. If you'd done as you were supposed to, he would still be at the ranch living well."

The men holding me tried to force me to watch what the others were doing to Claidon, but I closed my eyes tight and refused to do it. Brazzan had said Claidon's death was my fault, and the horrible words kept ringing over and over in my head. At first I tried to deny that awful accusation, but then I sobbed as I knew it for the truth it was. The man who had begun to mean so much to me would die because of me, and I simply couldn't stand it. I began to scream again, a wordless demand for my own death that went on and on and on and –

"No, no, child, you shouldn't still be demanding things," a deep voice said near Meriath, making her frown even as she almost awoke. "I had such high hopes for this experience, but apparently you haven't learned as much as I wanted you to. I'm afraid we're just going to have to try again."

Meriath tried to struggle against the gentle arms holding her, desolation and loss filling her with terrible pain. She couldn't seem to wake up enough to know why she felt like that, but she still continued to struggle. She had to do something for someone, but the darkness enveloped her too fast for the matter to come clear…

11

I didn't so much wake up as become aware of my surroundings, which were definitely strange – as was the sudden awareness. I seemed to be walking through a cave of sorts, all gray stone walls that looked to be chewed out of the rock rather than dug out. A greenish glow came from those stone walls, not enough to see things clearly, but enough to let me tell where I walked.

And the next moment I remembered where I was, a memory that briefly turned me cold with fear. I was one of those who had been chosen for the great honor of being sacrificed to the Beast, to keep him from coming out of his labyrinth and devouring everyone. My death would prevent the deaths of many, many others, and my family would be honored for my personal sacrifice.

I stopped in the rough passageway I walked to make a sound of derision. If our people had gotten together and armed themselves, our "great sacrifice" would have been unnecessary. But it's easier to "honor" the families of those thrown to an uncaring beast than it is to stand up for yourself with the strength of your own arm and courage. And even easier than that is to drug the victims of your cowardice so that they don't understand what's being done to them...

That last thought told me why I seemed to have awakened on my feet, so to speak. I'd been drugged just like the others, to keep me docile until I became some monster's meal. But I'd awakened before being discovered, and that might help to keep me alive. If I could only figure out what to do... I was clearly deep in the labyrinth, but hadn't a single memory about coming as far as I obviously had. Without that, how could I find my way back out?

I looked around again where I stood, seeing nothing new. The craggy gray rock was beginning to be depressing, but it was much too soon to give up. I thought it might be a good idea to retrace my steps as far as possible, and was just about to turn around when I heard a faint sound from a short distance ahead of me. At first I thought it might be the Beast and almost started to run, but then I realized that the sound was more like crying.

The idea of crying in the labyrinth piqued my curiosity, so I moved slowly ahead until I heard the sound more clearly. I still saw nothing but the rock, but the crying guided me to a place where the ragged stone of the wall to the right... folded into what might be a crevice or nook. I looked more closely and sure enough, there was a very narrow opening behind the fold.

Squeezing through the opening was a bit difficult, but in a moment I stood in what looked to be a pocket in the cave wall. The crying came from two girls who huddled together, a short distance away from a group of five older girls. The older girls seemed to be sharing something to eat, which struck me as odd. All of them wore the same white skirt and vest I also had on, but the outfits of the older girls looked dingy, worn, and downright dirty compared to what the crying girls and I wore.

"Well, well, another newcomer," one of the older girls said as she got to her feet and moved a step away from the others. "Come closer, girl, so I can see whether or not we'll let you join us."

"Who are you that I might want to join you?" I asked, but still moved closer as directed. "And why are those two crying?"

The closer I got, the more familiar the two crying girls looked. It finally came to me that the younger girls were those I knew slightly from the city, so they must have been sent into the labyrinth at the same time I was.

"I'm Listia, the leader of this group," the girl who had spoken before informed me haughtily. "And it doesn't matter whether or not you want to join us. If you can't be of any use to us, like those two over there, you won't be allowed to stay. We know how to survive down here, but if you're useless you don't get to join us."

"And what makes someone useful or useless?" I put next as I stopped only a few feet away from Listia. She was a very pretty girl with dark hair and eyes and a really good figure, and I had the impression that the other four behind her were almost as attractive.

"Whether or not you can earn food and protection is what makes you useful or useless," Listia responded, now studying me carefully. "The two things are connected, you see, but those two over there will never be protected or earn food. You, though, are another matter entirely, which leads me to wonder why the priests would let someone with your looks be sacrificed."

"I suppose the chief priest disliked the way I refused his... 'offer' of personal protection," I told her, making a face as I remembered the time. I'd kicked the slimy old man where it had hurt him the most, refusing to let him put his damp, claw-like hands on me. He'd almost been drooling, and my kick had nearly made him choke on the drool.

"I was a late bloomer, so I was never made the offer," Listia said with a wry smile. "I would have accepted immediately, of course, but I didn't get the chance. Now

I get to spend the rest of my life in this cave, but that's better than dying. Especially when I have so much to bargain a better life with."

Listia smiled and smoothed her dark hair, the gestures showing she meant her beauty. My first thought was that she was right to use her beauty to get what she wanted, but something inside me immediately disagreed. I didn't quite understand why, but instead of thinking about it I changed the subject.

"Why would you have to spend your life in this cave?" I asked. "I was about to try to find my way out when the crying led me to your... haven. It might take a while to find the way, but if we got in then we can get out again."

"And then do what to get past the guards?" Listia countered immediately. "They have guards stationed outside to cut down anyone trying to get out again, and I know that for a fact because I saw it happen. They don't *want* us to get out again, so it's stay in here or die at once."

That made a disgusting kind of sense. The priests used the yearly sacrifices to control the people, and the people were too backward to take matters into their own hands...

"So you might as well join our group," Listia continued with a gesture toward the other four girls behind her. "You'll do really well as long as you remember that I'm the leader, and what I say goes. The first thing you'll need is protection, but there's no sense in wasting the time. I'll bargain us some food before I let them have you, and then we'll – "

"Just a minute," I interrupted, understanding nothing of what the girl had been saying. "You're leaving out a few details that I need to follow what's going on. What does this protection consist of, who does the protecting, and how does food enter into the whole thing? And for that matter, what makes those two girls over there useless?"

"I don't have to tell you anything, but I'm the mood to be nice," Listia said with a toss of her head. "The information should also help you to adjust more quickly, which will be to my benefit, so here it is. You know that it isn't just girls who are sacrificed, but boys as well, don't you? Well, some of those boys survived to become men, and they're the ones who make you protected."

"I think I'm beginning to see," I murmured, something of an understatement. "The Beast insists on having virgins, so anyone not a virgin is protected. So where do the boys – the men – get the food?"

"There's an entrance to the labyrinth where people leave the Beast gifts of food and drink," Listia answered with a shrug. "The boys found it early, and they won't tell anyone else where it is. But they *will* trade for some of the food and drink, after they've agreed to protect a girl the first time. They won't protect every girl, only the ones they find acceptable, and those two over there won't even be considered. But

that's all right. The Beast has to have *some* virgins to keep him quiet and away from the rest of us."

I turned to study the two sobbing girls briefly, seeing again how plain they were. They hadn't been blessed with beauty, so the... survivors in the labyrinth didn't consider them worth saving. Again I had the feeling that at one time I would have agreed with the idea, but right now I didn't.

"It's too bad that the Beast doesn't have a taste for the shallow instead of for virgins," I commented as I looked back at Listia. "That would be one way he could make the world a better place to live in. If those two girls aren't good enough to join you, then neither am I. And I'd rather be swallowed whole than nibbled to death a little at a time. That isn't my idea of living."

"You're a fool," Listia pronounced with a sneer and a laugh to match. "You could have survived as one of us, but now I won't even let you stay here in our haven. I want you out, right this minute."

"How clever of you to order me to do something I'd already decided to do anyway," I said, giving her a faint smile. "It makes you look good to the fools who are stupid enough to follow you. Tell me, Listia, don't they ever notice that you bargain *their* use more often than you bargain your own? Or don't they understand why you do it until they find themselves with babies growing in their bellies? You must push them out really fast when that happens, before the others catch on."

"There's nothing for anyone to catch on to," Listia snarled, her expression making her a lot less beautiful. "You get out of here right now, or – "

"But of course there's something for them to figure out," I interrupted to disagree. "Once the girls get pregnant, there's a virgin life inside them. That would make them immediately vulnerable again, and not in a way that the boys' 'protection' can change. That's why you risk your followers more often than you do yourself. You're interested in nothing more than saving your own worthless hide."

The girls behind Listia began to mutter in a disturbed way, but Listia herself was livid. She began to scream curses at me, her voice growing louder and shriller when I turned away from her with a shrug of disinterest. I didn't care how unhappy I'd made her, not when her reaction proved that everything I'd said was true. If the other four girls weren't complete fools, they'd leave her to betray only herself and find someplace else to stay.

I stopped near the two crying girls on my way out, willing to let them come along with me. But they turned out to be too afraid to leave the safety of the nook even if they did have nothing to eat or drink. They might change their minds later – or they might be forcefully ejected – but for now they couldn't bring themselves to leave. I wished them luck with a sigh, then went back to the narrow opening I'd come in by. They'd decided to put off the terror as long as possible, but I'd decided the reverse.

Once I was back in the uneven stone corridor, I continued on in the direction I'd been going. Turning back and finding my way out had become a useless effort, and not just because Listia had said it was. I'd seen armed guards at a labyrinth entrance myself once, before I'd been chosen as a sacrifice. Their presence had seemed odd at the time, but everyone had refused to talk about those guards. Now I knew why everyone refused to talk about them...

So I'd made up my mind to get the unpleasantness ahead of me over with as quickly as possible. I could remember a time when life was of intense and all-encompassing interest to me, but for some reason that had changed. I felt sad and lonely on the inside, not to mention wounded deeply, and although I had no idea why I felt like that, there was no doubt that I did. Ending the pain had become my new interest, and wandering around aimlessly ought to accomplish that fairly quickly.

The caves weren't called a labyrinth for no reason. I walked from one corridor into another at random, picking the way that appealed to me most when a choice was offered. And the choices were offered rather often, with the stone corridors branching off in many different directions. At one point I thought I heard the sound of male voices, and made sure to turn in the opposite direction as soon as possible. Protection was the last thing I wanted right now...

I wandered around for a good deal longer than I thought I would, but bad luck changed to good when I rounded one curve and saw my objective just ahead. The Beast walked in the same direction I did, which meant I saw him before he saw me. My insides lurched a bit at the size of him, bigger than most men and heavily muscled around the cloth wound about his waist, but I refused to back down from my purpose.

So I hurried my pace a little to catch up with him. I had no idea where he was going, but he certainly ought to be willing to stop for a short snack. His hair was long enough to hang below his shoulders in back, and it swung with his movement when he suddenly stopped and whirled around. His face... I'd believed the stories that said he had the head of a bull, but that wasn't completely true. He did look a lot like a human bull, but that seemed to be nothing more than extreme ugliness.

"Who are you, and why are you following me?" he demanded as soon as he saw me. "If you were thinking about jumping me from behind, you should have found a weapon first."

"Of course I was thinking about jumping you from behind," I answered dryly as I walked up to him, staring up into his dark, puzzled gaze. "But why would I need a weapon? I'm so much bigger than you that looking for one would be a waste of effort."

"Good point," he agreed in a less intense voice, sudden amusement in those dark eyes as he folded his massive arms and looked down at me. "You clearly have me at your mercy just as you are, so how about answering my question about why you were following me?"

"I'm... not in the mood for running and screaming and crying, so I... thought I'd... do something to make all that unnecessary." For some reason I felt a bit foolish about the decision I'd made, but I still wasn't prepared to abandon it. "You *are* the one who does the devouring around here, so who else would I follow?"

"Most of the others seem to prefer to follow the small groups that have made homes in my domain," he countered, surprising me. "They'd probably accept you immediately, so why aren't you with them instead? Or haven't you been down here long enough to find out about them?"

"No, I do know about them, but I chose not to join their... efforts," I answered, folding my own arms. "If I can't live as a human being instead of a scavenger, I'd rather not live at all. So how about it?"

"All right, if you insist," he said with a shrug and what seemed suspiciously like even more amusement. "But this isn't the best place, so come along."

And with that he turned and walked off, leaving me to follow or not as I pleased. I discovered I was having trouble believing he was serious, but that didn't stop me from hurrying after him. Maybe *he* wasn't serious, but I was.

The Beast continued on straight up the corridor for a while, but then he turned into an opening in the rock on the left. When I reached the opening I saw that it was a lot wider than the first opening I'd gone through, which it would have to be for the man to fit through it. He stood waiting for me to come through behind him, and when I stopped beside him I gasped at what I saw.

Instead of a tiny nook surrounded by stone, this crevice had hidden what almost seemed to be another world. We stood on a ledge above a gigantic cavern, and equally far above us was a stone roof that was pierced at many points. The holes above, which must have been rather large, let in streaming sunlight that shone down on both planted fields and neat little houses. There was also what looked to be pasturage among the fields, with cattle grazing in one place and sheep grazing in another.

"If you don't close your mouth fairly soon, the flies will settle in and make a home," the Beast said, a definite chuckle behind the words. "I take it you like what you see?"

"It's beautiful," I agreed, still drinking in the miniature splendor below. "Has it always been like this?"

"This cavern must have formed ages ago, but it wasn't... developed until relatively recently," he answered. "When they first started to send me people by the dozen I had no idea what to do with them, until I remembered this place. The folks down there have settled in rather nicely, I think."

"But everyone says you eat the sacrifices sent in here," I accused, turning to stare at him. "Why *don't* you eat them, and if you really don't, why are there groups running around 'protecting' themselves from you?"

"To answer your first question, I prefer chicken, beef, and pork," he said, his arms folded again as he looked down at me. "That virgin sacrifice thing has never been to my taste, most especially since it doesn't often work the way your leaders claim."

"Not my leaders, thank you," I corrected, but then curiosity got the better of me. "What did you mean, that the virgin sacrifice thing doesn't often work the way they claim?"

"Virgin is supposed to mean innocent and pure," the man said with a sigh. "Those people can't seem to get it through their heads that a bodily condition doesn't necessarily mean innocent or pure. How you think and look at the world is more to the point, and I've run across some very impure and knowledgeable virgins."

"I think I know what you mean," I muttered, remembering Listia and the way she did things. An attitude like hers doesn't spring up overnight, even if that night is filled with something other than sleep. Listia was mean-spirited and self-centered, two traits that take years to develop... "But you still haven't said why people are hiding from you if you don't use them to fill your larder."

"The people in those groups *know* what the truth is," he replied, again with a sigh. "From time to time some of the farm people try to tell them the real truth, but the ones in hiding refuse to believe it. They think it's a trick to make them do their 'duty,' and they don't seem to care how many other people will suffer as long as they aren't numbered among the sufferers. Some of the girls end up finding out the real truth, but not until they no longer have a group to belong to."

"So what happens now?" I asked, taking the opportunity to voice my own sigh. "Farm life has never really appealed to me, but if that's my only choice other than joining one of those groups, I guess I'll have to – "

"Well, you do have one other choice," the man interrupted slowly, now sounding downright diffident. "I – enjoy the company and conversation of people, but even those I've helped tend to be somewhat... reluctant to stay near me for very long. If you don't feel the same, you might want to – accept accommodations in my apartment and – stay around for a while to – visit."

I studied him in silence for a moment, astounded to discover that he almost squirmed where he stood like a nervous little boy. It came to me that he must be really lonely, and that was what had forced him to offer the invitation that he seemed to expect me to turn down. He was so ugly that when I'd first seen him I'd wanted to look away, but now that I was getting used to his appearance...

"Most people talk to me once and then decide that they don't ever want to do the same again," I commented after the pause. "Are you sure you're desperate enough to want to risk it?"

"What I don't want to risk is withdrawing the offer now that I've made it," he said, amusement suddenly showing in those dark eyes again. "You're much too dangerous for me to take the chance of getting you mad, so the offer stands."

"Then you *are* that desperate," I acknowledged with a nod. "Okay, if you can stand it I guess I can too. Which way do we go? Down?"

"No, not down there," he said, a brief look of regret showing in his expression. "They invite me down to visit every once in a while, but they'd be uncomfortable having me around all the time. My apartment is this way."

He led me out into the corridor, and then back the way we'd come. I followed along in silence for a short time, and then thought of something that needed mentioning.

"My name is Meriath," I told the broad back in front of me. "If we're going to be having conversations, I ought to have a name to call you as well."

"You can call me Xegio," he answered after something of a hesitation, glancing back with a faint smile. "It's the name of someone who was my friend for a while, and I like it better than my own name."

"All right," I agreed, and then, after a hesitation of my own, added, "Did you two have an argument, or did your friend die?"

"Neither, actually," Xegio responded with a sigh, slowing his pace so that he walked beside me rather than ahead. "He met a girl he wanted to start a family with down among the farm folk, and the girl was... more than a little delicate. Because of that I haven't seen him in quite some time."

"Delicate," I echoed, trying not to sound disgusted. "Did she throw a fit whenever you came near, or just scream a little and faint?"

"It wasn't *her* fault that she was too frightened to be anywhere around me," Xegio protested, looking down at me in an odd way. "And my friend really loved her, so naturally he stayed close to give her the support and encouragement she needed."

"You know, I'm beginning to learn that there *is* such a thing as being too innocent and pure," I commented, glancing at my companion as we walked. "The woman didn't want competition for your friend's attention, so she became 'frightened' and 'delicate.' He, on the other hand, was such a moron that he let her lead him around by the easiest hand-grip, and never stopped once to think about what was happening. If he really *had* been a friend, he would have found the time to visit with you."

"You don't seem to have a very good opinion of people," Xegio observed, his tone more sober than it had been. "Have you really been betrayed all *that* often?"

"Yes, I suppose I have been," I agreed after thinking about it for a moment. "When I was a child, my mother loved to brag about how smart I was. The attitude let her feel superior to her friends, but all it did for me was make most of the other

children resent me and refuse to play with me. Then I became a woman, and my father took his turn."

"And what did *he* do?" Xegio asked, his tone even but the expression in his dark eyes beginning to smolder.

"He got lots of business for his shop and gifts from his friends by hinting that I would be available to 'borrow,'" I answered, fighting to keep from gritting my teeth. "All those low-lives wanted to be 'first,' or close to it, and my father almost had a fit when the chief priest tried to 'protect' me. But my father wasn't worrying about me, only about all the business and gifts he would lose."

"And then, because you obviously didn't cooperate with the chief priest, you were sent down here," Xegio summed up with a nod. "Yes, I think I can understand now why you aren't very fond of people, but you have to understand that they're only human. If they were perfect, they would be gods."

"You don't have to be perfect to be decent," I muttered, trying to close the subject. I hadn't even mentioned all the boys who had suddenly become interested in me, but only because they liked what they saw. Before then, they'd wanted nothing to do with me…

Xegio let the subject be closed, and we walked along in a pleasant silence. At one point I had the distant impression of someone protesting that I was in the wrong place, that I should have gone to be among the men in hiding, but that was ridiculous. I wanted nothing to do with those men, and even a distant impression should have known that.

I was led through a series of corridors that confused me completely about where I was, but then we came to a small wooden door set into the rock. Xegio opened the door and then stood aside with a sweep of his arm, so I walked in to look around – then gasped with surprise.

The room beyond the door was very large, but that was the least of it. The rock of the walls was hidden behind silk hangings in dazzling white, and expensively made furniture stood on soft, thick, white carpeting. The furniture was mainly brightly colored with only the scattered tables in dark wood, and lamps glowed on the walls to give the whole place a warm, attractive feel. There were also doors in some of the walls, but they were of finer workmanship than the plain wooden door leading into the room.

"Oh, this is really nice," I couldn't help exclaiming as I moved forward into the room. "And I have to admit that I never expected to find anything like it down here. My parents lived rather well, but we never had anything this good."

"Over the years, people have left a very wide variety of gifts for me," Xegio said from behind me as he closed the outer door. "There isn't much else to do down

here, so I spent a lot of time making myself comfortable. I haven't had much chance to show it off, so I'm glad you like it. Would you also like something to eat?"

"Yes, thank you, I would," I answered, turning to look at him. "I hadn't realized how hungry I am until you mentioned food, and if you like I'll even do the cooking."

"I appreciate the offer, but it isn't necessary," he replied with a warm smile. "My needs in that area are taken care of by magic, so all that's left is to eat. If you'll take a seat at that table, I'll be right back."

He pointed to a beautiful darkwood table with two matching chairs that stood to the left against a wall halfway across the room, the lace cloth on the table doing nothing to hide a gleamingly polished finish. Xegio strode away toward a door not far from the table, so I went over and sat in the chair that looked as if it had a lot less use than the other one. Obviously, the man had guests only rarely...

Xegio reappeared almost immediately with two goblets and a bottle of wine, and after putting his burdens down he disappeared again. I opened the wine and poured some for each of us, and by then Xegio was returning with two covered dishes. By the time he came back with plates, cutlery, and table linen, there were six covered dishes on the table as well as two baskets of bread. Only then did he take the other chair and smile at me.

"At least I can eat as well as I used to," he said, reaching for his goblet. "How do you like the wine?"

"I was waiting for you, so I haven't tasted it yet," I informed him with a very cool look. "What sort of crass guest do you take me for?"

"I suppose I took you for the kind of guest I usually end up having," he responded wryly, now looking apologetic. "I'm sorry about that, and I promise not to do it again. I shouldn't have let your disappointment with people rub off on me."

"Why not?" I countered, trying not to sound too annoyed. "If you don't make a habit of expecting at least a modicum of good manners from people, they tend to think they can get along without showing any manners at all. Or at least a lot of them act that way. There are a few people around who don't need to be reminded."

"And you're obviously one of them," he said, the amusement back in his eyes. "So let's reward your good manners by getting right to eating. I've discovered that I'm as hungry as you said you are."

I gave him a smile in return, and then we began to uncover dishes. I didn't know what kind of magic produced his food, but I was certainly glad it did. There was everything from roast chicken to beef slices to a pork stew of sorts that was really just the pork in a marvelous sauce, and I tasted it all. There were also vegetables with their own sauce, and the bread seemed to have butter already baked into it. I ate as much as I could hold and took only a few sips of the excellent wine, but finally I reached my

limit. Xegio was still going strong with his own food, so I sat back with my wine and waited for him to finish.

"That was excellent, and I thank you for providing it," I said when he finally pushed away his plate. "Now that we're both fortified, I wonder if I can ask a few intrusive questions."

"If you're waiting for permission, they must be really intrusive," Xegio observed, sitting back with his own wine. "All right, you might as well go ahead and ask. I'd hate to have a guest of mine die of curiosity."

"Well, I'll ask, but you don't have to answer if you don't want to," I said, this time finding nothing to smile at. "You – said something about at least being able to eat the way you used to. I know that means you weren't always... here, so where were you and why did you leave?"

"I – used to live with my family," he said after a very long hesitation, no longer looking at me. "I know there are a lot of stories about why I was banished to the labyrinth, but the truth of the matter is I was insufferable. At least after all this time I've learned that much."

I couldn't think of anything to say to that, but Xegio only paused to take a breath before continuing.

"I had the good fortune to be born into a very... important family, you see," he said, his gaze on some inner picture that I couldn't see. "And not only was my family important, but I was also a very handsome man. My mirror showed me that and everyone assured me it was true, so I knew that other people were privileged to be in my company. I was very special, and they were lucky I let them associate with me."

He sighed deeply then, and shook his head.

"I went along like that for quite some time, and then I managed to insult the wrong person," he said. "That person turned out to be one of the gods, and the gods aren't known for laughing off insult. I was turned into the... creature you see before you and put into this labyrinth, to see if I could learn the error of my ways. I can leave any time I please, only I can't bring myself to do it. I also haven't begged to be turned back to the way I was, because I don't think I'm ready for that yet. If I looked the way I used to, I'd probably also start to act the same and I don't want to do that."

"I can't picture you being that much of a fool," I couldn't help saying when he fell silent. "I've known a lot of fools in my time, so I consider myself something of an expert on the subject. You're a better person than anyone I've ever known, and that no matter what you look like."

"It's nice of you to say so, but you haven't known me very long," he said, and his disagreement was so strong I could almost feel it. "I think you'd better wait a while before you make up your mind, and now I'll have to ask you to excuse me. It's been a long day for me, and you must also be tired. I'll show you to your bedchamber."

He stood up then, and I had no choice but to do the same. My big mouth had ruined the really nice time we'd been having, but there was no way to take back what I'd done. So I followed him silently to one of the doors, then walked into the room past him. He bowed with a touch of irony, and then he was gone to brood in solitary. The room he'd given me was a beautifully furnished bedchamber, but I was too busy cursing myself to really appreciate it.

I closed the door and sat down in a lovely chair to wait, hoping he would shake off the dark mood and come back to talk, but he never did. I finally went to bed, determined not to make the same mistake again – assuming he ever spoke to me again…

12

I didn't sleep very well, in spite of having a more comfortable bed than I did at home. When I woke up for what seemed like the twentieth time, I decided not to try again and simply got up. I had no idea what time of day it might be outside the caves, or even if it *was* day. I just knew I had no interest in spending any more time pretending that I was trying to sleep.

I'd taken off my skirt and vest to sleep, of course, and once I'd brightened the lamp I'd left burning low and washed a bit in the room's basin, I went to dress again. It was a surprise to discover that the white skirt and vest has been replaced with a silver skirt and golden vest, more so since I hadn't heard anyone come into the room.

Both items of clothing looked as if they'd only just been made, which brought me some curiosity. Vests were worn only by maiden girls, and the girls who were sent into the labyrinth wore nothing but white. Where, then, had the silver cloth come from, and why had a vest been made of it? Could it have been produced by someone in that hidden farm community? Were they actually raising families down there, without the sanction of the priests?

That seemed to be the only logical conclusion, and I thought about the situation as I dressed. Those of us who had been sent into the labyrinth had been abandoned by the priesthood, but not everyone looked at the matter in that light. If there was a community that had managed to slip the iron hold of the priesthood, something might be done to free everyone else. It was a matter worth considering, but I discovered that at the moment I was too hungry. If breakfast wasn't ready to be served, I'd have to find something to nibble until it was.

The very large sitting room was deserted when I walked out, but going over to the table showed me covered dishes and a place setting already laid out. But only one place setting, which probably meant I was supposed to eat alone. My first urge was to sit down and do just that, but then I came to my senses. If my big mouth had caused difficulty the night before, the only fair thing was to use the same instrument in an attempt to make things better.

So rather than sitting down, I went to the first doorway beyond the one Xegio had gotten our food from last night and began to knock. When a couple of minutes of brisk knocking drew nothing in the way of an answer, I opened the door and peeked inside. Dim lamplight showed me a lovely bathing room, but the large and beautiful tub was empty of water and no one sat alone in the room. My quarry was obviously elsewhere, so I pulled my head out and went on to the next door.

This time my knock produced a faint stirring sound in the room beyond the door, but still no response. I stood there knocking for a good five minutes, more than long enough for the man to wrap himself in his body-cloth, and then I ran out of patience. It was most likely brooding rather than modesty that kept Xegio behind a closed door, and that was what I'd come to change. So I opened the door, said, "Here I come," and then stuck my head in the door.

The bedchamber behind the door was very dim, but there was just enough light to see that it was even larger than the one I'd been given. A large, well-upholstered chair stood to the left not far from the door, and that was where Xegio was. He sat staring at me with a frown, so I shook my head at him.

"Some host you are," I said with plenty of accusation in my tone. "Inviting someone to join you for conversation and then locking yourself away alone is not considered good manners where I come from. If you aren't hungry, the least you can do is keep me company while I devour the food. I admit I'm not very attractive when I'm in the midst of devouring, but I did think you were strong enough to stand the horrible sight."

"I – have some thinking to do," Xegio answered with just the hint of faint amusement in his expression. "Why don't you have your breakfast in peace, and then maybe later I'll – "

"So you changed your mind after all," I interrupted to say very flatly, finally seeing the light. "You don't like having me speak my mind any more than those outside these caves do, but you're much too... genteel to say so. You'd rather sit back and let me figure it out on my own, which I've just done. Thanks for the breakfast, but for some reason I've just lost my appetite."

I closed his door again and headed out of the apartment, hating myself when I realized how much of a fool I'd been. No one liked my version of the truth when they didn't happen to agree, but I'd still voiced my opinion to Xegio as if he were different. Now he'd decided to avoid me rather than put up with hearing more of what he didn't like, and making him hide out in his bedchamber wasn't fair. The apartment was his, after all, so the only thing to do was leave him to it.

I was barely half way across the big room when I heard a door open behind me, but rather than turn and look I just kept going. I was certain that Xegio was just

131

making sure I left the way I'd suggested I would, so when my arm was suddenly taken in a big, gentle hand I was really surprised.

"You can't just leave without having breakfast," he said when I turned quickly to look up at him. "I do value my reputation as a host, you know, and if anyone found out I'd let you leave hungry, that reputation would be ruined."

"You don't have to pretend that you want me to stay," I told him, doing nothing to match the rather forced smile on his face. "I've said the wrong thing often enough to know when I'm not wanted, so let's just do this the easy way. I'll walk silently out of your life, and then you can go back to enjoying the peace and quiet."

"Aside from the fact that I don't *want* you to leave, where would you go?" he countered, those dark eyes seriously concerned. "You'd get lost wandering around the labyrinth yourself, and might even die of hunger and thirst before you found the first trace of the groups living down here."

"So what?" I asked him very flatly, in no mood to be talked out of my decision. "I'm *supposed* to die down here, so what difference does it make what I die *from?* At least once I'm gone you won't have to lie just to make some loudmouth feel better."

"I wasn't lying when I said I don't want you to leave," he insisted, his hand on my arm keeping me from turning and walking away. "I also wasn't trying to avoid you just now. I sometimes get a bit... gloomy, and I was just trying to spare you the burden of my presence. If you think you can stand it, I'll be glad to keep you company while you eat."

"I said I no longer have an appetite and I wasn't lying," I muttered, refusing to turn and look at him again. "I know what I'm like, so trying to deny the truth won't get you anywhere. And since I'm not going to say anything else, you can consider our conversation bargain broken and let me leave."

"I can't let you leave because now *I'm* hungry, and I need someone to keep *me* company while I eat," he said, starting to pull me back in the direction of the table. "You don't have to eat anything yourself, just keep me from getting lonely. And of course you'll hold up your end of the conversation, I can't imagine you doing anything else."

He dragged me all the way back to the table and made me sit in my chair, and it was disappointing to see that there were now two place settings and more covered dishes. I'd hoped to be able to slip away when he went into the kitchen, but all he did was sit in his own place. I remembered my thoughts on how lonely he must be, and realized that the condition had to be even worse than I'd imagined. But being alone was better than being with someone who always said the wrong thing, a truth he would finally get around to understanding. And once he saw I meant what I said about not speaking again, he'd step out of my way and let me do what I had to...

"You look really nice in those clothes," he commented as he reached for the first covered dish. "I should have given you the chance to bathe before putting on clean clothes, but I honestly didn't think of it. I have lots of outfits that you can wear, so if you like you can bathe later and change again."

Xegio pretended to be too busy filling his plate to pay much attention to me, but I could see that he watched me out of the corner of his eye. I really wanted to ask him where he'd gotten all those clothes he'd mentioned, but I'd had plenty of practice keeping quiet no matter how bad my curiosity got. He put one serving dish down and took a second, and then he smiled.

"Isn't it a nice day?" he remarked, spooning out a helping from the second dish. "I enjoy nice days, but I also enjoy a good rain at this time of year. Will you enjoy it if it rains later?"

His question was so outrageous that I looked away from him and down at my hands. It would have been the perfect time to point out how hard he was working to make me feel better, which supported my contention that he was a more than decent person. But that was the claim that had gotten him so upset the night before, so I wasn't about to repeat the performance. All I could do was wait until he got tired of trying, and then quietly leave...

"All right, I surrender," he said suddenly, and the lightness was gone from his voice. "I thought I could tease you into talking to me, but obviously I was wrong. And I think I'm getting an idea of what you must have gone through in your life. It isn't hard to be stiff and distant with people who tell you things you don't want to hear, even if those people are only trying to help. Or maybe especially if they're trying to help..."

He paused to take a deep breath, giving me the chance to say something, and when I didn't take advantage of the opportunity, he sighed.

"You forced me to do a lot of thinking last night, and I really need someone to talk to about it," he said heavily. "I don't like the conclusion I've come to, and if I'm wrong I need to know it. Will you at least do me the favor of listening? If you decide I'm making things up, you don't have to say a word."

There was such bleakness in his tone that I just had to look up, to see if the same happened to be in his eyes. The bleakness was there, all right, so I made no effort to look away again. He was right about listening being the very least I could do, but as far as speaking went...

"I couldn't understand why I felt so... bothered when you said I wasn't fool enough to go back to my old way of acting." Xegio spoke after something of a pause, sounding as if he forced the words out against his will. "If someone else had said the same I would have smiled and thanked them for the compliment, but you... I had the feeling that you never say things just to be polite, and that's what was disturbing me so

badly. I worried at the feeling for hours before the truth finally made me look it squarely in the eye.

"The key to the way I felt was what I'd said about not begging to be returned to the way I'd originally been," he continued with another sigh. "As long as I could tell myself that there was a reason not to ask to be changed back, I didn't have to admit that I'm afraid to ask. I was never told that I would be changed back, you see, not in so many words. I'm afraid that if I ask and I'm refused, I'll lose the last hope of ever again being what I was. Or at least that's what I think I'm afraid of. Am I somehow looking at it wrong?"

"If you want the truth, I'm having trouble deciding what to comment on first," I said, finding it impossible to ignore the pain in those dark eyes. "Are you sure you want to hear what I have to say?"

"I had the feeling you were going to ask that," he said, actually flinching as he looked away for a moment. "I don't really *want* to hear it, but I do need to. Give me a minute to brace myself, and then go ahead."

"I'll start with an easy one," I promised, leaning back in my chair. "I was wrong last night about you not being a fool. You *are* a fool, and not just a little one."

He raised his brows in surprise, but he didn't interrupt even to argue the contention.

"To begin with, being afraid to walk head on into something that means the most to you isn't being a coward," I expanded, starting with the smaller subject. "If you've spent years and years hoping and praying for something, to expect yourself to calmly and coolly face the possible permanent loss of that something is sheer stupidity. With things that are really important, no one can grin and shrug at the thought of failure."

"But then shouldn't I have been happy to hear you say I've changed more than I realized?" he asked, still looking lost and hurt. "The changes would better my chances of being given a positive answer, which should have increased my hope."

"Having your chances bettered just puts you closer to the need to ask," I said, speaking as gently as possible. "If you get to the point of having no choice but to ask, you risk getting an answer that will kill your hope for all time. But you *are* overlooking something, probably because you can't face the possibility and therefore can't think about it."

"And what's that?" he asked, now looking nervous as well as confused. "I've been living with this situation long enough to believe that I haven't overlooked any- thing at all."

"You've overlooked the fact that real beauty doesn't come from the outside, but from the inside," I said, hoping he would listen rather than just dismiss what I had to say. "A person's outer appearance is useful only to attract others at the beginning.

134

It's an initial physical attraction meant to make getting together with others easier, but it's the inner beauty – or lack of it – that makes for permanent attraction or distaste. You say you were a very handsome man; did that physical beauty keep people near you after they'd noticed your inner ugliness?"

"It kept *some* of them near me," he grudged, fighting silently to keep from granting the point completely. "For the most part they were people who would have stayed around even if I'd had two heads that breathed fire, or they were people who just like to be near physical perfection. But if I hadn't had that physical perfection, no one would have come near me at all."

"Possibly," I granted at once, "but only because your attitude would have kept them away. It's a proven fact that if you see yourself as ugly, or pathetic, or a lot less than desirable, that's the way others see you. If you see yourself as friendly and someone worth knowing, people find themselves attracted just to find out why you feel like that."

"Of course they do," he said, his tone now very dry. "Just the way the people down here are instantly drawn to me. Do you have any idea how hard I've had to work to keep them from screaming and running at the first sight of me?"

"What do you expect when they think you'll be roasting them for dinner?" I countered immediately, ready for the contention. "All their lives they've been filled with a dread for the monster in the labyrinth, and you expect them to shrug that off because you smile warmly in greeting? It doesn't even matter that they know you won't hurt them. They've been raised to believe otherwise, and that's hard to throw off."

"It doesn't seem to have been too hard for you," he pointed out, the expression in those dark eyes growing stubborn. "If a slender girl can get beyond the fright, then so should a lot of others. But they haven't gotten beyond it because of what I look like."

"How are they supposed to get beyond what you look like when *you* can't get beyond it?" I challenged, rapidly running out of patience. "I'll bet that when you go down to that beautiful farm valley, you expect the people to be standoffish so *you're* standoffish. Your keeping yourself aloof from them reinforces their nervousness, and their unsteady nerves causes you to be even more aloof. Each reaction feeds on the other to make them both more intense."

"And how do *you* know so much about it?" he challenged in turn, his lack of denial making my guess a good one. "You're just a young girl who hasn't seen more of the world than the tiny city you come from. What makes you so sure that you're right?"

"When people have many and varied reasons to avoid you, you sometimes tend to watch from the shadows," I said, finding the reminder the least bit painful. "When a girl is beautiful, most of the other girls who would otherwise be her friend avoid her to avoid the competition of her looks. And the boys who find her attractive

135

also discover that more powerful and older men are interested in her, which puts her beyond their reach. That turns some of the boys resentful, and they blame *her* for the interest of others, which causes the resentment to turn to ridicule. But when the one doing the ridiculing can't hold his own in a verbal contest with his victim, he then decides to ignore her completely. The others follow his lead, and that gives her a lot of time to do her watching. Does that answer your question?"

"A bit more thoroughly than I expected to have it answered," he responded quietly with compassion. "I'm sorry I forced you to discuss that."

"It doesn't matter," I lied, gesturing aside his apology. "The only thing that does matter is that I know what I'm talking about because I've seen it happen so often. If you don't give people a chance to see your inner goodness and warmth, how are they supposed to know it's there?"

"What's the difference whether or not they know it?" he countered, immediately back to being defensive. "I see myself as ugly because I *am* ugly, and what's inside doesn't matter because no one can see it. If inner beauty were all that important, I'd have crowds of women throwing themselves at me. Do you see crowds, or even one woman? Are *you* getting ready to throw yourself at me?"

The directness of his stare was unsettling, but not as bad as the pain filling his demand.

"Haven't we gotten a bit far from the original point we were discussing?" I said, trying to get rid of that pain. "We were talking about inner beauty as opposed to outer, and – "

"And you haven't answered my question, which really answers it completely," he interrupted to state in a very flat way. "You claim you can see my inner beauty, but that does nothing to make you want me as a man. If I were as wonderful as you've tried to make me believe, you would be interested in me as a man. So go ahead and tell me you're interested, I dare you."

"But I *am* interested!" I blurted before I could hold the words back. It wasn't a lie, but interest was the least of what I felt. I'd had so many men want me for nothing but my beauty and my body that I cringed at the thought of getting together with any man at all. It was something I'd spent all my adult years running away from, so how was I supposed to suddenly change my mind…?

I'd looked away from Xegio to study my nervously twisting fingers. When, after a moment or two, his hand came to my chin to raise my face I almost jumped.

"You know, for a minute there I didn't believe you," Xegio said in a soft and gentle voice, a smile curving his lips. "Then my thickheadedness remembered the kind of life you've led, and what I couldn't believe was that you were able to put your feelings into words. Thank you for that, and for being kind to a very lonely man. You don't have to worry that I'll do anything to make you regret your kindness."

136

"Do you have any weapons in this apartment?" I asked after a very long moment, fighting to keep myself from screaming furiously. "If you do, I'd like to borrow one for a short while. I'll give it back as soon as I finish using it."

"Is it my imagination, or are you threatening me?" Xegio asked as he blinked at me in astonishment. "What have I done now?"

"What have you done!" I echoed with a screech, pulling my face out of his hand. "You've done exactly what I said you were doing, and you're doing it again!"

"I hate to ask for a translation, but what you just said makes no sense at all," he ventured, now sounding cautiously wary. "What have I been doing that I've now done again?"

"You're holding yourself aloof because you think I want you to," I answered through my teeth, hearing the growl in my voice. "You didn't stop to ask if I really did want that, you just assumed I did. You're trying to make me see you through your eyes, and I refuse to let that happen."

"Really," he commented, now leaning back to study me from under half closed lids. "I thought I was being a gentleman, and I apologize for the error. If you don't want me to hold myself aloof, then of course I won't. You find me of interest, so the least I can do is return that interest. We'll share this breakfast, and then we'll share a bath before we go on to other things. That *is* more in keeping with what you had in mind, isn't it?"

He sat there waiting for me to refuse the offer he hadn't really put forward seriously, and nervousness almost made me give him that refusal. He was a man and I had reason to distrust men, but the interest I'd considered small was a lot larger than I'd thought. Quite a bit of me didn't *want* to refuse him, and that part made me nod woodenly in answer to his question.

"Your enthusiasm is overwhelming, but I'm strong enough to handle it," he said dryly before reaching for another of the serving platters. "Let's see to our breakfast, and then we'll see to the bath."

I wasn't often unsure of myself, but in this instance I spent so much time trying to decide if I was making a mistake that I had a plate full of food in front of me before I knew it. Instead of wondering how the food had gotten there I began to eat it, suddenly so hungry that I felt absolutely hollow. By rights I should have had even less of an appetite than I'd had earlier, but that inner part of me seemed to be at it again. Something specific was scheduled for after the meal, and that inner part of me was eager to get to the time.

I ate until I couldn't hold any more, using the glass of milk provided to wash down the food. When I put the empty glass aside I found Xegio watching me, an odd confusion in his gaze.

"If I didn't know better, I'd think that your enthusiasm had increased," Xegio commented, his tone less assured than his words. "Well, I can take care of that. I'm ready if you are."

He finished his announcement by standing up, but I had the distinct impression that what he was ready for was to sit down again when I refused his challenge by staying where I was. Instead of doing something that foolish, I pushed my chair back and got to my feet.

"Sorry to disappoint you, but I'm also ready," I told him, refusing to admit that his behavior was making me wonder if he could actually be uninterested. Just because those disgusting old men had wanted me didn't mean others would, but I couldn't let myself think about that. I didn't want to start to feel that I was forcing myself on Xegio the way those old men had tried to force themselves on me…

"Then let's get on with it," Xegio said, gesturing toward the door that hid the bathing room before starting toward it. "If we take too much time getting down to the bathing and such, one of us could suffer a sudden change of mind."

One of us. As I followed after him, a tiny voice in my head asked if that one would be him. The voice knew it certainly would not be me, and guilt began a sneaking approach to my thoughts. I pushed the guilt away as firmly as I could, hating the idea that I might be taking advantage of Xegio…

The big man opened the door of the bathing room and strode inside, very pointedly not looking back to see if I followed. Being barefoot made my footsteps just about soundless, so when Xegio suddenly turned and started back toward me he almost ran me down.

"Oh, I'm sorry, I didn't realize you were so close," he apologized at once, putting a hand out to steady me. Then his expression grew peculiar, and he pulled his hand away again. "I – was just going to close the door before putting water in the tub."

"All right," I agreed quietly when he hesitated as though waiting for me to comment. "I'll see to the lamp."

It was still really dim in the room, so I brightened the lamp that was already lit, then used its flame to light two other lamps. When I turned away from the second lamp it was to see that the door to the room had been closed and to hear water pouring into the very large tub. Xegio stood staring at me, but when he saw me notice the stare he quickly looked away.

"It won't take long to fill the tub," he commented as he moved toward a low cabinet that was fairly wide. "The water we'll bathe in comes from the bowels of the earth already warmed, and in fact usually needs to be cooled. I also have towels for us to use… afterward."

There didn't seem to be anything to say to that, so I just walked over to the tub to watch it being filled. Then I crouched to put a hand near the stream of water coming out of the spout, and was able to detect the warmth easily.

"Not having to heat your bath water must make life a lot more pleasant," I commented, now looking forward to the bath even more. "And there's so much room in this tub. It must be like bathing in a heated lake."

"Yes, it is rather pleasant," Xegio agreed as he brought over the towels and stood next to where I crouched. But that was all he had to say until the tub was completely filled, when he reached over to touch a lever. The water immediately stopped pouring into the tub, which meant it was time for the bath.

"Well, now we get to take our clothes off," Xegio said in a very neutral voice, his gaze directly on me. "Why don't you go first."

I felt my cheeks warm at the thought of being completely undressed in front of a man, but it was a bit messy to bathe any other way. I straightened out of the crouch and gropingly slipped out of my vest, discovering after a moment that I no longer looked directly at Xegio. Taking the skirt off was harder, but when I finally managed it I folded the skirt neatly and put it to one side where it would stay dry. Once that was done, I forced myself to look over at the man again.

"All right, I'm ready," I announced as though he couldn't see the thing for himself. "What about you?"

"You really are stubborn, aren't you?" he answered with a sigh that I didn't understand. "All right, let's see just how stubborn."

He turned away from me to remove the cloth wrapped around him, and when he turned back I quickly gave my attention to the tub.

"I hope the water isn't *too* hot," I commented as I dipped the toes of my right foot into the water in question. It turned out to be deliciously warm instead of too hot, so I stepped down to the broad ledge that ran around the top of the tub. That brought the water almost to my knees, and a second step down took me to the floor of the tub where I quickly sank down to let the water cover me.

I heard Xegio following me into the tub, but didn't dare look up. The glance I'd gotten of his bare body had set me trembling on the inside, but not with fear. I had occasionally seen naked men before, but none of them had been made as... beautifully as Xegio. If he hadn't been acting so really strange, I probably would have said so...

"So, are you enjoying the water?" Xegio asked after he'd settled himself on the opposite side of the tub. "You look like you're not quite certain."

"Oh, I'm very certain," I answered quickly, raising my head to look at him. "I'm enjoying the water quite a lot, so thank you for suggesting this."

"Stubborn," he muttered under his breath with a headshake, then he returned to a normal voice level. "If you're enjoying yourself so much, you won't mind if

I suggest that you might like to add to the enjoyment by soaping me. The soap is in the little jar here by the edge of the tub."

I blushed again at the suggestion, mostly because I liked the idea very much. But I still hesitated, because his expression had grown peculiar again. I wanted to continue to ignore the possibility that I was taking advantage of him, but this time I had to fight to do it.

"I don't hear agreement from you," Xegio pointed out, the words far too even. "Have we finally reached the place where kindness is forced to give way to distaste?"

"Kindness?" I echoed, trying to figure out what he was talking about – and afraid that I already knew. "And distaste? If you're saying you're tired of being kind to me because things have turned too distasteful, then I – can only – apologize for upsetting you – "

I started to get up, intent on leaving the tub before I broke down and began to cry. I made it as far as my knees before a big hand wrapped around my arm.

"What do you mean, *I'm* tired of being kind?" he demanded, confusion filling his dark-eyed stare. "You're the one who's been acting kind, pretending that there's anything at all in this hulk of a body that could interest you. I really do appreciate the effort, but you don't have to continue on with it to the point where it turns your stomach."

"Does... that mean you aren't putting up with me just to be nice?" I asked in an unsteady voice, knowing the confusion in my own eyes had to be a match to his. "I'm not... taking horrible advantage of you?"

"Taking advantage of me?" he echoed with brows high, and then he laughed once. "Every man should be lucky enough to be taken advantage of like this... Meriath, listen to me. I know you're a good friend, so you don't have to go on with this just to prove it. I'm prepared to grant the point you were trying to make, so you don't have to – "

"You think I'm trying to prove a point?" I interrupted, finally seeing the light. "You don't believe that I'm seriously attracted to you? What do I have to do, knock you down and have my way with you over your feeble protests just to prove I'm sincere? I thought the man was supposed to handle that part of it, but if you insist..."

And with that I threw my arms around his neck and brought my lips to his with the best kiss I could manage. What seemed to be shock held him still for half a dozen heartbeats at least, and then he took me gently by the arms and moved me back away from him.

"All right, that wasn't a very good kiss and I admit it," I said at once, hoping desperately that he could overlook my clumsiness. "I know I don't have much experience with kissing, but if you'll just be patient – "

"Meriath, hush," he interrupted the flood of words, a smile curving his lips and warm amusement lighting his eyes. "I realize that this is taking me longer to accept than it reasonably should, but I can't imagine that a girl as beautiful as you could possibly be serious about a man as ugly as I am. Are you sure you *are* serious?"

"I could never be interested in an ugly man," I assured him, raising one wet hand to touch his face. "Only the most beautiful of men could cause me to make a complete fool of myself and not care, and I'll stand behind that statement for as long as I live. But... does your uncertainty mean I *will* have to take charge? I really have no idea what I'm doing..."

"What you're doing is making a dream come true that I never actually had the courage to dream," he said with a wider smile, just short of laughing. "I'm probably only dreaming right now, but if so I don't want anyone to wake me. Will you be gentle when you knock me down and have your way with me?"

"Of course I will," I assured him with my own laugh. "I could never bring myself to hurt someone as beautiful as you."

Once he had my assurance he let my arms go, which let me put them around his neck again. This time he answered my kiss, gently and tenderly at first, and then with more and more abandon as I lost my own self control. His shoulders and back were so warm and hard under my hands, and his own hands felt so good as they stroked my body...

I lost myself to the delight of being held and kissed by him, but not so completely that I didn't know it when he picked me up and stood himself, then carried me out of the tub. My body was aflame with desire for him, and the tub water had done nothing to quench the flames. I half expected to be put down again on the tile of the floor, but Xegio carried me over to a wide and armless couch that could be used to nap on after taking a bath. He put me down on the couch, and then broke the kiss we'd been sharing.

"I want very much to make love to you, but you'll definitely have some pain from it," he whispered as he used one hand to brush back some of my hair. "You *are* still a virgin, and I don't want to hurt you. If you're afraid, or would just prefer to put off the time - "

"No, I don't want to put it off," I said at once, more determined about that than about anything else in my entire life. While we were still in the tub his fingers had probed at my womanhood, and although there *had* been some pain I didn't care. "They say it only hurts the first time, otherwise you're doing it wrong. You don't make a habit of doing it wrong, do you?"

"I never used to," he said with an amused laugh. "I haven't had much practice lately, but maybe you can help me change all that. I'll be as gentle as it's possible to be."

141

Since I hadn't expected him to do anything else, he was silly to mention the point. Rather than answer I pulled his lips to mine again, using his hair to bring him closer. The desire in his eyes had increased mine almost beyond bearing, and I moved my body against his in a silent plea that he hurry. If he took much longer getting to it, I *would* knock him down and take over.

But I didn't have to. His need must have been a perfect match to mine, and once his manhood was positioned at the entrance to my womanhood he didn't hesitate. His thrust inside was firm and controlled, making me cry out only once. After that he pushed all the way inside me, and the sensation was absolutely marvelous. I wanted and needed him inside me, and hadn't thought I'd be able to take so much of his glorious size. The fit was on the tight side, but he did fit.

And then he began to stroke slowly and carefully, obviously to make sure he wasn't hurting me. I moaned in delight and tried to match his movements, but the effort didn't accomplish what I wanted it to.

"Am I hurting you?" he asked anxiously, immediately stilling the movement of his hips. "Are you trying to escape me?"

"No, I was trying to encourage you," I answered in a voice just short of a wail. "I told you I don't know what I'm doing… "

"What you're doing is just fine," he hastened to assure me with something of a groan. "Let's try it again, but if I do hurt you, tell me at once."

I agreed with a nod, but just to ease his mind. I knew he would never hurt me, and he certainly didn't. He made me scream with delight and claw at his back, but he never hurt me. The pleasure went on for a very long time, and when my body unexpectedly exploded I had trouble breathing for a minute or two. After that I just lay on the couch unmoving, and Xegio lay in the same way beside me. We shared the silence in the same way we'd shared our bodies, and then Xegio stirred.

"I have to say I admire your ability at pretense," he said, still sounding somewhat winded. "You were so good that I almost believed you enjoyed that."

"No, I didn't enjoy it at all," I said without opening my eyes or moving. "Your performance was terrible, so as soon as I catch my breath you're just going to have to try again. And you haven't given me that weapon I asked to borrow."

"If you expect me to give you a weapon, either you're crazy or you think I am," he said with a laugh, and then he was bending over me to show his tender smile. "I apologize for being so terrible and I'll certainly try harder next time, but you'll have to give me a bit more than a minute or two. I'm an old man, so I'll need at least five minutes to recover."

"All right, five minutes, but not a second more," I conceded with a grumble, then reached up to stroke his face. "And if you can't manage to be better, I can live with terrible. Anything for a man as beautiful as you."

He actually managed to laugh at that, and then he took me in his arms to wait until the five minutes were up.

13

We made love a second marvelous time, and then we went back to the tub. Washing each other sent us both into fits of laughter, and that set the tone for the next two days. Xegio and I spent our time laughing and making love, and it was the best time of my life. His desire always ignited my own, as if I needed something to ignite me. Xegio was exactly the kind of man I'd always dreamed about, and I finally learned the meaning of contentment.

We also spent a lot of time teasing each other, a pastime I proved to be better at than Xegio. It took almost no effort to exasperate him, and my laughter at his expression usually added to his exasperation. The practice quickly turned into a fun hobby, but then Xegio came up with something of his own during lunch the second day.

"You know, it's really too bad that you don't fully trust me," he commented after I'd teased him again about whether or not I had interest in him. "You seem to like the way I make love, but as far as trust goes it's fairly clear you don't feel much."

"How can you say that?" I demanded with fists on hips, having no idea what he was talking about. "If I didn't trust you, would I have come to this apartment in the first place?"

"You didn't have much of a choice about coming here," he pointed out with a shrug, his tone sober and reasonable. "It was join me or wander the labyrinth until you died of thirst and hunger. That isn't my definition of showing full trust, but that's all right. I never really expected it of you."

"I think you must be the most annoying man ever to have lived," I stated, staring at him with the annoyance I'd mentioned. "What will it take to convince you that I couldn't possibly have more trust in you?"

"Something I know you won't want to do," he answered at once with a sigh. "It would lay my doubts completely to rest, but it's actually rather unreasonable. That's why I haven't mentioned it sooner."

If I'd had any intelligence at all, I would have been suspicious at the speed of his response. But as it was, I had no idea he was leading me down the garden path just to get even for what I'd been doing to *him*.

"All right, what's this thing that you know I won't want to do," I asked with a sigh. "And if I do agree to do it, will that finally convince you that trust isn't an issue between us?"

"If you do it I will be convinced, but it's something you have to be shown rather than told about," he came back, still looking unsure. "If you like, we can get into it after lunch."

"After lunch sounds fine," I agreed, determined to prove his latest doubts wrong. I really should have remembered how much trouble my big mouth usually got me in, but big-mouth disease seems to affect the intellect rather drastically…

When we finished eating, Xegio took my hand and led me into his bedchamber. I'd been in the room with him any number of times before, but this time he stopped short of the large bed.

"All right, here it is," he said, still looking soberly doubtful as he gestured toward the bed. "If you really trusted me you'd let me tie you to the bed with those lengths of silk. Trust would make you know that you had nothing to fear, but lack of trust will make you refuse. I know how much I'm asking, so don't be upset when you find you have to refuse."

"I'm supposed to be afraid of being tied up?" I blustered, taking no time to wonder where the lengths of silk had come from. I really didn't want to be tied, but… "That's the silliest thing I ever heard of. What am I supposed to imagine you'll do to me that you can't do even with me not tied?"

"There are all sorts of things I could do, some of them really terrible," he replied, looking down at me with very serious dark eyes. "That's why agreeing would show your trust. But as I said, I don't expect you to agree. It would be asking more than is reasonable."

"Well, that shows how much *you* know," I answered at once, finding it impossible to refuse the challenge. "I do happen to trust you, so let's get on with it."

"Do you really mean that?" he asked, something like wistfulness now in his gaze. "You'll let me tie you up, knowing I can do anything I please to you? Agreeing to being tied would also be agreeing to whatever I decided to do."

"I'm completely aware of that," I told him haughtily. "And once this is over, maybe you'll finally have some trust in *me*."

"You could be right," he agreed with a thoughtful nod. "Okay, then let's get it done. We start with you getting out of your clothes."

I almost asked why I had to take my clothes off, but just asking the question would prove that I had doubts and that was what I didn't want to prove. I still wore my vest as well as the skirt, so I slipped out of both articles of clothing and then turned to Xegio.

"Okay, I'm ready," I announced as I looked up at him. "Now it's your turn to take something off, so the very faint interest I have in you might have a chance to grow some."

"All in good time," he answered, taking my arm to lead me closer to the bed. "First we have to get you arranged properly."

Arranging me properly consisted of putting me down on my back on the bed, and then tying two of the lengths of silk to my wrists. Once one end of each length of silk was snugly attached to me, Xegio tied the other ends to two of the slender posts that made up the headboard of the bed. The posts weren't all that far apart, but I still couldn't reach either of my wrists with the opposite hand, or even the knots on the posts.

"There, that part of it is done," Xegio said, more with satisfaction than with the hesitation he'd been showing. "Now for the rest of it."

The rest of it meant putting the two remaining lengths of silk on my ankles, and then attaching the ends of those lengths to the posts in the footboard. I was able to raise my knees a bit, but couldn't bring my legs together. I suddenly discovered that I was very uncomfortable even though the silk wasn't tied too tightly, so I forced myself to laugh lightly.

"There now, you see?" I told Xegio, trying to sound completely unbothered. "I let you do it just as I said I would, and it isn't all that terrible. Now you can untie me again, and we can take a short while to enjoy ourselves."

"You really are very sweet," Xegio answered with a fond smile before he leaned down to kiss me briefly. "But you're also very innocent, which isn't a safe thing to be for someone who so enjoys tormenting others. You do remember how often you tormented me, don't you? About whether or not you had any interest in me, I mean."

"That wasn't tormenting, it was teasing," I protested, moving my wrists in the silk that bound them. "You know it was only teasing."

"Once or twice might have been teasing," he disagreed, and his expression was no longer fond. "As much as you did it, though, it was definitely tormenting. Now I get to do a little tormenting of my own."

"You can't be serious about this," I protested again, almost in a wail. "Xegio, I didn't know it bothered you so much, or I would have stopped. If you'll untie me, I'll promise not to do it ever again."

"I think you'll promise even if I don't untie you," he responded, speaking to me over his shoulder as he walked a short distance from the bed. "In fact I'm willing to bet that you'll promise."

I had no idea what he had in mind, but I didn't have to know the details to know I wanted no part of it. I struggled against the silk holding me even harder than I'd been doing, hoping to make the slippery material let me slide loose. I should have

been able to do *something* to get loose, but Xegio had somehow tied me in a way that didn't let the silk slip. I struggled uselessly for a minute, and then Xegio was back at the bed with something in his hands.

"My squirming at your comments really tickled you, so I thought I'd add to that a bit," he said, gesturing with what he held. "Isn't this the prettiest, fluffiest feather you've ever seen?"

I looked more closely, and it *was* a feather that he held. But the thing was really long and more than fluffy, and I couldn't imagine what sort of bird it could have come from.

"Isn't it nice that all my needs are carefully seen to down here?" Xegio asked with much too much amusement showing in his eyes. "I needed a feather just like this one, and once I'd visualized my need it was supplied. Let's see how it works."

He reached down and began to run the feather over my body, and I found myself gasping in shock. The light, gentle touches shouldn't have bothered me, but not being able to avoid them seemed to make me ten times more aware of the sensation produced. Xegio tickled my breasts and belly slowly and carefully, and then he slid the feather down to my thighs. I whimpered as my thighs were gently tickled, knowing where the feather would go next, but it wasn't possible to close my legs to keep it from happening. When he finally reached the entrance to my womanhood, I jumped in desperation.

"Oh! Please, don't!" I begged, squirming as the heat suddenly burst forth inside me. "Xegio, please stop! I can't bear it!"

"Of course you can bear it," he disagreed, using the feather between my legs in a way that would soon drive me insane. "I'm only teasing you, after all, and you consider teasing nothing to get upset about."

"Why – why don't you – have your way with me instead," I suggested as fast as I could, my entire body on fire. My nipples were so hard I thought they would burst, and I needed Xegio more than I had that first time. "I can't – stop you, after all, so – why don't you – take advantage of me the way – I did with you?"

"Oh, I would never take advantage of you," he protested, still driving me wild with that feather. "I do consider myself a gentleman, remember, and a gentleman would *never* do something like that."

"But – but I'm giving you my permission," I pointed out desperately, my eyes closed against the incredible sensations I was being forced to experience. Being tied made me feel so helpless, and for some reason that increased my need more than I'd ever dreamed possible. "I – I'm definitely giving you my - permission, so there would be – nothing ungentlemanly about – going ahead with it."

"That's very true, but it also makes for a problem," Xegio mused, still plying that feather. I wanted to scream, but couldn't afford to miss hearing what he had to say.

"If you're giving me permission to take advantage of you, then what I did couldn't be considered taking advantage. And since it's the taking advantage part that's supposed to make me feel better... You see the problem?"

"Yes! Oh, please, yes, I see it!" I wailed, squirming so hard that I thought I would die. "But there has to be *some* answer, please, there has to be!"

"Well, there might be one," he drawled, taking his time with replying. "If you agreed that I had the right to do anything I pleased to you, then I could take advantage of you in a way that would be satisfying. But you probably don't want to agree to something like that..."

"Yes I do!" I babbled at once, frantic to make that feather stop touching me. "I agree that you have the right to do anything you please to me! Please, Xegio, let me agree!"

"All right, if you insist," he said, and I could hear the amusement in his voice again. "I now have the right to do anything I please to you, so we'll continue with letting the feather appreciate you for a short while longer."

I did scream then, loud and long, but the tickling didn't stop until I began to cry. It took a moment to realize that I wasn't being touched any longer, and when I forced my eyes open it was to see Xegio coming back to the bed with a jar of something. As long as it wasn't the feather I felt incredible relief, but the relief didn't last long.

"Now we're going to try something new," Xegio informed me as I sniffled and tried to stop crying. "You may not like it, but since I have the right to do whatever I please to you your likes shouldn't matter. Just as my likes didn't matter to you."

"What – what are you going to do?" I managed to ask as he began to untie the silk on my ankles from the footboard. "And you're wrong about your likes not mattering to me. They did matter."

"But they didn't matter enough to make you stop tormenting me," he pointed out as he worked. "You knew the teasing bothered me, but you were having too much fun to stop. Now it's my turn to have some fun."

By then he'd untied both of my ankles, and I didn't point out that he hadn't answered my question because I felt a disturbance from something other than my need. I hadn't realized my teasing was bothering him that badly, but obviously I should have. For someone who boasted that she was good at observing people's reactions, I hadn't noticed something I really should have...

"Oh!" I exclaimed, startled out of introspection. Xegio had turned me to my stomach on the bed, and now knelt between my legs to keep me from turning back. Because of the silk still on my wrists my arms were crossed above me, and I was held in place just as firmly as I'd been before.

"I meant to introduce you to this in another way, but your actions made me change my mind," Xegio said from behind me. "I think you need to learn how frustrat-

ing it is to want one thing while being given another. I'll be as gentle as possible, but you do need to have the experience."

I still had no idea what he meant, of course, and gasped when I felt him sliding a finger into my bottom. The finger seemed to be covered with something cold and slippery, and he brought more of whatever it was to my bottom two additional times. He paused briefly after the last time, and then his hands were at my thighs and raising my bottom higher. I thought he was about to make love to me, and could have cried with delight. His finger in my bottom had increased my need for him, but when he brought his own desire to me it wasn't put where I needed it the most.

"Wait, no!" I gasped out, then couldn't keep from wailing. "Xegio, please, not there! That isn't the right place!"

"For the moment it *is* the right place," he denied, his desire sliding slowly into my bottom. "I've greased us both so there shouldn't be too much pain for you, but there also won't be the kind of satisfaction you now need. Try to remember what I said."

I choked over the wild protest I tried to make, the sensation of his sliding into me making it happen. I'd never felt anything like that before, and then he began to stroke slowly in and out. Whimpering was all I felt capable of doing, as the sensation made me want him inside my womanhood even more than I had. I needed him inside me in a different way, but his sounds of satisfaction said he didn't need that different way. I began to get hysterical again, but this time he didn't stop until he reached full satisfaction.

I cried wildly when he withdrew, but all he did was turn me to my back again and hold me while he murmured what was probably supposed to be something soothing. Needless to say I wasn't soothed, not until he rose above me again between my legs. He'd paused very briefly to wash himself, but I had the impression he'd still done a thorough job of it. I managed to notice that his desire had returned, and then he was entering me the way I'd wanted him to. I welcomed him with my entire being, and it took quite some time before he saw to my need completely. I felt exhausted by then, but once he withdrew to hold me in his arms again I looked up into his face.

"Xegio, I'm sorry," I whispered, finally sated enough to feel really ashamed of myself. "If that was what I made *you* feel, I deserved to be treated much worse than this. I apologize from the bottom of my heart, and promise never to do it again."

"You know, you really are the best woman I've ever met," he responded, smiling as he smoothed back my sweat-soaked hair with one big hand. "I half expected you to blame me for treating you like this, but instead you took the first opportunity to apologize. Do you have any idea how glad I am that you're here?"

"You can't be half as glad as I am to *be* here," I answered with my own smile. "Another man would have really hurt me for what I did, or maybe even just turned and

walked away. Instead of doing either of those things you just taught me a lesson, one I promise never to forget. Can you... untie me now, so that I can hold you?"

He smiled and took the silk from my wrists, and I was finally able to hold him around as I'd been dying to do. I fell asleep for a while that way, and when I awoke we went to the bathing room to wash each other. And, of course, I never even considered tormenting him again...

On the third day we made love before sitting down to breakfast, and when we were done Xegio took my hand.

"I have to go visit my farm people today, and at first I decided to take you along," he said, kissing my fingers as he spoke. "I hate the idea of being apart from you, but then I remembered what you said about the uneasiness of the farm people being my fault. I'm beginning to believe you're right, and I'd like to see if I can correct the problem alone. Do you mind terribly?"

"Don't be silly," I answered with a smile as I tightened my hold around his fingers. "If the attitude of those people changes, you need to know that it's *your* doing, not the presence of someone they might want to impress. How long will you be gone?"

"Only until tomorrow," he said, the faint worry in his eyes disappearing. "I've never before stayed overnight with them, and this is the time to break that former habit if I'm ever going to. Your food will appear on the table at mealtimes, so don't worry about that. You said you wanted to read some of the books in my bedchamber, and this would be the perfect time to do it."

"You're right, so that's what I'll do," I assured him. "I know you have to make the visit, so stop worrying about me. I'll be fine here until you get back."

"I know you will be," he said with a silly smile as he kissed my hand one last time before letting it go. "I'm the luckiest man alive, but it took your arrival to make me realize that truth. I'll see you tomorrow."

We exchanged a last, loving kiss and then he left, to test the truth of what I'd told him. I knew he'd discover I was right, and I was really happy for him. A person as beautiful as Xegio deserved to have everyone know him as well as I was beginning to.

I chose a book from his bedchamber, and settled down with it to read. The story was well written and really absorbing, and I took it with me to the table when it was time for lunch. Afterward I went back to the couch I'd used all morning, and happily continued to read.

It was almost dinnertime when an odd sound out in the corridor finally captured my attention. I realized I'd heard the sound more than once, something like a strange scraping against the door. At first I couldn't imagine what it might be, and then a stab of fear crashed into my heart. Somehow Xegio might have been hurt, and he could have dragged himself back here with the last of his strength. If that was so, the

scraping against the door could be the only way he had to let me know he was there and needed my help.

I threw the book away as I jumped to my feet, then ran to the door and pulled it open. There was nothing to be seen right outside the door, so I stepped out with heart hammering to look up and down the corridor. There was also nothing to the left, but as I turned to the right something hit me hard enough to send me into unconsciousness.

I came back to awareness of the world slowly, wondering why I was so uncomfortable and why my surroundings looked so unfamiliar. A moment later my head cleared enough to realize that my wrists were tied, and then I remembered being hit. I now lay on a pallet in a cave of some sort, a largish cave that was lit with torches in sconces on the wall. There were groups of people, mostly men, doing various things around the cave, and three of the men detached themselves from the largest group and came to stand over me.

"Well, so you're finally awake," the man in the lead said with a good deal of satisfaction. He was a handsome man with dark hair and eyes, and stood with the presence of a leader. "I hadn't realized I would enjoy this part of our plan quite so much, but I don't believe in refusing whatever gifts luck sends my way."

He and the two men behind him laughed raucously, but that didn't stop them from staring at me with heat in their eyes. A surge of need flashed through my body, but I felt in no mood to pay attention to it.

"Who are you, and why have you brought me here?" I demanded, forcing myself to sit up with the help of my bound hands. "Whatever plans you may have, I'm not interested in being part of them."

"Oh, but you *are* a part of them," the man corrected without losing his amusement. "One of us saw the Beast take you into the place where he dens, and we thought that would be the end of you. But the next day another of us heard the two of you laughing, and we suddenly understood that the Beast had taken you for sport rather than supper. We've been looking for a long while for something that would bring the Beast to us when we were ready for him, and you're that something. When he gets back and finds you gone he'll come looking for you, and that's when we'll finish him off."

"Don't you dare even think about hurting him, you slime!" I cried, pulling my skirt out of the way so that I might struggle to my feet. "He's not – "

"Quiet, woman!" the man snarled as he hit me in the face and sent me back down to the pallet. "I never thought I'd find a woman low enough to let herself be used by an animal like him, and you're enough to turn a decent man's stomach! Once the Beast is dead we'll all show you what you should have wanted in place of an animal, and then we'll send you to join him in death before we leave this place. If we're

carrying the head of the Beast they'll *have* to let us out, and then we'll be heroes instead of outcasts. In the meantime, don't tempt me into hitting you again. I want you mostly undamaged so the Beast will have a reason to make the effort of getting you back."

"Why don't we take a taste or two of her now?" one of the men behind the first suggested as he licked his lips. "She's better looking than any of the females we keep fed, and taking just a single ride seems like such a waste… "

"I've already explained that," the first man answered with impatience, turning to look at his follower. "For all we know, our using her will turn the Beast uninterested in getting her back. If we lose this opportunity to surprise him, we may never get another. Since something guards the threshold of his den and refuses to let us get in there, our only chance is to make him come to us."

The second man grumbled and complained, but he didn't really argue the decision. They all looked at me one last time before walking off, and once their backs were turned I wiped at the thin thread of blood coming from my lip. My heart pounded with fear, but not for myself. If Xegio died I didn't *want* to keep living myself, but these vermin were intent on killing him. I had to do something to stop them, but I didn't know what that could be. Something had to be done, but what?

I sat up on the pallet and racked my brain, but hours went by and I still had nothing of a plan. I'd spent some time looking around the cave, but the one thing of any consequence I'd found I wished I hadn't. Some of the men were sharpening a long wooden stake against the stone of the cave floor, bringing one end of the stake to a very sharp point. That was what they were going to use on my beloved, then, to end a life that was more precious than all of theirs put together. How was I, alone and tied, supposed to stop something like that?

As the time went by I grew more and more frantic, only the knowledge that I had until the next day to think of something keeping me from screaming and attacking those fools with my bound hands. Also, my body was strangely aroused, but although the feeling grew more and more intense I continued to have no trouble ignoring it. There were more important things than bodily satisfaction taking my attention, and until Xegio was safe that would continue to hold true.

I was deep in thought when the arrival of a group of women brought me back to awareness of the cave. Three of the women walked up to the man who had spoken to me with little concern, but the forth moved more slowly and uncertainly. She also appeared to be younger than the first three, and her delicate beauty was strained by the presence of fear and hesitation.

"We're here to trade for food, Verlin," the woman leading the small group announced to the man who had spoken to me. "Since you and your men will enjoy protecting her, we'll expect a bit extra on our side of the bargain."

"The extra is yours, Senti," the man Verlin replied as he looked the younger girl over with a lip-licking expression. "She's the best you've brought by in quite some time, and I'm really in the mood right now to protect her completely."

One of the other men pulled a pallet into the middle of the cave floor, and Verlin took the younger girl by the arm and all but dragged her over to it. The girl had begun to cry with fright and she tried to pull away, but Verlin wasn't about to allow that. He threw her down to the pallet, turned her to her stomach, then lifted her skirts and tossed them over her head. One of the other men held her down while a third handed something to Verlin, which Verlin then inserted in her bottom. The girl cried out in fear and pain, but Verlin turned her to her back again without letting her reach down to herself.

"Now, now, girl, that's in you for your own good," Verlin told her with a satisfied smirk as one of the other men held her wrists over her head. "The pointed sphere won't hurt all that much if you don't try to tighten your muscles, and if you do try it will remind you to relax the muscles again. You need to be protected against the beast, and this is the best – and only – way to do it."

The girl whimpered as Verlin pushed her skirts out of his way, she struggling pathetically against the grip of the second man. She wasn't able to free herself, of course, and when Verlin moved between her thighs and presented his manhood to her she whimpered even more. The next instant she was screaming at the top of her lungs, and as Verlin thrust himself inside her again and again I had to look away.

The sound of pain and fear went on and on, and I couldn't even put my hands over my ears in an effort to block it out. The girl was being savaged by a man who cared nothing at all about her, one who cared only about himself. That sphere he'd mentioned... If the girl tried to lock her muscles against his entry, the points of that sphere would imbed themselves in a very sensitive part of her. She wasn't being allowed to refuse Verlin access to her body, but Verlin called *Xegio* a beast...

Two more of the men took their turn with the girl before she was allowed to roll into an hysterical ball on the pallet. One of the other men in the cave brought a package to the three women who had brought the girl there, and the women left without a backward glance. They arranged to come back for the girl the next "day," which made me believe that the girl would be used again by more of the men during the time. I had no idea how any of the women stayed sane after being treated like that, or why they would make others go through the same horror. It was a terrible way to make all the women in the caves feel equal to all the others...

One of the men announced that the evening meal was ready, so all the rest of the men went to get their shares. I wasn't offered any of the food and neither was the girl they'd savaged, but I didn't have anything of an appetite to make me regret the oversight. The girl just lay rocking on the pallet while she moaned in a very low voice,

and I wished I could go over to her to offer compassion at the very least. But I knew well enough what would happen if I tried to leave the place I'd been put, so I didn't bother to give Verlin a reason to hit me again.

The men exchanged companionable conversation while they ate, but mostly it was Verlin and his inner group that was the loudest. Many of the other men ate silently with their backs to the girl who had been hurt, looking as if they were trying to forget what had happened to her by not looking at her. At that moment I hated the priests more than I ever had before. If not for their sick need to run the lives of everyone around them, decent people would not have been put in a position where they had to ignore outrage in order to survive...

I went back to worrying at my problem, but I wasn't allowed much time to spend on it. There was a sudden flurry of excitement when a man ran into the cave, his face flushed with exertion and something else.

"Verlin, Verlin, the beast!" the man called, panting as he fought to get the words out. "He got back and found the girl gone, and now he's on his way here!"

"Good," Verlin answered with excited satisfaction while I straightened in shock. "You all know what you have to do, so let's go do it."

The men in the cave all began to rush around, some of them going to the girl on the pallet and pulling her out of the way. But others were running forward with the long stake they'd sharpened, holding it low and hiding it with their bodies. I couldn't believe that Xegio was coming back sooner than he'd said he would, but terror for his safety was making me believe. He must have missed me as much as I missed him, and had decided to stay overnight at the farms on some other occasion. I had to do something to save him, but I still didn't know what that something could be –

"All right, girl, the time has come for you to be of use," Verlin said as he pulled me to my feet. "We don't want the animal to hesitate before stepping into the trap, so we'll let him see the bait. Not a single sound out of you now, or I'll personally see to it that you die in agony."

After speaking his promise, Verlin dragged me to the center of the cave and stood me in front of him. Xegio would see me as soon as he walked in, and because of that would not see the men and their sharpened stake. I felt frantic and desperate as I tried to escape the iron hold of Verlin's fingers on my arms, and then a bellow of rage came to take everyone's attention.

Xegio had appeared at the entrance to the cave as if by magic, and I'd never seen anyone look so angry. He bellowed again and started to move directly toward me, his intention to reclaim me plain. He also seemed ready to kill or maim anyone who got in his way, and what he didn't see was the group of men with the long stake. He strode into the trap like the innocent I knew him to be, and I just couldn't bear it.

Something had to be done to save him, and there was only a single something that could…

Without hesitation I threw my head back into Verlin's face, making him shout with pain as his grip loosened. Pulling loose took very little effort then, and I was able to run toward Xegio.

"Don't you hurt him, don't you dare!" I screamed as I ran, sending the words like knives toward the men who stood behind my beloved's back with their sharpened stake. "Xegio, look out!"

Xegio seemed too confused to know what I meant, so I couldn't run to his opened arms the way I wanted to. Instead I ran past him, to get between him and the men who wanted to see him dead, screaming, "No! No! No!" with every step –

Ah, child, why do you continue to shout your denial to the universe? a voice said from somewhere as the scene in front of my eyes faded. *You must learn to be more understanding if you wish to end the lessons, but you haven't yet reached that point. Therefore…*

Meriath found herself awake at last, still seated in the lap of the very large man who looked like a shadow. She – no, I – resisted the demand that I sleep again, and instead fought to bring coherence to my thoughts.

"Zolanus, release me," I husked, speaking for what seemed like the first time in quite a while. "I refuse to go through that again."

"Now, child, you do have to learn," the God of Justice said in a way that was meant to lull me to sleep again. "You must – "

"Stop calling me a child," I interrupted, trying to put some snap into my voice. "I may be young in comparison to you, but in all other ways I'm fully matured. You were insulted and so had the right to take revenge, but you've already had that revenge. Now remove the suppression band from my brow and free me."

"But it wasn't revenge I meant to take," Zolanus said, still trying to lull me. "My aim was to teach you a bit of humility, and that hasn't happened yet. You still demand rather than ask."

"It's my nature to make demands instead of asking for things nicely," I pointed out, managing to rouse myself even more. "If you mean to change that part of me, you may as well end my existence here and now. You'll accomplish the same end without the strife and agony in between."

"How odd," Zolanus murmured, and I had the impression that he studied me closely. "When we first began this, you weren't able to resist me in the least. Now I would have to make a definite effort to take control of you again, and I would like to know why that is."

"It seems that your previous efforts brought about something you hadn't anticipated," I said, ignoring the strong need my body resonated with. "I say again: either release me, or destroy me completely. I'll allow no other choice."

"You also sound different," Zolanus observed, giving the impression of raised brows. "Very well, I'll release you on one condition: you must tell me everything of what you experienced. I know only in general what lives I set you into, and no more than that they failed to impress you as I wanted them to. Will you speak as I wish?"

"I can't discuss my experiences until I come to terms with them myself," I said with a sharp headshake. "If you'll take my word that I'll give you what you wish at another time, I'll accept your bargain."

"When we first began this, I would not have accepted your word," Zolanus said, allowing me to sit up straight. "Now, however... Very well, you may return to me when you've put your thoughts in order. I sincerely hope that the time won't be overlong, else I'll likely lose patience... "

He let his words trail off in a threatening way, but when I said nothing in return he simply sighed and reached to my brow. A moment later the band was gone, and my abilities as a goddess were fully restored. I gave Zolanus a formal nod of thanks, then translated myself to my dwelling. It seemed like ages since I'd last been home, but the reaction of the First Hands belied that feeling when they appeared to greet me.

"Ah, you've returned, glorious child," the First Hands said as they floated near to pet me. "We trust you had a marvelous experience during the time you were gone, as marvelous as you deserve. We – "

"Please, no more," I interrupted, holding up my own hands. "Have wine brought to my contemplation room, and see that I'm not disturbed."

"As you wish, child," the First Hands acknowledged with a flutter that seemed a bit on the disappointed side. "Once you've gloried in the sweetness of your memories, you may decide to share them with those who feel nothing but love and concern for you... "

By then I'd reached the door to my contemplation room, and walking inside let me hear nothing more of what the First Hands were saying. My thoughts were completely in chaos, and I paced back and forth until another pair of Hands brought wine and a goblet. I allowed the Hands to fill the goblet before gesturing them out, and then I was finally alone.

I raised the goblet and took a deep swallow of the wine, needing the bracing like never before. My body no longer demanded the attention of a male, but that was small consolation. I remembered every one of the lives I'd been forced to live, and all I wanted to do was cry. It was unheard of for a goddess to be foolishly emotional, but

that wasn't what kept the crying from happening. The fact that tears would be useless kept me dry-eyed, that and the need to do something more than mourn.

If I'd had the heart, I would have cursed Zolanus's name for making me feel so wretched. My mind and memories were full of three men who had loved more than outward beauty, and because of that love had come to terrible ends. The experiences hadn't really been mine, I knew, but having lived them with the human women who did experience them made them absolutely real. I'd never been taught what actual love was, but I knew I'd loved those men and couldn't bear to think about what had become of them.

I took my goblet of wine and sank down into a chair, trying to make myself believe that those lives I'd seemed to have lived were just like stories written on a scroll. They weren't real, not in *my* life, so why couldn't I get them out of my head? Maybe drinking more wine would take care of the matter...

I finished the decanter of wine the Hands had brought, then willed the decanter full again and emptied it a second time. I'd just done the refilling for the second time and was about to pour another cupful, when a painful truth came to me. Only humans found oblivion in wine; gods weren't quite that fortunate. I closed my eyes in pain for a moment, then left both goblet and decanter where they were and willed myself to a mountain stream known only to the children of the wild. I needed to be really alone, and when I reached the place I wanted I sat down and leaned against a tree.

"Wender," I suddenly whispered, useless tears filling my eyes. "Claidon... Xegio... How I miss you... "

The tears streaming down my cheeks said I did more than miss them, far more. None of them was mine and never had been, but that didn't seem to make a difference. Just as it made no difference that I still wore the same tiny outfit that I'd returned in from Zolanus's realm. There was no one around to see me, no one to look at me with crippling desire...

I cried for quite a long time, and once the tears were gone they were replaced with an idea that should have come to me sooner. I *was* a goddess, after all, which was a double lucky thing. If I hadn't been, all that crying would surely have left me too exhausted to carry out the best idea I'd ever had...

14

Once I had control of myself again, it didn't take long to figure out what had to be done. Zolanus had put me into the lives of real humans, so I willed myself to find the first of them. The queen who had announced herself as Meriath had a different name, of course, but I didn't bother to learn it. I simply thought of her as the first Meriath, and in that way found her easily.

The woman had lost herself in the woods trying to find her way to the house of the man Forain, the one who had been an advisor to her father. Her inner being still wept with hurt and betrayal, but she hadn't been betrayed by the one she thought she had. I freed her of Zolanus's... gift, and then moved her to a place only a short distance from the house of Forain. She noticed none of my doing, nor was she aware of it when I deftly took control of her.

Then I was the one who saw Forain's house through the trees, and hurried to reach the front door. Everyone, especially Clovan, would certainly be looking for the missing queen by now, so there wasn't much time. I went up to the door and knocked, and when a servant opened the door I brushed past him.

"I need to see Forain immediately," I said as I entered the house. "Where is he?"

"My master is in the back garden," the servant answered nervously because of the tone I'd used. "May I tell him who has come to call?"

"I'll tell him myself," I answered with a brusque gesture. "You, however, can lead the way."

The servant gave me an unsteady bow, then hurried off in the direction of the back of the house. I followed at the same pace to a small door to the outside and through it, and Forain looked up from the chair he lounged in.

"Your Majesty!" Forain gasped and struggled erect when I threw back my hood. "Are you all right? Everyone in your palace is frantic!"

"I could do with something to eat and drink, but other than that I'm fine," I said as I let him seat me in a second chair. "But I do need your help in a very important matter."

"Fetch food and wine for the queen," Forain told the servant, and once the man had run off to obey, Forain turned to me again. "How may I serve you, Your Majesty?"

"You can help me do something about General Clovan," I answered immediately. "The man means to have my throne, and if he succeeds the realm will suffer even more than it's already doing. I only just found out what he's been up to, but surely you knew all about it… "

I tried to keep my words a question rather than color them with accusation, but the effort turned out to be unnecessary.

"But of course I knew about it," Forain agreed with a sigh. "That was the reason I asked for a meeting with you, but you refused to see me. The only conclusion I could come to was that Clovan acted according to your orders."

"No one told me that you'd asked to see me," I said in a near growl, disliking the situation more by the minute. "That lack suggests Clovan isn't working alone, so we'll have to be more than just discreet. Can you get me back into the palace and lend me your arts to counter whatever they have waiting in the way of a trap?"

"Your Majesty, I will gladly support you with whatever small talent I possess," Forain agreed at once, his face suddenly looking years younger. "I dreaded the thought of going up against the daughter of my old and dear friend your father, but I would have needed to act soon in any event. Too many of our people were suffering for me to sit back and do nothing forever."

"Dear Forain, if I'd been behind what's going on, I would have deserved to have you stand against me," I assured him with a smile as I reached over to pat his hand. "Now we can stand together instead, and face down those who care only for power. Let's begin to make plans."

It turned out that Forain already had a plan, so I listened while his servant brought food and wine. Forain joined me in the meal, and once we were through we began to put his plan into action.

I entered the city in Forain's coach, but when it came to entering the palace only my father's former advisor was seen. The old man did have a good deal of magical ability, and it needed only a touch or two of my power to get us to my apartment. Once there I bathed quickly and dressed as a ruling queen properly should, and then it became Forain's turn to be invisible. I'd been considering the matter, and I thought I knew which of my advisors was working to put Clovan on the throne in my place. That meant it was time to visit the man, which I did at once.

The guards standing in front of Jildar's apartment bowed and quickly opened the doors to his sitting room. I walked inside with Forain invisibly at my side, and waved away the servant who came forward with a bow to offer his help. Jildar was usually in his study at that time of day, so that's where I went. When I opened the door

Jildar looked up from his desk in annoyance, but the words of anger he clearly meant to speak turned into startled surprise.

"Your Majesty, you've returned!" he said as he got to his feet, his sudden awareness of my expression making him forget to bow. "Is something wrong? Where have you been? We've all been frantic with worry, and this must never happen again. Steps will have to be taken, and although you may not care for those steps, we must keep the good of the realm in mind. We've decided that – "

"Your decisions don't interest me, Jildar," I interrupted in a cold and even voice. "What does interest me is the reason why you betrayed our people. You and I have never really liked one another so betraying me is understandable, but why would you do something like this to our people?"

"The people are there to be used in whatever fashion their betters wish," Jildar answered with a curt gesture, making no effort to deny my charges. "By using them properly I will become the sole advisor to a strong king, rather than just one advisor among many of a headstrong queen. The new king will keep you tightly under his control, and I will reap the rewards of a loyal supporter."

"You really are a fool," I said into his smirk, my words filled with all the disgust I felt. "Clovan isn't the kind to listen to or even want an advisor, and as soon as he was crowned he would have rewarded you with death or permanent imprisonment. Haven't you ever heard the general say that a turncoat can't be trusted even by the one who turned him?"

"No, I haven't, and that's nonsense," Jildar huffed, trying to talk himself out of believing me even as his face paled. "I'll be rewarded with power and riches, and nothing you can say will make me think otherwise. Right now I'm going to have my door guard return you to your apartment, where you'll wait quietly until General Clovan can be sent for. He's out searching for you, since his marriage to you couldn't be announced until you were found. Then we'll – "

"No, you'll do nothing," I interrupted again, no longer having the slightest doubt that Jildar had earned the fate that would be his. "Your days of doing things are over, as of this moment."

That was the cue for Forain to put Jildar under his power, which was quickly done. My former advisor stiffened where he stood, his face losing all trace of expression. A few fast questions unearthed the fact that only one other of my advisors was in league with Jildar. The man in question was even more of a fool than the one who had recruited him, and had no idea he would be done away with as soon as Clovan took the throne.

"This Jildar knows nothing else of value, Your Majesty," Forain pointed out after asking a few questions of his own. "As his acts of treason were freely admitted, is there any reason not to give him his due?"

"None at all," I conceded with a nod of my head. "I would be honored if you would see to the matter."

Forain bowed his agreement, and then he turned to Jildar and gestured in a complex way. Once the gesture was completed, Jildar had disappeared, never to be seen again. After that we visited my second disloyal advisor, and the man turned out to be a petty tyrant who looked forward to lording it over everyone in the city. When we had the truth from him he followed Jildar to wherever the first man had gone, and only one more traitor had to be seen to.

It was rather late by the time word reached Clovan that I'd returned to the palace and he was able to do the same. I'd had a very pleasant dinner with Forain, and we were in the midst of sipping wine and discussing my changed plans for the realm when the general arrived. The door to my private sitting room was thrown open without warning, and then Clovan was striding into the room.

"Where have you been, woman?" Clovan demanded as he approached me, paying no attention to Forain. "Do you have any idea how much trouble you've put me to? You will immediately go to your knees before me and beg my forgiveness, and then you'll beg to be punished."

"Someone would think he already wore the crown," I commented to Forain in a very mild way, causing Clovan's face to darken even more. "Do you think he really missed me all that much?"

"Oh, I certainly did miss you, my dove," Clovan said before Forain could utter a word, and the general's tone had suddenly gone back to being silky smooth. "We had such marvelous fun together before you disappeared that I knew you would want to repeat the time as soon as you returned. Send the old man away and we can begin at once."

"We aren't at the time of beginnings, General, but at the time of endings," I said, remembering all too well what he'd done to me – and letting the memory show in my expression. "If you think there's a reason for me to let you live, you'd better mention it quickly. I find I have very little patience left with you."

"Do you really think you're still in charge here, my dove?" Clovan asked with clear amusement, his helmet shifted to the crook of his arm. "It's *my* men who stand armed in the hallways and corridors, men who take orders from no one else. Whoever that old man is, you now needn't bother to send him away. I'll enjoy having him see the punishment I give you, to add to the humiliation of the time. Once I'm done you'll beg me to marry you and take the throne as king, and then – "

"Excuse me, Your Majesty, but I simply couldn't bear his arrogance any longer," Forain said in annoyance after performing a gesture. Clovan had been cut off in mid sentence, and now stood like the statue he would never have erected to his prowess. "Is there anything you wish to ask him before I send him after the others?"

"We'll need a list of those who really are loyal only to him," I told Forain, then got another idea. "And rather than simply sending him after the others, I wonder if we might do something else."

Forain raised his brows questioningly, and when I explained my idea, he laughed aloud.

"Yes, I do prefer that to simple oblivion, and I do believe I can manage it," Forain said with a chuckle. "But first we need to have that list."

We got the list that happily contained only a few names, then Forain put Clovan into a deep sleep. The general's second in command hadn't been listed as a loyal follower, so I arranged for the man to take command of the army. But only after Forain and I spoke to and then disposed of the men who were loyal to Clovan. By that time Forain and I were really tired, so we separated for the night and went to bed.

Bright and early the next day, I had Forain ride out with my new general and a large number of his men. They also took wagons with them, and by following my directions they were able to locate the outlaw camp. I went along without their knowing it, and when Forain paused to put everyone in the camp to sleep he had my help. After that my guardsmen just had to load everyone into the wagons and bring them back to the city.

It was Forain's job to question the outlaws and find out which of them were seriously interested in breaking the law, and which had just been harried out of their lives by Clovan. The honest would be freed to return to their homes while the others would be held to account for their doings, but there was one outlaw I saw to personally. I had Wender brought to the palace, and when he awoke I sat not far from his bed.

"What – what's going on?" he asked groggily as he sat up and looked around. "Where am I, and what are *you* doing here?"

"We're in the palace, and I'm here because I'm your queen," I answered, feeling oddly nervous. "General Clovan is no longer in charge of my army, so all men are now free to go back to the lives that were stolen from them."

"I – see," Wender said, looking away from me. "When you disappeared I tried to find you, but – Well, none of that matters now, does it? You're not some man's mistress; you're the queen, so I really was a fool. Have you decided what to do to me for having treated you the way I did?"

"As a matter of fact I *have* made a decision about that," I said, fighting not to feel what my human host did and therefore have my voice tremble. "But first there's something you have to be told. Clovan and two of my advisors were in league to put the general on the throne as king, and to do that they needed my agreement to marry the general. To that end I was ensorcelled somehow, and made to feel an undeniable need for any man who desired me. I had no choice about serving those men, but the spell no longer holds me."

162

"Those filthy rogues!" Wender exclaimed, now looking at me with anger for what had been done. I'd only told him a small distortion of the truth, so there was nothing of guilt for him to see in my eyes. "That must be why Tilloh was able to – force you to his will, just as you told me he did. Please forgive me for doubting you."

"There's nothing to forgive," I assured him with a smile. "If I hadn't meant more to you than just a passing fancy, you would never have felt as hurt as you did. And I... did mean more to you, didn't I?"

I couldn't keep the question from sounding horribly diffident and forlorn, but my answer didn't come in words. Wender's eyes showed really great pain, and then he looked away from me again.

"My queen has always meant a great deal to me," he said in a choked voice, trying to evade the question I'd asked. "I'm a loyal citizen of the realm, so – "

"Wender, stop it," I interrupted gently, leaving my chair to walk to the side of the bed and put a hand to his arm. "Before I left your camp so... abruptly, I'd made up my mind to abdicate the throne after I got rid of Clovan. That was because giving up the throne is easier than giving you up, and I still feel the same way. I'd enjoy it if you would agree to become my consort, but if you can't live with that arrangement I *am* going to give up the throne. If you'll have me."

By that time he looked straight at me again, a stunned expression covering him completely.

"But – but you're the queen," he protested lamely, nearly begging for help in understanding what was happening. "What would I do as your consort?"

"You would remind me not to make excuses, and punish me if I did make them," I told him with a smile, sitting down to take his hand. "Queens always need someone like that around to keep them from getting sloppy, and I think you'd do a better job of it than anyone else. If you decided I was worth the effort."

"And if I say no, you'll really give up the throne?" he asked, now looking better as his hand came gently to my face. When I nodded quietly, he gave his own nod. "Yes, I believe you would. I'll have to think about this for a short while, but you should know that I went looking for you after our argument to apologize for what I said. It didn't take long for me to realize that I didn't want to live without you no matter what your hobbies were. Now that I know the hobbies weren't your idea, I don't see a single problem that we can't work out together. But I'm curious about what was done with General Clovan. Was he executed, or simply locked up?"

"Neither," I answered with a smile. "I thought it unfair to take his great pleasure away from him entirely, not when he enjoyed it so very much. Instead I made it possible for him to continue with that pleasure, only from a... slightly different point of view. Would you like to see what I mean?"

I'd made the offer because of the puzzlement in his eyes, and he accepted at once. He left the bed and followed me out of the room and into the hall, and from there I led the way to the private entrance of a room Forain and I had provided. The room we entered was a small one and dark, but light leaked through the glass wall separating the small room from a larger one.

"The other side of that window is a mirror, so we won't be seen unless we light a lamp in here," I told Wender softly as we approached the expanse of glass. "After a time chairs will be brought in here and the lamps *will* be lit, but for now Clovan will be allowed his privacy. Do you see him there?"

Wender looked through the glass and studied the two people in the room with a frown. A rather large blond – and naked – woman was bent over the lap of an even larger man, her wrists bound behind her and a gag stuffed in her mouth. The man struck her reddened bottom with the paddle he held, the stroke of his arm making her jump and writhe each time the paddle struck her seat. She also seemed to be trying to say something through the gag as tears poured down her face, but the man spanking her had no interest in what that might be.

"I somehow had the impression that Clovan looked quite a bit different than that," Wender said as he nodded toward the man. "But that's beside the point. What I'd like to know is why you're rewarding him with a female slave when he tried to enslave *you*."

"The man in the chair isn't Clovan," I answered with amusement, having anticipated Wender's confusion. "That's Clovan getting his bottom warmed, but now he's no longer a 'he.' He enjoyed doing that sort of thing to so many others that I offered the loyal members of my guard the chance to do the same to him. There are a number of small spheres that were inserted into Clovan's bottom before that spanking began, and he – pardon me, she – may be trying to beg to serve that guardsman with her body. She eventually *will* serve the guardsman – and many others, one by one – but for now release won't be allowed her. She hasn't yet earned the right to it."

"Clovan's probably wishing right now that you'd had him executed," Wender said with a laugh, no longer bothered by what he saw. "Once word begins to spread about what's being done to the general, the people he tormented and betrayed should feel more avenged than his death would have accomplished. You're a very wise woman, and I might just like the idea of being the consort of a woman like that."

He took me in his arms to kiss me, and that was when I moved back to let him kiss his future wife. What decision they made and how they lived was *their* business, and I had business of my own elsewhere…

The next ones I had to find were "Meriath" and the slave Claidon, who'd been caught by the slaveholders. I willed myself to that place, slid into the body of my host, and then froze all the men where they stood. It took a bit of effort to free myself from the ones holding me, but once I had I went over to the tree where they had Claidon. The rope was already around his neck, so I took it off as he pulled himself free of the hands holding him.

"I don't understand what's happening," Claidon said in a whisper as he looked around fearfully. "Why are they all standing still like that?"

"It must be one of the gods holding them like that," I said without the smile I felt on the inside, and then turned to look at the man Brazzan. "People who keep slaves are despised by the gods, because they're too stupid to understand the consequences of what they're doing. They never seem to understand that if you let the next man or woman be enslaved, you're just opening the way for the same thing to happen to you. And you know what? That's just the fate you have waiting for you."

Brazzan couldn't move, but the sudden strain around his eyes said there was nothing wrong with his hearing.

"That's right," I told him with a smile. "It's your turn to know what being beaten is like if you don't perform perfectly. When you get back to the ranch you'll find the enemies of your lord waiting in hiding, ready to jump out and put you all in chains. They've already done that to Espelle and his cronies, so you'll have lots of company. But don't think you can avoid your fate because you've been warned. You'll have no choice about going back even though you know exactly what you're walking into. Consider the condition an additional punishment for liking the idea of hanging so well. You can all leave now."

Brazzan and his men all turned and headed back for their mounts, most of them looking frantic and the rest looking terrified. Lord Espelle's enemies didn't believe in "coddling" their slaves the way Espelle did, so there would be nothing to make the time easier for the new slaves. They would find out just how "kind" they'd been, and would learn to regret not having worked to end slavery instead of fooling themselves into believing they were doing it the right way.

"The judgment of the gods is harsh, but I can't see it as being unjust," Claidon said from behind my right shoulder as the men disappeared. "Do you know what's going to happen to *us*?"

"Yes, I certainly do," I said, turning to him with a smile as he put his arms around me. "Brazzan and his men will be nice enough to leave us two mounts and all the gold and silver they happen to be carrying. We aren't far from the boundaries of the next realm, where slavery is forbidden. The people there will happily make a place for us, and then we can get on with our lives."

"But we'll also have to do something to free other slaves," Claidon said as his arms tightened around me. "I could never enjoy my own freedom while knowing there were others who yearned for the same."

"And I'll help," the woman in his arms assured him as I moved away from them. "I don't think the gods will interfere again, but we'll still manage on our own."

Claidon agreed and bent to kiss his woman, and I watched only a moment before going on to my next business.

Finding the labyrinth and the cave where Xegio and "Meriath" were was no more difficult than finding the other locations had been. I arrived just in time to keep the sharpened stake from driving through my body and then into Xegio's, stopping the men who carried the improvised weapon with a single gesture.

"I don't know how you did that, but I'm certainly glad you managed it," Xegio said as he pulled me into his arms and away from the path of the halted stake. "Now it's my turn to do something, a something I should have done much sooner. Letting these users live as they liked in my domain was a mistake."

"Xegio, please let me do the something," I asked as I put a hand to his face. "Not all of these fools are as vicious as the rest, they're just afraid to be on their own. They were wrong to follow along, but they're also the victims of an even greater wrong that can now be righted."

He raised shaggy brows to show his lack of understanding, but then he nodded his agreement to my request. He was the most beautiful person I'd ever known, and I paused to kiss him briefly before turning away.

My first chore was going to the young girl who had been hurt by Verlin and the others. I healed her of all wounds both physical and mental, at the same time taking all memory of her ordeal from her mind. When she sat up I froze her in place the way I had with the others, and then I turned to the men. It didn't take long to find out which of them were with Verlin because they enjoyed doing as they pleased and which were there because of fear. The larger number of men weren't part of Verlin's inner circle, and I separated the two groups by standing them on opposite sides of the cave.

I darted away for a moment to touch the other women in the caves of the labyrinth, healing the ones who were hurt and making them forget the pain and terror. Then I returned to the cave I'd started in, and gestured to produce what everyone would see as the hacked off head of "The Beast."

"There," I said as I looked back at Xegio. "The innocent men will round up all the groups of women hiding down here, and together they'll go out to show the world that 'The Beast' is dead. That means they'll be able to go back to the lives that were stolen from them, and the priests will suddenly find that their influence has lessened considerably. How does that sound?"

Xegio nodded his agreement with a faint smile, so I released the innocent men and the one girl, and sent them on their way. They all believed sincerely that "The Beast" had been killed, and the bloody head they carried with them would prove the fact. Then I led Xegio out of the cave, and once we were outside I sealed it closed.

"The ones who are left in there will have enough food and drink that they'll be able to live very long lives," I told Xegio once the cave entrance was gone. "They just won't have anyone but each other to savage, which I'm sure they'll eventually get around to doing. But what they won't be able to do is get out and ruin any more lives."

"Killing them probably would have been kinder, but the gods don't believe in kindness," Xegio answered quietly, an odd pain in his eyes. "May I ask which of the gods *you* are?"

"I'm not really any of them," I answered, not precisely lying. "One of them is just working through me, and she isn't yet done. In her opinion you've earned the right to be turned back to your original appearance, which she'll do if you want her to. But she's also willing to leave you as you are, or make you no more than homely, or give you any other choice you'd like to make. Apparently she's almost as fond of you as I am."

"Is fondness all you feel for me?" Xegio asked at once, coming a step closer before he stopped himself. "I thought – that is, I hoped – "

"Fool," I said with a laugh as his tangled words ended abruptly. "*She's* the one who's fond of you. I'm the one who loves you, and who would have happily died to save your life. Aren't you going to answer her question?"

"I'll answer as soon as I tell you that you're never to do something like that again," he answered with a growl and lowered brows. "Do you think I'd want to live if you didn't? Talk about great big giant fools…"

"Yes, all right, I'm sure you two can discuss the point later, in privacy," I said after clearing my throat. "Right now I'd like that answer so I can get on to the last of my business."

"What I'd like is to be ordinarily homely, so that no one ever runs in fear from me again," Xegio answered with a silly smile as he folded me in his arms. "I'd ask to be handsome again if I really believed I could handle it, but some people aren't as strong as others. Maybe some day I'll be strong enough, but right now I'd rather not take the chance of doing something stupid and losing the best thing that ever came into my life."

"Who are you calling a thing, you beast?" I asked as I put my own arms around him. "Ordinarily homely it is, but if you ever change your mind you just have to call on Meriath. I'll hear you, and I'll come."

"Thank you," he said with a glistening in his eyes, and then he leaned down to kiss me. I slid away from his love while he did that, and made the change he'd

requested. Now he and his woman could either stay in the labyrinth or lead the rest of their people back out into the world. The choice would be theirs, but I hadn't been lying.

I did still have one last piece of business to take care of…

15

I went to my dwelling and let the Hands bathe, comb, and dress me, and then I went to take care of the last of my business. I wore the plainest gown I had with nothing in the way of jewelry or decoration, and my hair flowed free without ornament of any sort. I willed myself to the front entrance of Zolanus's dwelling, rang the bell hanging there to make my presence known, and then waited.

Surprisingly, a pair of Hands responded almost immediately. I'd expected to be kept waiting, but instead was shown to a small sitting room where Zolanus, surrounded by his darkness, awaited me. The Hands guided me to a chair and then supplied a cup of wine, after which they disappeared to leave us alone.

"I find myself surprised by how quickly you've returned," Zolanus said as I took a sip of the wine. "And, if we're to be completely truthful, I half expected you not to return at all."

"You're entitled to the details of what I experienced, so here they are," I said, and then told him everything, reserving only my own feelings. "And now that your curiosity has been satisfied, you may complete your revenge for the insult I gave you."

"You're offering to let me put you under my control again?" Zolanus asked, his tone faintly bewildered – and something else I couldn't define. "If you expected to be captured again, why did you come back?"

"When you hurt people, especially for no reason, you deserve to be hurt in return," I answered, looking at my cup rather than at him. "You have a right to revenge yourself in whatever way you see fit, but I would appreciate it if you would get on with it. I feel a great need to be alone, but solitude will have to wait until you're satisfied."

"Give me a moment, please," he murmured, his tone odd again. "I must think about what you've told me."

I nodded agreement to his request, and simply sat and waited. My mind seethed with thoughts demanding attention, but they would have to wait until I found a place to be alone. A handful of minutes went past, and then Zolanus stirred.

"To begin with, I think it's perfectly obvious that you're not the same being I captured originally," he said with a sigh. "With that in mind, my... revenge will consist of asking certain questions to which I expect complete and truthful replies. Do you agree to this demand?"

"As you wish," I allowed after a very brief hesitation, voicing my own sigh. His questions would most likely be pointless, but I did owe him time and effort at the very least. I still hadn't looked up at him again, but he didn't seem to have noticed.

"Good," he said, and for some reason his tone had apparently warmed. "You told me everything that happened to you and what you did after I released you, but what you haven't told me is why you went back to those mortals. Did you feel obligated in some way?"

"In a manner of speaking," I agreed, having trouble finding the right words. "My disagreement with you interfered with their lives, so I felt compelled to intercede on their behalf. It seemed the right thing to do."

"In my opinion it was a very right thing to do," Zolanus said with obvious approval. "But I have the feeling that more than simple fair play moved you. Tell me what you learned from the human lives you shared."

"I... learned a number of things," I replied, trying not to avoid the pain of answering truthfully. I'd earned that pain, and not putting the matter into words would do nothing to make bearing the ache any easier. "I learned that physical beauty is nothing, not if there's no matching beauty inside you. Ugliness comes from caring only about yourself, from being mean-spirited and narrow-minded, and most of all from thinking that you have an incredible amount of worth when you really don't have any at all."

"What about being stubborn?" Zolanus pursued, his tone now mild. "Isn't hardheaded stubbornness ugly?"

"Only if you're stubborn about the wrong things," I responded, moving my gaze to the fingers in my lap. "If you refuse to hear or learn the truth, you've found another way to be ugly. If you use your stubbornness to the advantage of others, then you've found another way to be beautiful."

"You say the words 'the truth' as if they mean something special to you," Zolanus observed. "Have you learned a truth apart from the other things you've learned?"

"I've... learned the truth of how completely useless I am," I whispered, putting aside the cup I held to bow my head. "Beauty without substance is a mockery, but that's all I stand for. Beauty alone is meaningless, but I'm completely alone. What more obvious truth can there possibly be?"

"There's a truth you've overlooked," Zolanus said, and I heard/felt him shift forward in his chair. "Beauty can also be found when someone is willing to learn from

170

their mistakes and correct their faults. Everyone has faults, but the trick is to see them clearly and be willing to do something about them."

"That's more of an opinion than a truth," I disagreed with a headshake. "Correcting your faults is all fine and good, but you have to be left with something of worth when you're done otherwise you're wasting your time. If there isn't anything of worth inside you to begin with, correcting faults won't bring anything out."

"But sometimes we can't see our own worth," Zolanus said in disturbed argument. "Just because we can't see it doesn't mean it isn't there, especially if others see it in us."

"Sometimes others see things through their inner beauty that just aren't there," I countered, refusing to fool myself again. "They're good enough to want to believe that the worth is there, but it really isn't. Is this going to take much longer…?"

"Meriath, listen to me," he said as he reached over to pull me from my chair and into his lap. "When I first started this you *were* shallow and useless, but that kind of person never would have done what you ended up doing. I think I can eventually convince you of that, but I also have the feeling that something else is bothering you. Will you tell me what that something else is?"

I sat stiffly on his lap with my head down, fighting to uphold my end of the bargain and answer his question. I tried to speak, I really did, but tears began to stream down my cheeks and a lump closed my throat. Wender… Claidon… Xegio…

"Oh, my poor child," Zolanus suddenly groaned, his arms closing tightly around me. "You felt the same love for those men that their real women did, and you had to turn away and leave them to the women meant for them. I'm so sorry…! I never meant for that to happen, I swear I didn't. An outcome like that isn't justice, it's agony. No wonder you're without hope or belief in yourself."

When he pulled me against his chest in an attempt at comfort, I couldn't hold back the sobbing any longer. It wasn't possible to find comfort, but it also wasn't possible to refuse the offer. I cried out the terrible pain I felt, a pain I knew would never leave me, and Zolanus made small sounds of encouragement as he held me close and rocked me. The storm lasted for quite some time, and when it was over I felt mortally exhausted.

"Are you all right now?" Zolanus asked once the sobbing had eased down to ragged breathing, his hand still stroking my hair. When I nodded and tried to move away from him, he refused to allow it. "No, just stay where you are for a short while. The only thing I can give thanks about in this whole mess is that Hamaius isn't around to see it. If he were, I'd regret it even more than I do now."

"Hamaius?" I echoed in a whisper, feeling a bit confused. "Why would you worry about the God of Wisdom?"

"I'm... concerned because Hamaius is the one who decided to temper *my* arrogance when I was your age," Zolanus admitted with a sigh after a short hesitation. "I was the God of Justice, after all, and I took a great deal of pleasure in handing out what I considered justice to mortals and gods alike. Hamaius made me live through some of what I considered so just, and afterward I felt shattered. Nothing teaches you the error of your ways like having to live with what you consider so right for others – but don't consider right for yourself."

"Somehow I can't picture you being like that," I said, leaning back a little to study his outline form. "And I don't understand how justice can be anything but... just. If someone has earned a taste of that justice, how can it be wrong to give it to them?"

"Justice should always be tempered with mercy," Zolanus told me, his big hand smoothing down a tangle in my hair. "There are very few instances where the harm people do has no source other than themselves. Take your General Clovan, for instance. He was raised by a mother who idolized him, and gave him everything he ever wanted. He grew up knowing that he was entitled to do anything he pleased to others, that it was his right to treat them like slaves and their privilege to accept that treatment. He definitely earned the justice you gave him, but who was really responsible for his actions?"

"I see your point, but don't completely agree with it," I said after taking a deep breath. "His mother should have been smacked hard for raising him like that, but once he looked around at the world he should have known enough to temper his own actions. You don't have to let people spoil you, not when common sense should tell you it isn't in your own best interests. But he didn't even have the sense to know what was and wasn't good for him."

"I think I understand now what you meant when you mentioned your nature earlier," Zolanus said, giving me the impression of a smile. "You do seem to be the sort to speak your mind no matter who you happen to be disagreeing with, and I know now how you were able to break free of my control. I'd bound one kind of being, but without my noticing it you turned into another kind of being entirely. In one way you're much more attractive now, but in another... I'm not used to being argued with."

"That seems to amuse you," I observed, trying to study him. "The others do give you a lot of... respect, so I don't imagine they do argue very often. Is that why you show only a shadow of yourself, so they'll be more impressed and argue less?"

"The gods aren't all that different from mortals," Zolanus said with another sigh and a nod. "If they saw my true features they would be more likely to dismiss me than listen to what I have to say, so I hide behind a mask of darkness. You, however, tend to argue with me anyway, so would you like to see what I look like?"

"Only if you really want to show me," I answered with my head cocked slightly to one side. "I *have* learned that individuals are much more than what they

happen to look like."

"But what they look like does happen to affect how they behave," he countered, and again I had the impression of a smile – for a brief moment. "Keep that in mind when you see me."

I nodded my agreement to the request and simply waited for the shadow to take on form, but that didn't happen immediately. There was something of a hesitation, and then suddenly, all at once, I sat on the lap of a being rather than an outline. Zolanus was still big, but his features were so ordinary that he was nearly nondescript. Neither handsome nor ugly, the God of Justice probably would have disappeared behind a crowd of only two or three. I wondered briefly if that was because justice is neither good nor bad, it just *is*…

"I think I see your problem," I said as I studied mild brown eyes and medium brown hair. "Justice is a serious matter, but when you aren't spectacular in some way it's too easy to dismiss you. No wonder you turned arrogant when you realized what your abilities were."

"Yes, arrogance often comes to those who are dismissed by their peers just as it comes to those who are catered to by them," Zolanus agreed with a faint smile. "So what do you think of the god in whose capture you were?"

"I think I owe you my thanks for having pulled me out of perpetual childhood," I said with my own faint smile. "It was a rude and painful awakening, but if given the choice I'd prefer not to go back to what I was. Except I do miss the innocence of my former arrogance. There's no denying that I was happier then than I am now."

"Yes, we do give up blind happiness when we give up innocence," he agreed with a nod and a distant look in his eyes. "But we also learn what true happiness is, and that it *is* possible to attain. No child can know that, so the price we pay isn't quite as high as it seems at the time."

"You know, an odd thought just occurred to me," I said as I continued to study him. "I was in no condition to notice at the time, but you were awfully quick to guess what was really bothering me. And you seem to understand what I say without my having to explain it. Can it be that your own… experience brought you the same pain from the same kind of loss?"

"That was a long time ago, but I've never forgotten," Zolanus said with a bit more of a smile. "I didn't really mean to do the same thing to you, but I made a bad mistake. I thought you'd never come to feel what I had, but I was wrong. Do you forgive me for being arrogant and narrow-minded?"

"Well, I don't know," I said with a slow headshake, pretending to consider the matter. "I forgave you for your reaction to being insulted, and I forgave you for forcing me into adulthood. Forgiving arrogance and narrow-mindedness, though… That's another matter entirely."

"Really," he said flatly, looking at me with lowered brows. "Would you have the same trouble forgiving me if I were still just a shadow in your sight?"

"If you were still just a shadow, I probably wouldn't forgive you at all," I said, trying hard to sound prim. "I am, after all, who I am, and there's very little beauty in a shadow. Individuals show me much more, so I'm willing to be generous."

"What do you consider generous?" he asked, now looking very suspicious. "And what will that generosity cost me?"

"Oh, nothing more than everything you have," I answered, deliberately putting on a satisfied expression. "You can start by inviting me to dinner."

He continued to stare at me with suspicion, but that was perfectly all right. It had become very clear that the being who had opened my eyes to what was really important in the universe had suffered the same pain I had. If I could ease his pain just a little, my own might be eased as well.

"All right, I'm inviting you to dinner," Zolanus said at last, still not completely free of suspicion. "We'll relax and enjoy ourselves, and after dinner you'll forgive me."

"Will there be dancing?" I asked as I took myself off his lap. "I'm much more likely to be forgiving after a delightful time of dancing."

"I don't dance," he grumbled as he looked at me where I stood. "And if you try to ask for too much, I'll forget about asking for forgiveness and put you over my knee. After that you'll be more than happy to give me anything I want."

"Do you really think I'm that easy to bully?" I asked, moving closer to look him straight in the eye. "Maybe I used to be, but not anymore. If you want my forgiveness, you'll just have to be really strong and offer me everything you have. I promise I'll be as gentle as possible."

"Everything I have," he echoed, frowning again. "I thought you meant – What *did* you mean? You can't mean you want me to make love to you? That would be – "

"Can't you finish more than two sentences in a row?" I asked with as provocative a smile as I could manage. "I had the impression you were much more glib than that. And if it's too much trouble for you to make love to me, then you can forget about being forgiven. That would make dinner unnecessary too, not to mention the dancing – "

"Oh, shut up," Zolanus said with a laugh before scooping me off the floor and into his arms. "I've never before been forced to make love to a female just to get her to keep quiet, and I'm curious about what it will be like. Let's find out together."

He carried me out of the room into a bedchamber, and put me down on a wide bed. By now I had my arms around his neck, so I had no trouble pulling his head down where I wanted it. I tasted his lips slowly and gently, letting recent memories fill my mind. Zolanus had a lot to live up to, but I had the feeling he just might be able to…

"Are you sure you really want this?" he asked after we'd touched lips for a few moments, his hands under me against my back. "If you think you owe me something, I assure you that you don't."

"As long as you don't think you owe *me* something," I answered, responding in the same sober way he'd spoken. "I want to share something, the way we shared painful memories, not give or be given an act of charity. If you really have no interest in that sharing, say so now and I'll leave quietly."

"If you want the truth, I approached you that first time because I thought I saw something... special in you," he answered, his voice as soft as his smile. "I do very much want to share something with you, now even more than before. Our kind doesn't usually develop a closeness the way mortals do, but maybe... if we closed our eyes and pretended... "

"Yes, let's pretend to be mortal," I agreed happily, wondering if there was another god anywhere who would have been capable of even suggesting such a thing. "It may help for at least a little while... "

He knew exactly what I meant, and his gesture rid us of all clothing before he joined me on the bed. He kissed my face and my neck and throat before working his way down to my breasts, the touch of his tongue to my nipples making my breath race in and out of my body. He kissed my stomach and then worked his way down to my thighs and between them, the length of time he took bringing me desire more intense than any I'd ever felt before.

I tried to hurry him then, but he refused to allow it. He continued to take his time until I felt ready to cry again, and that was when he came to me. His rod was like steel when he entered me, and he gathered me to him before he began to stroke in and out. I moaned out my delight with the pleasure he gave, holding him tight and returning the kiss he brought down to me.

His stroking was an absolute marvel, and I had one last coherent thought before pleasure took me over completely. Maybe it *is* possible to find happiness, no matter who you are...

Other Books from Greenery Press and Grass Stain Press

Bitch Goddess: The Spiritual Path of the Dominant Woman
edited by Pat Califia and Drew Campbell $15.95

The Bottoming Book: Or, How To Get Terrible Things Done To You By Wonderful People
Dossie Easton & Catherine A. Liszt, illustrated by Fish $11.95

Bottom Lines: Poems of Warmth and Impact
H. Andrew Swinburne, illustrated by Donna Barr $9.95

The Compleat Spanker
Lady Green $11.95

The Ethical Slut: A Guide to Infinite Sexual Possibilities
Dossie Easton & Catherine A. Liszt $15.95

A Hand in the Bush: The Fine Art of Vaginal Fisting
Deborah Addington $11.95

Juice: Electricity for Pleasure and Pain
"Uncle Abdul" $11.95

KinkyCrafts: 99 Do-It-Yourself S/M Toys
compiled and edited by Lady Green with Jaymes Easton $15.95

Miss Abernathy's Concise Slave Training Manual
Christina Abernathy $11.95

Murder At Roissy
John Warren $11.95

The Sexually Dominant Woman: A Workbook for Nervous Beginners
Lady Green $11.95

Sex Toy Tricks: More than 125 Ways to Accessorize Good Sex
Jay Wiseman $11.95

SM 101: A Realistic Introduction
Jay Wiseman $24.95

The Strap-On Book
A.H. Dion, illustrated by Donna Barr $11.95

Supermarket Tricks: More than 125 Ways to Improvise Good Sex
Jay Wiseman $11.95

The Topping Book: Or, Getting Good At Being Bad
Dossie Easton & Catherine A. Liszt, illustrated by Fish $11.95

Training With Miss Abernathy: A Workbook for Erotic Slaves and Their Owners
Christina Abernathy $11.95

Tricks: More than 125 Ways to Make Good Sex Better
Jay Wiseman $11.95

Tricks 2: Another 125 Ways to Make Good Sex Better
Jay Wiseman $11.95

Coming in 1999: Jay Wiseman's Erotic Bondage Handbook, by Jay Wiseman; Blood Bound: Guidance for the Responsible Vampyre, by Deborah Addington and Vincent Dior; Health Care Without Shame: A Handbook for the Sexually Diverse and Their Caregivers, by Charles Moser, Ph.D., M.D.; Justice and Other Short Erotic Tales, by Tammy Jo Eckhart

Please include $3 for first book and $1 for each additional book with your order
to cover shipping and handling costs. VISA/MC accepted. Order from:

 greenery press

3739 Balboa #195 PMB, San Francisco, CA 94121
toll-free: 888/944-4434 fax: 415/242-4409 http://www.bigrock.com/~greenery